On the Cover: Linus Roache fronts a hippie cult in *Mandy*, © 2018, courtesy RJLE Films

Cover design by Irene E. O'Leary, © 2019

366 Weird Movies Yearbook 2018

By 366 Weird Movies Staff * Edited by Gregory J. Smalley * Copy editing by Giles Edwards * Contributors: Ryan Aarset, Alfred Eaker, Giles Edwards, Alex Kittle, John Francis Klingle, Rafael Moreira, Bryan Pike, Pete Trbovich, Gregory J. Smalley, Shane Wilson

Text copyright ©2018-2109, 366 Weird Movies, all rights reserved. All images and promotional materials used with permission, copyrights remain with the original copyright holders.

Text copyright ©2018-2019, 366 Weird Movies, ALL RIGHTS RESERVED. DO NOT REPRINT WITHOUT PERMISSION; except that, if accompanied by a citation to the original, short excerpts may be quoted for purposes of criticism, comment, news reporting, teaching, scholarship, or research.

IMAGE CREDITS:

Adolpho Kormerer photograph by Tamara Grise, courtesy Artsploitation Films

Apocalypsis still © Albino Fawn Productions, courtesy Indican Pictures

Stills from *Birdboy* and *Mind Game*, and *Night Is Short, Walk on Girl* poster courtesy GKIDS

Caniba still courtesy Grasshopper Films

Fags in the Fast Lane courtesy Zombie Zoo Productions

Hereditary still © A24

Hitler Lives! Poster © 2018 Haunebu Films Pty Ltd

It Takes from Within poster © Morke Films, courtesy First Run Features

Panel from "The Last Coloring Book on the Left" © Jimmy Angelina & Wyatt Doyle

Like Me still courtesy Kino Lorber

Luciferina and *Molly* cover art and *Snowflake* still courtesy Artsploitation Films

Madeline's Madeline and *November* stills courtesy Oscilloscope Labs

Mandy still and Panos Cosmatos portrait courtesy RJLE Films

Moon Child cover art courtesy Cult Epics

"Mystery Science Theater 3000: The Gauntlet" art and *Paradox* still, courtesy Netflix

Still from the "Patterson-Gimlin Bigfoot film" is in the public domain

"Room to Dream" cover © 2018 Random House

Sorry to Bother You poster ©2018 Annapurna Pictures

Suspiria still courtesy Amazon Studios

"A Trip to the Moon" cover art courtesy Flicker Alley

Zama cover art courtesy Strand Releasing

Zen Dog poster © 2016 Future Park, LLC

All images belong to their original copyright holders and may not be reproduced without permission.

INTRODUCTION TO THE 2018 EDITION

So, what happened to you in 2018? Did you catch *Mandy* and *Sorry to Bother You* in theaters, or were you stuck watching nothing but *Black Panther* and *Green Book*? What's that? Good to hear, that's just what we'd expect to hear from someone with the good taste to pick up this volume. Us? Well, nothing too special... unless you count the fact that *we finished our freaking List of 366 Weird Movies*! (In early 2019, true, but let's just pretend it happened in 2018 for the sake of this Introduction).

That's right, we completed the massive, foolhardy surrealist curation project that we began way back in 2008. But never fear, we're not quitting. With the List complete, we'll be focusing our coverage on new releases (and revivals), meaning Yearbooks like the one you're now holding in your hands will become an even larger part of the project than they are now. Expect us to keep releasing these books indefinitely, while continuing to add titles semi-officially to the List. We'll be adding new entries as "apocrypha" to distinguish them from the "canonically" weird 366. And, if history is any guide, new weird movies will be made every year, so our mission to bring you news of every weird movie in existence is not yet done.

The big news of 2018 was the release of *Mandy*, the long-waited psychedelic revenge movie that matched the talents of sophomore weird director Panos Cosmatos with the over-the-top thesping of the inimitable Nicolas Cage. *Mandy* was both the readers' and the editor's official choice for Weirdest Movie of 2018, but we shouldn't overlook the contributions of rapper Boots Riley, who debuted on feature film the agitprop capitalist satire *Sorry to Bother You*, or the austere Estonian fairy tale *November*. 2018 was truly a banner year in weirdness, as you'll soon read in the following pages.

If you're into "weird" movies—the umbrella term we coined to cover everything from Surrealist classics like *Un Chien Andalou* to midnight movies like *The Rocky Horror Picture Show* to oddities like Ed Wood's 1950s pro-transvestite documentary *Glen or Glenda?*—then you already know about 366weirdmovies.com, the only website dedicated to identifying the 366 Best Weird Movies of All Time (that's one movie for every day of the year, with a spare for leap years). In case you've somehow stumbled onto this tome with no foreknowledge of the project, that explains why in each review you'll see a section explaining "why it won't," "why it might" or "why it made" the List. All of the movies covered here are at least a little offbeat, but only a select few are brilliantly deranged enough to be "Canonized Weird." (You can see a copy of the completed List at the end of this volume!)

As thorough as we are—and we're the world's most complete source of information on weird movies—even we can't possibly cover everything. That's why we have a huge selection of "Supplemental Listings" synopsizing the year's strangest movies that we just couldn't get to in 2018 for one reason or another. We also include briefer entries on older movies that were re-released on DVD, VOD, or Blu-ray in 2018.

Note: all star ratings have been standardized to the conventional critical five-star rating system, which is about the only conventional element you'll find in the reviews.

And now, our program begins in earnest as we look back on the year in Weirdness, 2018! Here's hoping that 2019 is even weirder—in movies, at least, real life in America having become about as surreal as we can stand at the moment.—*Gregory J. Smalley, editor-in-c*hief

WEIRDEST MOVIES OF 2018

Mandy (2018) ★★★★1/2 (GE), ★★★★(GS)

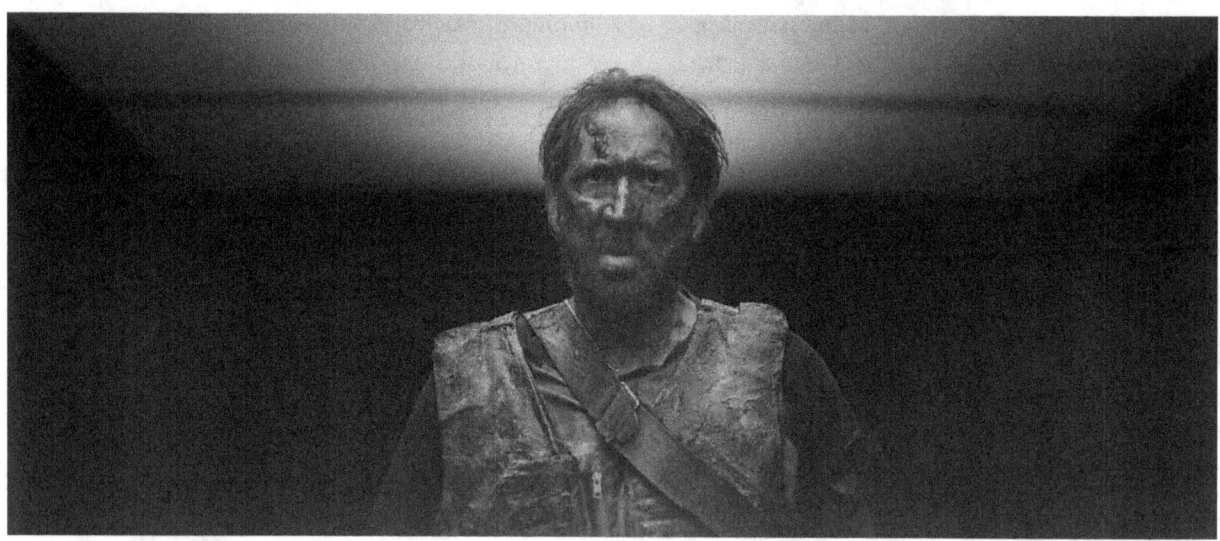

Nicolas Cage as Red in the action, thriller film "MANDY" an RLJE Films release. Still courtesy of RLJE Films.

"And now was acknowledged the presence of the Red Death. He had come like a thief in the night. And one by one dropped the revelers in the blood-bedewed halls of their revel, and died each in the despairing posture of his fall ... and Darkness and Decay and the Red Death held illimitable dominion over all." –Edgar Allan Poe, "The Masque of the Red Death"

DIRECTED BY: Panos Cosmatos

FEATURING: Nicolas Cage, Andrea Riseborough, Linus Roache, Ned Dennehy, Olwen Fouéré

PLOT: A cult is passing through the forested countryside in 1980s Pacific Northwest where Red Miller, a lumberjack, lives peaceably with his love, Mandy. When she catches the cult leader's eye, dark beings descend upon her and Red, robbing Mandy of her life and Red of his sanity. Red mercilessly exacts vengeance upon all who wronged him.

BACKGROUND:

- *Mandy* is Panos Cosmatos' second feature film, and his second film (after 2010's *Beyond the Black Rainbow*) to be Certified Weird. So far, all of his movies have been set in 1983.

- Cosmatos originally wanted Nicolas Cage to play Jeremiah Sand, but Cage preferred the role of Red. Co-producer Elijah Wood smoothed things out and got the two to work out their disagreements, resulting in Cage playing the protagonist.

- The character of Jeremiah Sand was based on cult-leader Charles Manson, another failed musician and acid head. Linus Roache, shortly before being cast as Jeremiah Sand, had dropped out of a cult after its leader had a meltdown.

INDELIBLE IMAGE: *Mandy* provides a full menu for this indeed—even if you winnow your options down to just Nicolas Cage looking crazy-go-nuts. However, the choice becomes clear upon reflection of whom this movie is actually about: Mandy and Jeremiah Sand. Mid-acid-trip-speech, Jeremiah's and Mandy's faces fade in

and out of each other, capturing both of their haunting visages in continuous oscillation between the poles of Mandy's mystical innocence and Jeremiah's mystical evil.

THREE WEIRD THINGS: Demonic apocalypse bikers; The Cheddar Goblin; Heavy Metal death axe

WHAT MAKES IT WEIRD: Described by the director himself as "melancholic and barbaric", *Mandy* plays like a Romantic era poem that collides violently with one helluva nightmare. *Mandy*'s signposts of color saturation guide the eye along the paths of love, wrong, and vengeance while the dirgy soundtrack cues the ear like a Greek Chorus. *Mandy* is almost a movie to be felt more than watched. And even putting aside all the artistry, a cursory look at its basic ingredients screams "weird" as forcefully as Red screams "You ripped my shirt!"

COMMENTS: *Mandy*, in perhaps its only convergence with convention, follows the three-act structure to a "T", going so far as to designate each act with a title card. The opening, "the Shadow Mountains 1983 A.D.," provides the exposition: lumberjack Red Miller (Nicolas Cage) and his wife Mandy Bloom (Andrea Riseborough) exude a preternatural aura of contentment. While her day job is working the cash register of a nearby gas station, Mandy's passions are reading fantasy novels and making sketches based on what she's read. With every small expression and action, she exudes a vivacious spiritual glow—which is unfortunately picked up on by Jeremiah Sand (Linus Roache), a failed musician turned cult leader, whose van passes Mandy while en route to his new church. The cult's dark supernatural forces blast into the bright mysticism of Mandy and Red's life, and so comes the rising action of the second act, "Children of the New Dawn". By the violent finale of the titular third act, both Jeremiah and the audience learn there is more mythical power in the seemingly normal Red than could ever have been guessed.

This simple narrative structure acts as a grounding canvas, as it were, which Cosmatos covers with all the fevered hues, dissonant lines, and explosive brush strokes in his paint box. Three color schemes dominate *Mandy*'s palette: red, pink-blue, and green. The first's meaning is obvious: evil and vengeance. The screen goes crimson with the arrival of the Children of the New Dawn, and when Red is on his rampage, crimson lighting soars in his wake. The "pink-blue" is a subtler harbinger of evil. Most prominently, the encounter between Mandy and Jeremiah is filmed in that bizarre color hybrid. Jeremiah's speech to Mandy begins, "Look at me. Look at me!" She does, and quickly discovers that what she sees is a fraud. The tones get harsher as Mandy begins her scornful laughter at the would-be messiah, as he finishes the scene shouting, "Don't you fucking look at me! Don't you fucking look at me!" to each of his followers. Green turns out to be the most significant, appearing only briefly on three distinct occasions: on the "Horn of Abraxas", which brings about demonic catalysts (in the form of bikers from Hell); the "Tainted Blade of the Pale Knight", which triggers Red's transformation; and in the final animated dream sequence during which the spirit of Mandy extracts a glowing green jewel from the battered body of Red's spirit animal before his final encounter with the cult.

Beyond all the careful lighting, there are countless other little touches that make *Mandy* further impress with each viewing. In a film with so many compelling characters, the three members of the "Black Skull" gang stand out as perhaps the most memorable trio. These unholy beasts on bikes might even be three horsemen of the apocalypse (though they are ultimately upstaged by Red Miller's "Death" as the fourth). They are introduced after Brother Swan blows

the Horn of Abraxas, and we first see them by their vehicles' lights. Between the three riders, there are six lights, and so one can conjure three sixes (a somewhat famed number).[1] There are also clever bits of foreshadowing. When we first meet Mandy, she's drawing a "jungle temple" not dissimilar from the temple in the middle of the woods Red must find. The dead deer that Mandy discovers becomes a harbinger of her fate: soon after, she is spotted by Jeremiah Sand.

And there are some just plain odd touches: the car-window gag scene between Brother Swan and one of the simpletons; Red's almost non-sequitur "don't be negative" remark to his friend just before he goes hunting for the bikers; and the altogether filmic joke of seemingly non-diegetic music playing when we are introduced to "the Chemist", which turns out to be playing from the sound system in his warehouse lab. And more! The opening track is by King Crimson from their album entitled "Red." Brother Swan quotes a Neil Young song whose lyrics appeared in the suicide note of Kurt Cobain. And smacking his own antagonist upside the head, Panos Cosmatos has Jeremiah Sand unable to do anything but lead his followers into a literal hole in the ground.

Mandy, I was told by a reviewer who seemed nearly driven to tears with emotion, was "the fulfillment of a promise made seven years ago". I had never heard of the man who made the alleged promise—Panos Cosmatos—until this past summer when his name sprang up with every mention of the much-hyped *Mandy*. I only learned later that Cosmatos had made a splash on 366 a few years back with his debut, *Beyond the Black Rainbow*. And so it was with virtually no background that I watched the film unfold at the Fantasia Festival—and having seen it three more times since, I understand why it took seven years to fulfill that promise. *Mandy*'s meticulous writing and filming left me struck with quiet awe. Upon the first viewing, it occurred to me that

Mandy was the closest I'd seen a movie come to capturing the feeling of an actual dream. The fourth viewing reinforced that sentiment. All of *Mandy* fits within its own logic, and any criticism of excess is, in my opinion, dismissible: this is Cosmatos' dream, and he translates it beautifully to the screen with an ethereal graininess of sight and sound. There's so much one can talk about with this movie: I haven't even touched on Cage's moving (and bestial) performance, the haunting beauty of the film score, or how *Mandy* can be viewed as a meditation on the grieving process—something that Panos Cosmatos has himself struggled with for the past two decades. *Mandy* stands alone as a work of art; here's hoping it's not another seven years before Cosmatos impresses us once again.

HOME VIDEO INFO: Image Entertainment brought out the DVD and Blu-ray release in a timely manner. The movie is presented handsomely, maintaining the look and sound of the big screen experience — haziness, disorientation, and crisp dirges all present and accounted for.

The extras are somewhat scant, comprising 13-minutes of extended and deleted scenes and a brief "making-of" featurette. My suspicion is that the pressing may have been rushed to capitalize on the Horror Holiday; it wouldn't surprise me if something more comprehensive were to appear on the market eventually.

Of course, you can always skip the disc: *Mandy* is available for streaming on most popular streaming platforms.—Giles Edwards

Gregory J. Smalley adds: The prophesied Nic-Cage-kills-bikers-and-hippies-while-tripping-on-acid fantasia you've been waiting on all your life is here! Visually, it looks like they doused Cage in red-dyed Karo syrup, posed him with a chainsaw in front of a series of blown up death metal album covers and pulp fantasy paperbacks, and filmed the action through a lava lamp lens. While

I liked Cosmatos' freshman effort, the spacey *Beyond the Black Rainbow*, well enough, I half suspected that it was the only decent movie the filmmaker had in him. His style seemed too austere, too laid-back, too stoned, and too nostalgia-bound for him to have a long career after the mellow buzz of his debut wore off. I was thrilled to be proven wrong with *Mandy*, a trippy achievement that suggests Cosmic Cosmatos might actually become the torchbearer for a new generation of midnight-minded moviemakers. The major factor in *Mandy*'s success is obviously the casting of Cage: his fiery mania is exactly the contrast needed to set off this director's dreamy delirium. They form a perfect foreground and background team. But even without Cage, *Mandy* would be a big leap forward. Cosmatos takes clichéd pop trash—demon bikers, psychopathic cults, black metal's pseudo-Satanic poses, ultraviolent cartoons—and turns it into mythical poetry. The first act is slow but hypnotic, catalyzing an idyllic chemistry between Mandy and Red, who spend blissful days cuddling in their Pacific retreat. Then, senseless evil cleaves their happy equilibrium, and Cage goes crazy and pours vodka down his throat while wearing a tiger shirt and tighty-whities, before smelting a wicked multi-bladed axe in the forge he apparently had built just in case of such a contingency (!) There's also a significant strain of black humor this time, one which was missing from the straight-faced *Black Rainbow*. Jeremiah asking, "Do you like The Carpenters?" to the woman he's just abducted and doped up with LSD is creepy/funny, but it's the Cheddar Goblin—a goofy *Gremlins*-like mac 'n cheese spokesman who vomits gooey pasta onto the heads of happy children—that puts the whole project over the top for me. In the end, *Mandy* is not much more than a true-love-triumphs-over-narcissism story, but Cosmatos' mastery of style transforms it into a universal epic for our junk-culture times.

Wednesday Night Lights: The Maker of *Mandy*

From my vantage point on the less-esteemed side of the velvet rope, I saw my quarry, Panos Cosmatos, posing for innumerable photographs with industry and festival bigwigs just before the Canadian premiere of his new movie, *Mandy*. I had been shuffled around no fewer than four times before being planted right underneath a bright spotlight a few feet from the director. Eventually, he came over—and I got my four minutes.

366: I'm with 366 Weird Movies, and we're a big fan of your previous movie, *Beyond the Black Rainbow*. It beat out 63 contenders in a readers' choice poll to be certified on our list–

PC: A list of "weird movies"? Nice.

366: Yup. We're looking for 366 of best weird movies we can find, one for each day of the year including leap years.

PC: Love it.

366: I have a few questions for you. In *Beyond the Black Rainbow*, we saw some Kubrick and Ken Russell influences; I was wondering if you might remark on some of the directorial influences specifically for *Mandy*.

PC: Honestly, for this film, I felt more that I was just tapping into myself, just following my instincts a little bit more and seeing where that took me.

366: In *Beyond the Black Rainbow*, there's a melancholic, sort of space-y feel. Obviously it's a very different tone from *Mandy*.

PC: Yeah, it's more "melancholic and barbaric".

366: Nicely put. Now, tapping into yourself, I know that your father was involved in any number of motion pictures. I was curious personally in regards to your mother, who was a sculptor. Did she influence you artistically in any way?

PC: Very much so, yes. She nurtured my creativity from the beginning and had an incredible way of looking at the world, and that's a big part of me.

366: Now your previous movie and this one, they both take place in 1983, and you've indicated in a number of interviews your reason for that.[1] Obviously it might be too early to ask about future projects, but do you think you'll be sticking with the year 1983 in the future, or do you think you might eventually go forward or backward?

PC: *laughs* I think the next film will probably go forward — but never the present. Never the present.

366: Your previous film was largely self-funded–

PC: Yup.

366: –This was a larger production. Were there any problems with "strings attached", or were you able to maneuver things?

PC: Amazingly, I was given basically complete freedom, that's why I got involved with SpectreVision, because they vowed to protect my vision and nurture it all the way through, and they lived up to that.

366: That's excellent. I'm from the United States, and I'm fearful I might not be able to catch this movie again; do you know anything about wider distribution?

PC: I think it's getting released on about 300 screens in the US on September 14th. Where in the US are you from?

366: Upstate New York.

PC: Cool! I always romanticize that area in my mind, having never been there. But I do have that romanticized version of Upstate New York in my mind.

366: Well, Upstate New York is very flattered.

PC: *laughs*

366: In regards to *Mandy* specifically, where in Heaven's name did that "folk song" come from?

PC: The lyrics were written by me and Dan Boeckner from the band "Operators". He wrote the verses, I wrote the chorus. And then Milky Burgess wrote the instrumentation and Randall Dunn produced it and we kind of just threw it together in the recording studio in a day or two.

366: It is, in its way, a very good song–

PC: *laughs*

366: –and it certainly conveys that fellow well. And one question I like to close all my interviews with, what's your home town and do you have a restaurant you can recommend?

PC: Where I live now? Vancouver, and I would recommend "Kingyo".

366: Thank you very much for your time. Fantastic movie, and I wish you the best of luck.

[1] 1983 was the first year that a young Cosmatos went to the store "Video Addict", during which time he would imagine the stories behind the box covers of horror films he was not allowed to rent.

...and with that, mere minutes before the film's start, he was summoned for further photographs.—Giles Edwards

Panos Cosmatos photo courtesy RJLE films

November (2017) ★★★1/2

"They're the sort of old legends that are made up just to find a simple reason for every complicated thing. No one wants to admit that they're foolish. The Frog of the North appeared in the sky from who knows where, and he disappeared again who knows where. But people couldn't be content with that! Humans can't stand things that are outside their reach."– Andrus Kiviräh, "The Man Who Spoke Snakish"

DIRECTED BY: Rainer Sarnet

FEATURING: Rea Lest, Jörgen Liik

PLOT: Estonian peasant Liina, who may be able to transform into a wolf, is in love with fellow villager Hans, who returns her affection until he catches a glimpse of the daughter of the German baron who now rules their territory and is immediately smitten. Liina appeals to a witch to cast a spell to turn Hans' heart to her. Hans, in turn, makes a deal with the Devil to build a kratt he believes will help him reach his beloved.

BACKGROUND:

- *November* is based on the Estonian novel "Rehepapp: ehk November" by Andrus Kiviräh, which was a massive success in its homeland. "Rehepapp" has not been translated into English, although Kiviräh's second novel, "The Man Who Spoke Snakish," which treats fading pagan beliefs in a similar fashion, has been.

- The producers raised money through crowdfunding to produce a model of a kratt, then used the test footage to secure money for the film from Polish and Dutch sources.

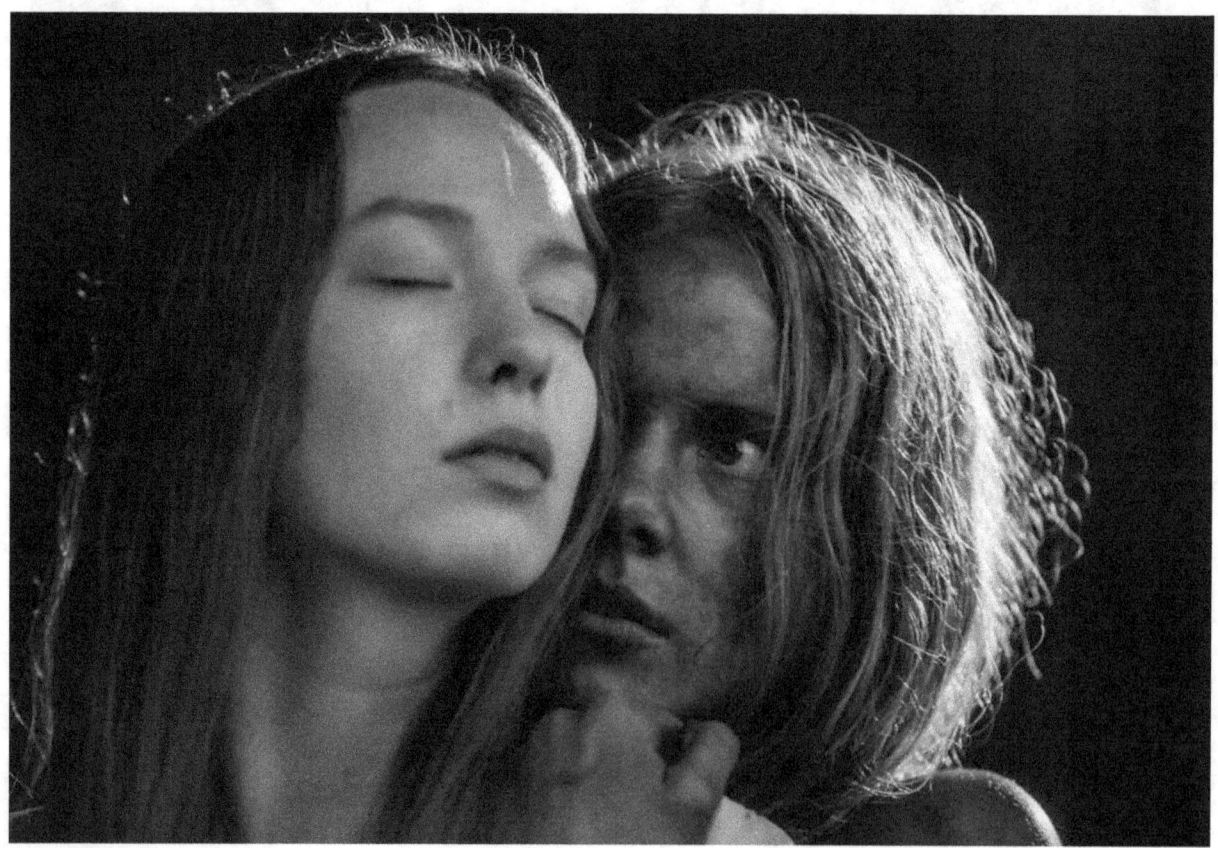

- Most of the minor villager roles are played by nonprofessional actors.

INDELIBLE IMAGE: Our first look at a kratt: it's a cow skull tied to three sticks, with sharp farm implements tied to them, which cartwheels across the lawn of an 19th century villa on its way to break down a stable door.

THREE WEIRD THINGS: Kratt airlifting cow; the chicken dead; two-ass plague gambit

WHAT MAKES IT WEIRD: Set in a world where our forefathers' craziest superstitions are literally true, *November* weaves a Gothic tapestry of sleepwalking noblewomen, hags, bewitched friars, and dead ancestors who sometimes manifest as chickens. And, of course, kratts that turn into primitive helicopters. You could not have seen that one coming.

COMMENTS: *November* is, at least superficially, like the Estonian movie Sergei Parajanov never made[2]. Written during a period of shaky independence rather than imperial domination, however, the tone of *November* is far different than Parajanov's nationalist fantasies—it's cynical rather than nostalgic, shot in a shadowy black and white rather than Parajanov's eye-popping psychedelic color schemes, emphasizes the peasants' shabbiness and superstition rather than their elegance and nobility. Although the story treats Estonian folk beliefs as if they were true—the Devil really does meet supplicants at the crossroads, and the robotic kratts are real things that argue with their masters—the Estonians are far from the heroes of the tale. While we might expect the German overlords to come off badly, they are mostly just shown as effete and ineffectual. The Estonians, meanwhile, whether because of their crushing poverty or their natural temperament, are greedy and banal, as eager to steal their own neighbor's cow as they are the Baron's underwear. *November* subverts our expectations of nationalist cinema, showing the conquered to be as venal, if not more so, as their conquerors.

Set in a 19th century that feels like the depths of the Dark Ages (aside from a few anachronisms like muskets and tobacco), *November* unspools like a compendium of folk legends. Beginning on November 1, All Souls Day, when the dead join their descendants for a light meal, the story takes us on a tour of peasant beliefs and traditions, with a few mini-tales recounted inside of the main plot: stories of mysterious women seeking passage across the river, of lovers mooning in a gondola. The most exotic feature of this magical realist landscape are the kratts, automatons made from whatever farm implements (or other materials) the peasants have lying around, powered by literal deals with the Devil. Before the opening credits we meet a three-legged monster cobbled together out of broomsticks, metal rods, an axe, a sickle, and a skull; it's capable of airlifting a cow, and develops a nasty temper when it's not assigned enough work. The kratts may be the most uniquely Estonian element here, but folkloric magic is an everyday part of these character's lives: diabolic meetings at midnight crossroads, lupine transformations on the full moon, disgustingly compiled love potions, and a bizarre scheme to trick the plague into skipping over the village all play parts in the story. Persistent pagan beliefs dominate Christian ones, leading to absurdly humorous situations. The villagers see Jesus as a powerful deity who, like the Devil, they can game for personal gain, and find non-Church sanctioned uses for consecrated hosts.

[2] A quick refresher for those who haven't been following along at home: starting in the 1960s, Soviet filmmaker Parajanov became famous for a series of experimental, nationalistic movies exploring the individual history and folklore of the various Soviet satellite republics, specifically Ukraine, Armenia, Georgia, and Azerbaijan.

The dreamlike monochrome camera and a doom-laden musical score nurture the magical atmosphere, while the griminess of the characters' hygiene and the baseness of their morals adds a contrasting level of realism that makes this alternate Estonia strangely believable. *November* rightfully won multiple awards for its cinematography. Passages of ineffable beauty arise like wispy winter blossoms growing out of the dung of the farm village. A parade of dead souls glows in formal white robes as the walk out of the black forest. The Baron's daughter sleepwalks on the roof, her diaphanous nightgown lit by the full moon. Pasty Venetian lovers with jewels embedded in their eyebrows kiss on an overexposed boat ride. And of course, there's the magical fascination of the lurking kratts, monstrosities cobbled together from coils, blades, leather, and bones, always clanking and creaking (are the peasants too cheap to oil their mechanical slaves?) The peasant's lives are hard and brutish, and their society is a confederation of traitors and thieves, but there is beauty to be found by those who can appreciate it.

While the Estonian villagers have adapted the magical elements of Christianity to their own purposes, they haven't internalized its ethics: they are a barbaric, mean, and backstabbing lot of louts, continually scheming and stealing from both their doting German overlords and from each other. This depraved condition may be imposed on them by the necessity of their hardscrabble existence and servitude. Young love, however, remains a beacon of pure idealism, even in this bleak world; proving, perhaps, that some ancient superstitions remain with us even today. Set in a world at a crossroads, where the Old Ways were still hanging on by a thread against encroaching Christianity and European cultural assimilation, *November* dawns in a world of interstitial cultural relativism. Folk beliefs are depicted as real, but only to show how absurd, grotesque, and self-serving human mythology can become. It's especially humorous to see how the people unthinkingly accept Christian beliefs as valid, but twist them so that they are consistent with their pre-existing mythologies and prejudices; for example, assuming that, if they scrape the gold off of a religious icon, Jesus' "sacred gold" will return to their pockets when they spend it.

Liina and Hans' tragically separate loves, on the other hand, transcend and cross cultural boundaries; their romantic yearnings are universal, neither Estonian nor German, pagan nor Christian, but pieces of the human soul. Their loves both begin selfishly, as befits their humble origins. Liina steals family heirlooms, which she trades for rich clothing; Hans, succumbing to the lure of the foreign, is willing to become an overseer and oppress his own people just to try to curry favor with the Baron. But through the course of the story they both move away from their individual desires to find a selfless, universal love. Liina repents of her plan to kill Hans' beloved. As for Hans, his encounter with his own spirit kratt introduces him to a concept of love beyond mere possession. A fellow villager can't understand why the lover in the snowman's tale would volunteer a valuable ring to his beloved, and even foolishly digs through the snow looking for the symbol of ardor which he believes the kratt must have left nearby. The villagers are cunning, able to cheat the Devil out of their souls by substituting currant juice for blood, but poor guileless Hans has less luck— because he is no longer one of them. Nor is the kratt he builds typical of its species; he crafts a poet instead of a laborer. Set apart from the peasants, he has lost their hardness and is vulnerable to tragedy. But it is only through learning the value of sacrifice that Hans and Liina's lives can have any meaning; there is no hope in the selfishness of the village. Caught in a cycle of survivalist materialism, the peasants can't even imagine a better life, much less an eternal one. But by absorbing the wisdom of a

snowman, Hans learns of a current of humanity that flows far beyond Estonia's borders, of other people who have thought noble thoughts unimaginable to his countrymen. Despite the loving recreation of very specific local folk legends, *November* is not a celebration of authentic Estonian identity; instead, it's a celebration of learning to transcend one's roots and find the universal truths hidden within the traditions.

HOME VIDEO INFO: Oscilloscope snapped up the rights to *November* and issued a DVD and Blu-ray in 2018. Supplements on video include the trailer; an 11-minute video essay by John DeFort examining the film's folklore in some detail; and the three minutes of test footage of the kratt (it turns out to be an alternate version of a scene that made it into the movie). There is also "Rekt läbi Setumaa," a seven-minute short documenting the lives of Estonian farmers in 1913, an extra most people won't care about much, but one that is of historical significance. There are also a pair of trailers for other Oscilloscope features, including fellow Certified Weird title *The Love Witch* (2016).

At the time of this writing *November* is currently streaming on Amazon Prime for free, or available for purchase or rental separately for non-subscribers.—Gregory J. Smalley

Sorry to Bother You (2018) ★★★★1/2

"When I'm making my art, it really doesn't help me to think about the definitions of what I'm doing. So what I do comes out ridiculous, or funny, or weird. That's because the world is ridiculous, funny, and weird."–Boots Riley

DIRECTED BY: Boots Riley

FEATURING: Lakeith Stanfield, Tessa Thompson, Steven Yeun, Armie Hammer, Omari Hardwick, Jermaine Fowler, David Cross (voice), Patton Oswalt (voice), Danny Glover

PLOT: Cassius Green can't find a job and needs to pay bills, so he hires on at a telemarketing firm. Once he learns to use his "white voice," he discovers he has a preternatural gift for selling, and while his co-workers stage a strike, he is promoted to a "Power Caller" selling questionable services to obscenely wealthy clients. When he reaches the top rung of the corporate ladder, the CEO of the company offers him a morally repugnant deal.

BACKGROUND:
- Director Boots Riley was a rap musician, music producer, political activist, and former telemarketer for more than twenty-five years before writing and directing this, his first feature film. It was workshopped at the Sundance writing lab.
- The idea for *Sorry to Bother You* originated from an unused song concept where Riley would rap as a telemarketer selling slave labor. In 2012 his hip-hop band The Coup produced an album of the same name inspired by the then-unfinished screenplay.
- An early version of the screenplay was published in McSweeney's magazine in 2014.

INDELIBLE IMAGE: We don't want to describe it, because it's a spoiler. Just prepare for a shock after Cassius snorts a huge line of—cocaine?—off a plate decorated with a horse. Besides that, the iconic image for marketing purposes is Cassius in a business suit with his head bandaged and a circle of red soaking through, iconography suggesting a blend of the corporate and the revolutionary.

THREE WEIRD THINGS: Commentary by earring; Mr. ____; equisapien MLK

WHAT MAKES IT WEIRD: Boots Riley's out-of-nowhere satire plays like something *Putney Swope*'s long-lost grandson might have dreamed up after an all-night pot-smoking session. I'm not going to get swept up by the mainstream hyperbole and tell you that it dials the absurdity up to "11"—but it pushes a solid 9.

COMMENTS: *Sorry to Bother You* is sneaky weird; it strangens slowly but persistently, until a third act turn towards sci-fi and light surrealism that loses the mainstream audience (sample customer review: "The trailer showed a comedy, this was just a bizarre twisted story and waste of the short time I have with my husband and on planet earth!") It begins conventionally, with Cassius Green interviewing for a telemarketing job for which he appears to be slightly overqualified. The interviewer quickly sniffs out that Cassius has faked his résumé, but doesn't care; he'll hire "damn near anyone," as long as they can read (so that they can obey the telemarketer's primary rule: "stick to the script.") This opening is funny, and more importantly it gives us the perfect introduction to our protagonist: he seems basically decent, but driven to desperate measures to earn a living. He's also a bit out of his league, even

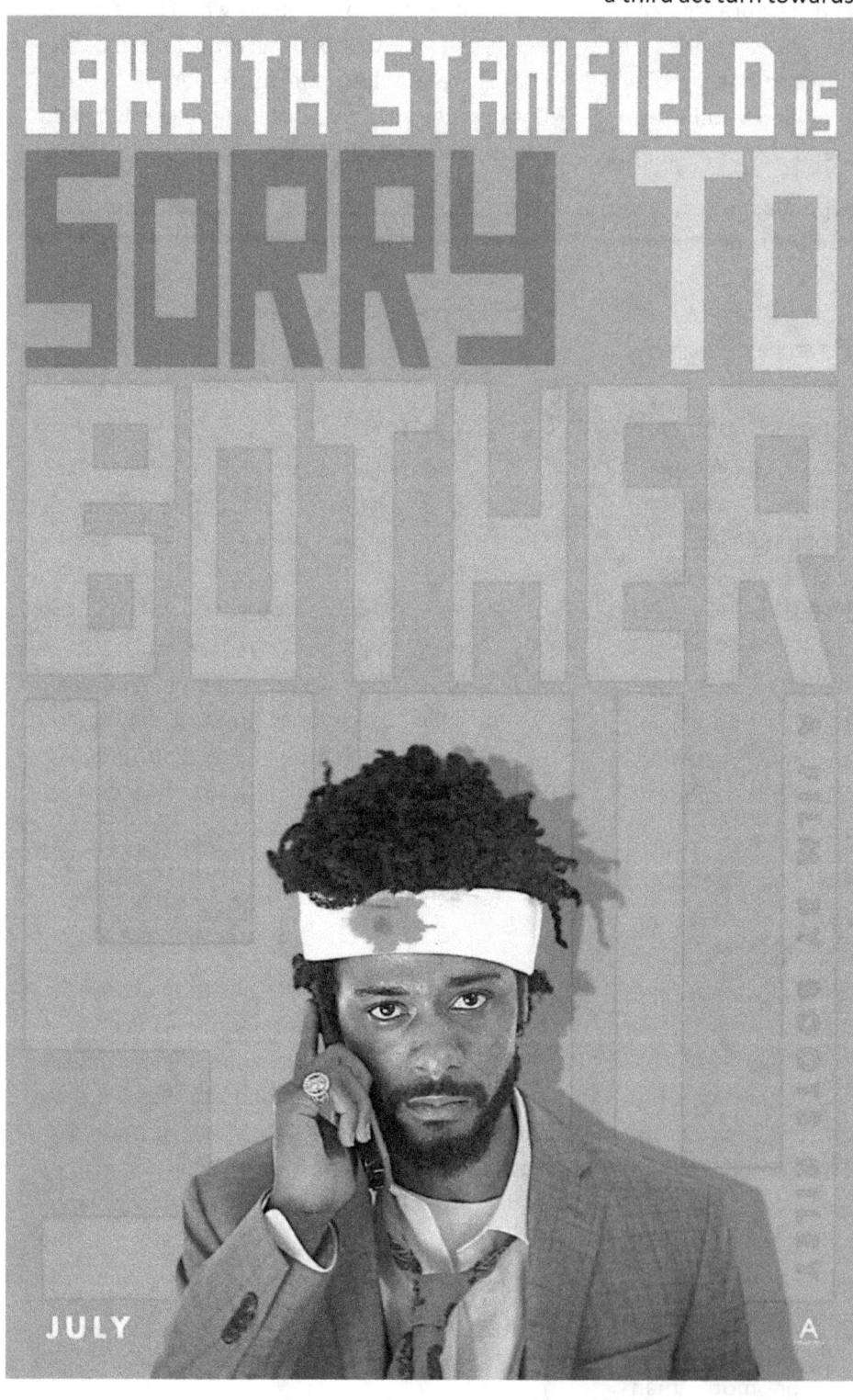

in the entry-level league. He's the kind of guy who tells the gas station attendant "forty on two" and means forty cents. So when "Cash" gets a little taste of success and some green in his pocket, you completely understand why he is willing to make a moral compromise or two, and even halfway root for him to get top dollar for that soul he's selling. Of course, those moral compromises will quickly snowball into a moral avalanche, but there wouldn't be a movie otherwise, would there?

The first real hint that something is off in this world and that we're not living in your everyday comedy, or even in the real world, comes in the form of an advertisement for "Worry Free Living": a company offering a lifetime employment contract in exchange for food and dormitory-style shelter, an arrangement that looks suspiciously like consensual slavery. *Sorry to Bother You* orients its audience in a familiar Hollywoodesque comedy genre before springing surprise after surprise as the plot gets deeper and weirder. We're eased into the strangeness with magical realist comedy sketches: still wearing his headset, Cash appears in the flesh at his cold calls' dinner tables, among more intimate settings. Then there's the uncanny "white voice" (explained in a monologue by veteran Danny Glover, who pops in mainly just to do this scene). By the time Cash is high on cocaine watching a stop-motion corporate propaganda film[3] hosted by a topless ape woman, you're totally immersed and invested in an anything-can-happen world very different from where we started. Detroit's confrontational earrings, a character whose name has been redacted, a blood-soaked performance art monologue from *The Last Dragon*, and a badly improvised, humiliating rap are just a few of the cleverly absurd gags that help distract us the nightmare scenario at the center of the film. It works on two levels:

genuinely funny, at times even hilarious, the laughs keep the audience hypnotized in their seats while the message seeps into the brains. Just like any good ad campaign.

As true narrative film, *Sorry to Bother You* follows a standard arc: humble hero accepts Faustian bargain, gains the world but loses his soul/true love, repents. But that familiarity is well-disguised by a barrage of techniques—absurdist comedy, magical realist sequences, fresh perspectives, and outrageous satirical conceits—to the point where the movie feels like something totally new. Its clichés are buried under what Riley calls "beautiful clutter." As an accomplished creator, but an outsider to the world of film, it's not so much that Riley is breaking cinema's rules as it is that he never learned them. Coming from the world of rap music, he appropriates film styles like they were song samples: a little Robert Downey Sr. here, a little Michel Gondry there, stealing only from the best. As a musical producer, he understands how to assemble a team of professionals to do their technical jobs to fulfill his vision. It might be delightfully ragged in temperament, but *Sorry to Bother You* is crisply produced and has a look that belies its relatively modest budget and rushed production schedule.

The casting is impeccable, with each character being likable or despicable as required. Lakeith Stanfield's Cassius is awkward and existentially confused. When he accepts deals requiring increasing levels of compromise, it's not just because he's greedy. It's not that he wants to selfishly upgrade his car and his apartment—he gives a lot of his salary away—so much as that he's desperate for the meaning and worth he assumes attaches to money. That's why we sympathize with his every move; he feels that he is finally being recognized and earning respect for being good at something, a goal we can

[3] Credited to one "Michel Dongry."

appreciate. He's such a nice guy that we don't feel bad admitting that we'd be tempted by the deals he accepts. Cash is easier to identify with than his idealistic friends, who are, well, ideals. They aren't fully fleshed out characters like Cassius, but this isn't a realistic drama; their purpose is to illuminate the hero's dilemma. Detroit (Tessa Thompson) is the girlfriend who validates Cash's true worth: smart, artistic, independent, she values him despite his lack of prospects. Steven Yeun's Squeeze, the union organizer, represents political commitment; he's logically a better match for Detroit, and therefore a real threat to Cash's security. But he's so decent that he won't steal the girl away—unless Cash slips up royally. Jermaine Fowler is the high-pitched comedy relief and the unassuming friend who demands loyalty. This trio represents everything Cash turns his back on for corporate advancement: friendship, integrity, and real connection. On the other side are an increasingly unscrupulous series of rungs on the ladder of success: the scabby call center managers who tempt Cash with the promise of becoming a "Power Caller"; a flirtatious middle-management liaison (comic Kate Berlant) who knows the code to the Golden Elevator; the sycophantic elevator voice (supplied by Rosario Dawson) who assures salesmen that they are "the top of the reproductive pile"; Cash's immediate supervisor, played by Omari Hardwick in bizarre facial hair and a bowler hat; and finally, at the very top, Steve Lift (Hammer), the debaucherous bro in sandals who throws the best parties with the best coke, and who's willing to sell anything that will keep him on top. Yes, they're all one-dimensional, but again, this is a *comedy*… and they're funny.

And funny, of course, is the crucial strategy. Riley understands that a joke is more effective than a sermon. *Sorry to Bother You*'s world is similar enough to our own to be recognizable, but askew enough off that the satire never seems like a paint-by-numbers allegory. There are no obvious characters from the current administration[4], but there is a reality TV show called "I Got the S#*@ Kicked Out of Me!", and it's possible to become a 15-minute celebrity by having a video of you being brained with a coke can make the rounds on YouTube. The movie addresses issues of racial identity, carnivalesque cultural depravity, and the working class' financial treadmill with a touch that's light but firm. Corporations are the bad guys and union organizers are the good guys, true, but *Sorry* wears its leftist themes surprisingly lightly. By putting you in Cash's shoes, it makes its case through empathy instead of lectures. It's a sneaky sucker punch square in the zeitgeist's gut. *Sorry to Bother You* has no reason to apologize.

HOME VIDEO INFO: A DVD and Blu-ray arrived via 20th Century Fox in a timely fashion. A Boots Riley commentary is the main attraction in either format. There's also "Beautiful Clutter," an 11-minute discussion with Riley; a stills gallery; and two promotional trailers along with the official trailer (and trailers for other current Fox Searchlight properties).

The movie is also available for digital purchase or rental on-demand from all the usual suspects.—Gregory J. Smalley

[4] The script was written during the Obama administration, and Riley changed a coincidental quote about "making America great again" so that people would not mistakenly assume this was a Trump diatribe.

2018 THEATRICAL, STREAMING OR VIDEO-ON-DEMAND 2018 RELEASES

All You Can Eat Buddha (2017) ★★

DIRECTED BY: Ian Lagarde

FEATURING: Ludovic Berthillot, Sylvio Arriola, Yaité Ruiz

PLOT: A vacationing gourmand stays on indefinitely at an all-inclusive resort, performs ambiguous miracles, and is treated as a messiah.

WHY IT WON'T MAKE THE LIST: It's one of those indie experiments that's content to hang out in its own strange little surreal corner of the film world, lacking the sense of purpose or urgency necessary to break into the big time weird.

COMMENTS: Director Ian Lagarde is better known as a cinematographer (*Vic + Flo Saw a Bear*). That background shows in his eye for composition in his debut feature, which contrasts bright tropical travelogue footage of a Cuban resort with moody images from the surrounding ocean, with the film's color palette growing increasingly shadowy as it progresses. He also finds a surprisingly charismatic lead in chubby Ludovic Berthillot, who, as Mike, looks like a melancholic Quebecois Curly Howard, yet somehow becomes believable as a mystical guru and sex god.

Unfortunately, that's about all that can be said on a positive note for *All You Can Eat Buddha*, a surreal slog that's ultimately less eventful than a day spent dozing and sunbathing at the beach. The credits play over a mini-symphony of crashing waves, whale calls, and discordant strings while a dark sea undulates with a ghostly negative image of Mike's buddhistically serene visage superimposed over it. This prologue promises a deep, somber, hypnotic energy, but the subsequent film is more somnolent than dreamy. The frumpy, solitary, and mysterious Mike arrives at the El Palacio, wanders around the beach speaking to no one, dines at the all-you-can-eat buffet, and decides to stay on. The film takes nearly twenty minutes to hit its first real plot point, although it's a good 'un: Mike rescues a grateful octopus caught in a net and the eight-legged sea beast grants him enlightenment. He then performs an ambiguous miracle or two, sleeps with a couple of lonely middle-aged women, and grows a small group of followers as he becomes a sort of anti-Buddha, renewing earthly desires rather than renouncing them. But then, like the viewer, the script loses interest in this plot line, and instead focuses on a "change of administration" in the hotel management (a political allegory?) that leads to the place deteriorating, as Mike's body simultaneously falls apart. A sort-of subplot about a hotel maid and her son has no real resolution, and the movie limps to an ambiguous non-ending that's neither a satisfactory convergence of themes nor a mystery that lingers; the film simply messes around for a while, then ends. A hard-eating hero, a telepathic octopus, beaches, a reference to Buddhism, adulation, and maybe some politics: it's a puzzle movie, but one where the pieces all seem to come from different boxes.

All You Can Eat Buddha debuted at the Toronto International Film Festival in late 2017, then shuffled off to video-on-demand and a freebie stint on Amazon Prime without ever stopping on physical media—an unfortunate trend that will prevent smaller films from having any sort of extended shelf life.—Gregory J. Smalley

Annihilation (2018) ★★★★1/2

DIRECTED BY: Alex Garland

FEATURING: Natalie Portman, Oscar Isaac, Jennifer Jason Leigh

PLOT: As her husband, the only survivor of an expedition into a bizarre phenomenon referred to as the Shimmer, recuperates, a biologist enters the region in search of answers.

WHY IT WON'T MAKE THE LIST: Novelist-turned filmmaker Alex Garland, who wrote the screenplay for *Never Let Me Go* before making his directing debut with the excellent artificial intelligence feature *Ex Machina*, probably has a really weird movie in him somewhere. This one isn't quite it—its ambiguities are just a bit too unambiguous—although it's definitely an off-cadence step in the right direction.

COMMENTS: Without giving away much more of *Annihilation* than you will find in the trailer, the story involves a trip into a rapidly expanding zone (existing behind a border which looks like a soap bubble) in which Earth's scientific laws—especially the laws of biology—have gone wacko. Inside the Shimmer, the exploratory team finds deer growing flowers from their antlers, crystalline trees sprouting on the beach, killer animals with unusual mutations, and gruesome videos detailing the misadventures of the previous expedition. (One of these provides the film's most squirmworthy scene, a true test of the viewer's intestinal fortitude.) The Shimmer is an extremely colorful world with rainbow colors and (feminine?) floral motifs. That said, I wasn't always a fan of the film's visuals, which seemed *too* unnatural, at the same time too clean and too soft, and sometimes needlessly intrusive (little prismatic sunlight beams distractingly filtering through the forest). Still, the look arguably gives the film a necessarily artificial sheen, and the flowing, fractal climax is well worth the wait for connoisseurs of acid trip visuals.

Annihilation glances at a couple of Tarkovskian science fiction themes: the enclosed "Shimmer" unavoidably recalls *Stalker*'s mystical "Zone," while the ambiguity of the ending is reminiscent of *Solaris*. It naturally nods at *2001: A Space Odyssey*, the granddaddy of "psychedelic" sci-fi films, too. These are only touchstones, of course: contra Tarkovsky and Kubrick, the movie is modern Hollywood in its overall approach, maximalist in its flowery CGI, and it even includes action sequences and jump scares (and bankable stars like Portman and Isaac) as accommodations to commercial realities. Whereas *2001* was a meditation on evolution on a macro (even a cosmic) scale, *Annihilation* draws its scientific impetus from inside, from cellular biology and the fundamentally unfair tricks it plays on us poor humans. Instead of *2001*'s telescope, *Annihilation* explores the cosmos through a microscope. The title refers, among other things, to the concept of programmed cell death, the idea that our DNA is coded to self-destruct—a theme mirrored by the film's psychological exploration of self-destructive personalities. The mutations found within the Shimmer are a sort of alt-science, alien alternative to our biological status quo. Scientifically speaking, they might as well be magic: no firm explanation is ever provided for either the source or motive of the mutations. It leaves you free to ponder questions like whether aliens were behind the phenomenon, why humans are programmed to die, and, curiously, why the last group of volunteers sent into the Shimmer are 100% female.

Annihilation is based on a series of novels by Jeff VanderMeer, but reportedly departs significantly from them (even courting a whitewashing controversy by changing the protagonist's race). Theatrical appearances were followed by a short exclusive run on Netflix before the Blu-ray dropped in early 2018.—Gregory J. Smalley

Apocalypsis (2018) ★★

DIRECTED BY: Eric Leiser

FEATURING: Maria Bruun, Chris O'Leary

PLOT: In a dystopian future/present/alternate history, a saintly albino woman has visions while reading the book of Revelation, and tries to convert an atheistic conspiracy theorist/hacktivist who's being hunted by agents of the New World Order.

WHY IT WON'T MAKE THE LIST: This straight-faced CGI-Revelation *cum* New World Order paranoia piece, steeped in psychedelic visuals, is a curiosity piece; a worthwhile trip if you want to follow the author's off-center obsessions for 90 minutes, but it's not essential weirdness.

COMMENTS: Taken at face value, *Apocalypsis* is an ecumenical outreach from the end times crowd to the chemtrails crowd. I think that writer/director Eric Leiser is correct in assuming that people who will swallow a character trying to use organite to shut down "the Grid" are also likely to find the Book of Revelation as credible a source of solid factual information as Infowars.

Apocalypsis avoids the pitfalls of boring, preachy "faith-based" films in favor of something more challenging. It replaces those pitfalls with conspiracy theory rabbit holes, but I'd much rather fall into those. Your spinster great aunt who goes to Bible study five nights a week is not going to dig *Apocalypsis*. It's informed by experimental movie aesthetics, with about twice as many trippy montages as plot points. (Maybe Leiser's recruiting the acidhead crowd, too?) The movie starts off by peering into some sort of cosmic whirlpool and never looks back, giving us

double images, time lapse photography, fisheye lenses, negative images, and so on throughout the film to give it an on-the-cheap "mystical" aura. Most notable are the heroine's Revelation visions, where you will see, among the CGI fractals, crudely animated scenes of dolls playing out Bible verses involving prophets, skeletal angels, seven-eyed lambs, and other briefly seen figures. It's unexpectedly effective; going for too much realism would have been a huge mistake. It somehow seems right that the Archangel Michael and a seven-headed dragon are sculpted out of plasticine, and their choppy stop-motion battle is *almost* as uncannily memorable as one of Ken Russell's green screen compositions from *Altered States*.

The main character is impossibly good, impossibly white, and persecuted by agents of the NWO for feeding the homeless. Mostly, she spends her time trying to convert her atheist friend Michael, who does an underground radio show where he warns listeners about the NSA trying to wipe out dissidents by using nanobots, or something. Michael has the squeakiest voice of any leading man in a 2018 feature, which is probably why his ratings are so low. After Evelyn takes him to Church, he squeals, "That was so awesome!," but he still professes "self-divinity." Black helicopters shadow them both, and there are also guardian angels wandering around in the script. According to the director-supplied IMDB synopsis, the whole film takes place in "a parallel universe entering a black hole," although the screenplay doesn't reference anything of the sort. It is, at bottom, a weird movie, for reasons both intended and unintended.

Apocalypsis is actually the third part of a trilogy, although neither of the leads appeared in previous installments. Maybe the other two films explain more about that black hole, though. If anything, *Apocalypsis* feels like the *opening* movie in a trilogy; instead of resolving anything, it leaves us with a lot of unanswered questions. Like, what just happened? Did we just get raptured through a black hole or something?

Apocalypsis is available solely on VOD at the present time.—Gregory J. Smalley

Batman Ninja (2018) ★★

DIRECTED BY: Junpei Mizusaki

FEATURING: Kôichi Yamadera, Wataru Takagi, Ai Kakuma

PLOT: Batman and Catwoman are having a bit of a tiff with Gorilla Grodd, who has a time-teleporting thingamajig; lo and behold; Batman is now in feudal Japan, dueling with Joker.

WHY IT WON'T MAKE THE LIST: *Batman Ninja* is an utterly bizarre hoot; the most refreshing take on the Batman character since Lego Batman. It is absolutely weird in the context of the Batman canon, pop mythology, etc. However, unlike *Batman Returns*, *Batman Ninja* is not standalone weird enough for this list.

COMMENTS: It's about time that the Dark Knight got a face lift. In addition to its nothing-is-sacred approach, *Batman Ninja* is also one of the most visually dazzling animation efforts I've seen (famed anime designer Takashi Okazaki practically has a kaleidoscopic, calligraphic watercolor orgasm onscreen, and it's gorgeous).

The film is hyper-kinetically paced. Within seconds after arriving in Japan, Batman is dueling with a small gang of Joker-faced samurai, which of course leads him to Lord Joker himself, as well as Harley Quinn. Catwoman arrives, too. She is a geisha with a kitty puppet, and she makes Dolly Parton look like an A cup. Oh, and she bought Alfred, too, *and* the Batmobile.

Grodd, the Penguin, Poison Ivy, Two-Face, Deathstroke, and sumo wrestler Bane (!) all exist in feudal Japan; each has his or her own territory, and they are fighting for control---a bit like the mafia in *Godfather*. That means Batman needs all the help he can get, so several Robins come to save the day, including a red Robin, and one with a green mohawk who has a chimpanzee for a sidekick!

The battles come fast and furious, including one in Joker's castle, one at sea with a Joker clipper ship, metallic simians, magic bats, and Bane mantling George "Watch Out for That Tree" of the Jungle.

In addition to the anime style (which suits Batman well), *Batman Ninja* has its tongue firmly in cheek with purple dialogue: "I am no longer the Batman. I will be what the Bat clan calls me. I will be their prophecy. I will be Sengoku Batman." Batman as a samurai isn't even half of it. He disguises himself as a monk and gets a tonsure hairdo---in the shape of the bat signal.

This is the opposite of all the Freudian Batmans we've been inundated with since Frank Miller. Thankfully, unnecessary character development and formulaic writing go the way of the dinosaur, and with all that out of the way, *Batman Ninja* is a creative and surreal romp. After seeing a 70-year-old plus character go from camp to dystopian, then to just plain godawful, Mizusaki actually does something new with him. Sure, Hamburger Helper-variety batfans will probably keel over from seeing their pedestaled funny paper deity put through the wringer and their formula diet challenged, but the rest of us can invite our weirdest friends over for one helluva extra anchovy pizza party and *Batman Ninja*.

P.S. Stay put for the credits.—Alfred Eaker

The Book of Birdie (2017) ★★1/2

DIRECTED BY: Elizabeth E. Schuch

FEATURING: Ilirida Memedovski, Kitty Fenn, Suzan Crowley, Kathryn Browning

PLOT: A young woman is brought to a convent to protect her from an unspecified danger. There, she explores both her emerging spirituality and womanhood.

WHY IT WON'T MAKE THE LIST: Schuch's movie relies heavily on a theological flavor of "magic realism". While it explores various fringe topics—(clerical) sisterhood, puberty, paganism, and suicide—using a variety of stylish techniques, it doesn't push boundaries as far as it should, and ultimately doesn't adequately explore the various narrative avenues it goes down.

COMMENTS: Director Elizabeth Shuch cannot be accused of lacking in ideas:

- The intersection between Femininity and Christianity.
- The intersection between Christianity and Paganism.
- The intersection between Paganism and Femininity.
- Coming of age, first love, and suicide.

Throughout *The Book of Birdie*, Shuch addresses all these topics while maintaining a precarious narrative thread.

Our story begins in a dying convent consisting of a dozen or so nuns. Young Birdie (Ilirida Memedovski) has been brought there for the protection and (ostensible) comfort that a life of

wholesome religiosity may bring. Birdie integrates with her new wards slowly, but surely, while also making acquaintance (then friendship, then love) with Julia, the groundkeeper's daughter. Birdie learns prayers, attends services, and sees the ghosts of two dead nuns haunting the convent. After staining her bedding with a heavy menstrual flow, things become slightly more unreal.

Arthouse film techniques abound. There are extended shots of Birdie's entrancingly dark eyes. Ephemeral lighting abounds inside the compound while a bleak sun saturates the outdoors. Animations of symbolic imagery are seamlessly integrated. While the camerawork and editing veer close to heavy-handedness, they never fall into parody. The nuns—both alive and dead—help to keep the film grounded in the reality of this hollowed-out haven. One enthusiastic Sister in particular stands out. She confides her aspirations to Birdie: "I knew Jesus was the only man for me when I had my First Communion. I felt the wafer sizzle in my mouth and I felt him calling to me. Everything I've done since then has been to prepare me for a spiritual life. I want to be the best." Unfortunately, it is Birdie who experiences the transcendence for which this nun strives. The cause (effect?) of this brings me to a needful observation.

This film has a lot of blood in it: a lot of menstrual blood. It shows up in specks around the chapel, it shows up in trails, and it shows up in the small vials that Birdie fills and, on occasion, drinks from. She also crafts what I can only describe as a "fetus fetish" from porridge and stores it in vinegar. This entity comes to life on occasion, as does a statue of Christ—as do her reproductive organs, which we see escaping her body and flying off, like an angel. There is a mountain of symbolism of which, with my limited catechism, I can only understand fleeting hints.

The important question, though, is whether this works as a movie. To that I say, "Yes… mostly." The performances are all tip-top and the limited scenery provides a real sense of a derelict haven. And the narrative moves from one point to the next, with a beginning, middle, and end. However, I can't help but feel that this movie is like an empty Chinese puzzle box: fascinating to watch unfold, but ultimately yielding nothing. An ambiguously tragic life is explored with ambiguously theological symbols bringing us to an ambiguous, tragic ending. All spirit and no flesh, perhaps?—Giles Edwards

Caniba (2017) ★★1/2

DIRECTED BY: Lucien Castaing-Taylor, Verena Paravel

FEATURING: Issei Sagawa, Jun Sagawa

PLOT: Confessed cannibal Issei Sagawa monologues to the camera, his face often out of focus, and talks to his caretaker brother, who is revealed to be almost as deranged.

WHY IT WON'T MAKE THE LIST: *Caniba* would make a list of the 366 most disturbing movies ever made—easily. Its subject is a weirdo *par excellence*—in fact, he may be the world's strangest living monster—and the film takes an experimental, offbeat approach to depicting him. Yet everything shown here is tragically real, and the effect goes beyond "weird" into "despairing."

COMMENTS: Issei Sagawa, an intelligent but shy Japanese man studying French in Paris, killed and ate a female classmate in 1981. He spent five years in a mental institution in France and then was deported to Japan where, due to quirks of the judicial system, he was freed. Since then he has lived a marginalized existence, making a meager living off his infamy. He is now weakened

by a stroke and holed up in a dingy apartment, cared for by his brother.

Lucien Castaing-Taylor and Verena Paravel, Harvard-based anthropologist filmmakers, chose to follow up their arthouse hit *Leviathan* (an uncontroversial documentary about commercial fishermen in the North Atlantic) with this perverted provocation about Sagawa. Most of the movie is out-of-focus shots of the ailing cannibal, close-ups of his twisted, trembling hands or his blank face as he delivers halting, unhinged monologues ("I know I'm crazy," he confesses). When he talks at all, he speaks as if he's in a trance, gathering the strength to push out each phrase, about five or six words per minute, with long pauses in between. We also meet his caretaker brother Jun, who eventually reveals some shocking fetishes of his own—leading one to wonder whether there is a genetic curse on the Sagawa clan, or whether Jun was driven mad by knowledge of his brother's crimes. Old black-and-white home movies of the two show what look like happy, normal children. Back in the present, we have a very odd pixilated porn sequence starring Sagawa, inserted without any context, followed by a tour through the manga he drew celebrating his crime. Jun is both fascinated and disturbed by the graphic drawings of the girl's corpse and his brother's erection when faced with it. "I can't stomach this anymore," he says, but continues turning the pages. Issei, distant as always, seems embarrassed, if anything, reluctant to answer the questions his brother poses. For the final scene, they bring in a prostitute (or groupie?) dressed as a sexy nurse to read the cannibal a bedtime story about zombies, then take the invalid demon out for a wheelchair stroll around the neighborhood. The end.

I am glad someone documented these two twisted specimens of humanity with minimal editorializing, but the result is no fun whatsoever, and offers no insight to their pathologies, making it a very difficult watch on multiple levels. It's of interest to sick thrill seekers and serious students of abnormal psychology. You should know this movie exists. God help you if you watch it. It played at a few film festivals, including Toronto, in 2018, but there is no guarantee it will get a commercial release. The film seems destined to remain forever underground, where it probably belongs.—Gregory J. Smalley

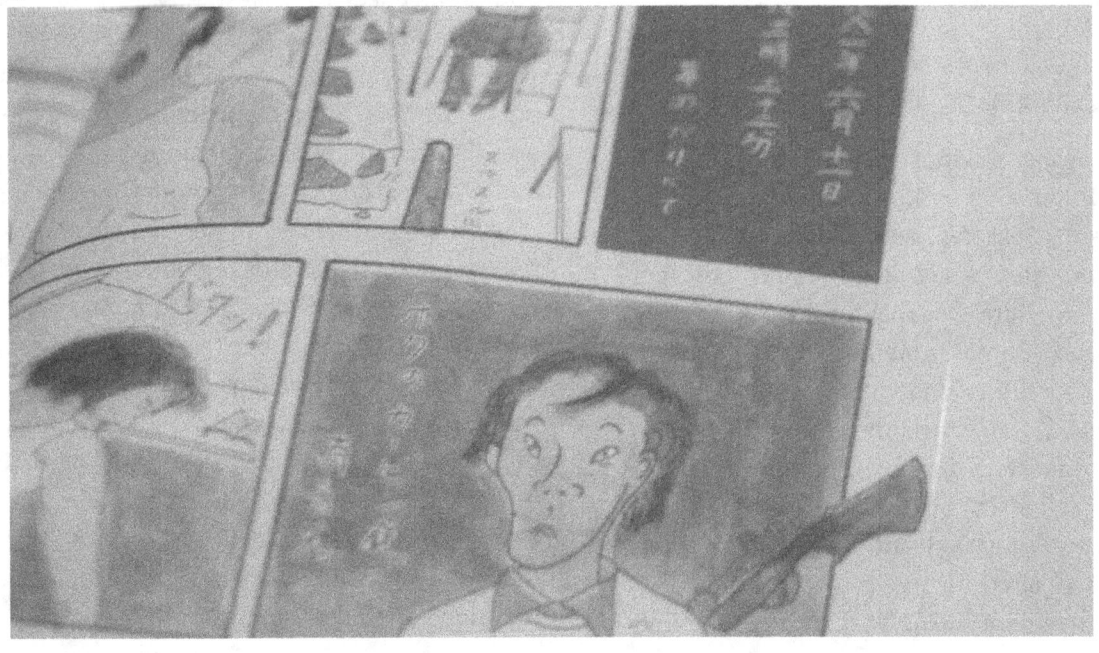

"Dirk Gently's Holistic Detective Agency, Season 2" ★★★★

DIRECTED BY: Douglas Mackinnon (episodes 1 & 2), Michael Patrick Jann (ep. 3 & 4), Richard Laxton (ep. 5 & 6), Wayne Yip (ep. 7 & 8), Alrick Riley (ep. 9 & 10)

FEATURING: Elijah Wood, Samuel Barnett, Jade Eshete, Amanda Walsh, Hannah Marks, Fiona Dourif, Mpho Koaho, Dustin Milligan, John Hannah, Alan Tudyk

PLOT: After the events of Season 1, Todd and Farrah are on the run and Dirk is a prisoner in a secret military facility; a new mystery begins when a visitor from the magical land of Wendimoor reveals that Dirk is prophesied to save their world from an evil Mage.

WHY IT WON'T MAKE THE LIST: TV series, not movie. But it's a series you may want to take note of: otherwise, we wouldn't be reporting on it, would we? "Dirk Gently"'s mix of absurd humor, bewildering but addictively complex plotting, and fanboy-friendly sci-fantasy tropes was just intriguing enough that that BBC America took a chance on it as potential cult item, but also so weird and difficult that it was cancelled after only two seasons.

COMMENTS: "Have you noticed an acceleration of strangeness in your life?"

The following synopsis may not make much sense to a lot of you. This includes veterans of "Dirk Gently Season 1" as well as newcomers to the series. The one advantage Season 1 viewers have over total neophytes is that they understand "Gently"'s method—throw about a dozen subplots and random events at the viewer in episode 1, then spend the rest of the season slowly connecting the dots, with every little detail merging in a "holistic" (and fantastic) fashion. So, I'll just lay it out: season 2 introduces a gay pink-haired hero with a scissor sword. A train in the sky. A fishing boat run aground in a field in Montana. A friendly, sort of slow sheriff and his hard-partying deputy. A beleaguered middle-aged woman with a limp, a crummy son, a crummy husband, and a crummy job at the quarry where her crummy boss is making shady deals. A dashing gangster in a snappy white suit with a black tattooed hand and a fabulous mustache. A magic wand. A car stuck in a tree. (The literal Purple People Eater won't show up until episode 4).

It does all connect, naturally. This high-fantasy based plot is perhaps not as satisfying as Season 1's time-travel yarn, but on the other hand the show devotes more time to building up its underlying infrastructure, dropping hints about Project Blackwing and introducing new "anomalous individuals" like Dirk and the Rowdy 3. (They're all sort of a team of metaphysical X-Men gone renegade.) Rather than dominating the plot with his clueless exuberance, Samuel Barnett's Gently is sidelined a bit this season, moping through most of the story in an existential crisis. He and Elijah Wood's Todd Brotzman invert their Season 1 dynamic, with Todd now eager to solve the case for his own reasons, dragging the reluctant detective along with him. Other characters pursue their own arcs. Farrah shows more vulnerability, and there are hints of burgeoning romance between her and Todd. Todd's sister Amanda develops magical powers, making her character more relevant--although this development feels a little forced. Ken is set up for a heel turn. And holistic assassin Bart (Fiona Dourif) remains the most fascinating entity. Her fans will be thrilled with her opportunities to prove she is the ultimate badass killing machine, and she gets by far the best lines: "I think that sometimes when you're killing people they don't like it, and it makes them unhappy, and scared, and also dead, which they don't like, I don't think..." If that monologue

doesn't intrigue you, then "Dirk Gently" isn't the show for you.

Unfortunately, the series has been canceled, and we'll never get to see where creator Max Landis was ultimately headed with all of this. The most bittersweet part of what turned out to be the series finale is that the last shot sets Bart up for a dramatically increased role in the unmade Season 3.—Gregory J. Smalley

Chained for Life (2018) ★★★★

DIRECTED BY: Aaron Schimberg

FEATURING: Jess Weixler, Adam Pearson, Stephen Plunkett, Charlie Korsmo

PLOT: While starring in a low budget period horror film, Mabel makes the acquaintance of some affable "freaks" brought on set for authenticity; while the main cast and crew's away, the freaks pass the time making their own movie vignettes.

WHY IT WON'T MAKE THE LIST: Made as a rejoinder to the infamous *Freaks* (1932), Aaron Schimberg's movie is non-exploitative, clever, funny, and professional. While the meta-narrative gets a little odd at one point, *Chained to Life* really boils down to being a feel-good comedy in the very best possible way.

COMMENTS: I found something very odd about my viewing experience of *Chained for Life*, and it wasn't the subject matter. After the brief introduction by the soft-spoken director, I was feeling nervous. Admittedly, I've had difficulty coping with the sight of deformity (in person and otherwise), but having thought about it—and having now seen the movie—it was the wider critical interpretation that I'd read beforehand that made me apprehensive, and afterwards made me confused. I'll talk about what other critics saw later; me, I saw a charming, character-driven comedy.

When a busload of disabled people show up at the shoot for a period horror film, there is a hiccup of apprehension on the part of the "normals" already present. The leading lady, Mabel (Jess Weixler), plays the movie-within-the-movie's leading lady, a blinded woman who is to be cured through radical surgery. However, *Chained for Life* focuses primarily on the actors and crew involved, in particular on the blossoming friendship between the physically self-conscious Mabel and the physically self-accepting Rosenthal (Adam Pearson). While primary filming progresses by day, the "freaks" lodge in the hospital by night, eventually deciding to play around with filmmaking themselves. One twist leads to a cute reveal after a ways, but the story is pretty simple.

That's not to say it isn't well done. By using the pretentious art-house nonsense being filmed by a hyper-Herzog stand-in (billed only as "Herr Director"), Aaron Schimberg crumples up any fear of "the Other" by focusing on the lighter side of the banality everyone faces. And there are also moments of considerable hilarity scattered throughout. At one point, Herr Director demands Rosenthal "emerge from the shadows". When asked the simple question, "What am I doing in the shadows?" Herr Director goes off on a lengthy, increasingly impassioned tangent concerning *The Muppet Movie*, the Muppets' epic quest, and the big reveal of Orson Welles. The director's obsessions are handily revealed without providing Rosenthal with any good reason why his character would just be kicking around in the dark while nicely linking the two phenomena together: as Schimberg remarked in an interview, whenever there's a big reveal (chair swivel, shadow emergence), it's either a celebrity or a "freak".

But what of those other critics? One used the term "black comedy", and I still can't see the "black" part. Another's mind was blown by a modest twist found in the final act; it was as if he watched a far more complicated movie than I had. But despite the unsettling undercurrents discovered by other reviews, I found *Chained for Life* to be as pleasing as it is witty. As the credits appear, they spool over one long take on the bus of the variously disabled actors after the in-movie movie shoot. This stunt pays off handsomely: what do we see when we watch them on the bus? Totally normal people being totally, normal, bored. It was an excellent flourish and a perfect way to underline the film's thesis.—Giles Edwards

Keeping It Normal – An Interview with Aaron Schimberg

On Thursday, July 19, I had the pleasure of meeting with director Aaron Schimberg, whose new movie *Chained for Life* had its International Premier the night before.

366: This is Giles Edwards sitting down with Aaron Schimberg who directed *Chained to Life*… Pardon? Oh, *Chained for Life*. Terrible start. It played to a full house, and I also noticed when I was out in line that the press line was as long as the ticket-holder line, so that will hopefully get the word out on this great feature. You probably saw the reaction of the house a lot of clapping and laughing.

AS: I only paid attention to the people who weren't clapping and laughing.

366: Well, there were plenty of people who were. Now, *Chained for Life* is kind of a "meta-movie" about making a period hospital-horror film while mostly focusing the actors' world. We recently did a long-form review of the movie *Freaks*, and one of the things remarked on by the reviewer was that that was the kind of film you really couldn't make anymore. But you, obviously, have put together something that, while different in tone, is comparable in structure, with a band of "normal" actors and production people and individuals with different disabilities. So it looks like that kind of thing is still possible. Did you have difficulty corralling the groups together or starting this project in any way?

AS: The film is in many ways a response to *Freaks* and an update of it. It was hard to cast in a way because there aren't a lot of advocacy groups for people with disabilities, but not everyone in the film was an "actor." Just because it's a low budget film, it's difficult to cast anyway, so I had to cast sort of by any means necessary: either pick people out from the street, or go through casting agents, or friends, or people that we'd seen in other movies. Everyone seemed to me—if you're asking about actors with disabilities—seemed to relate to the script and seemed fully on board. It was almost like a summer camp atmosphere, a very positive environment. It's hard to get a film off the ground, but once we were up and running it was a pretty smooth process.

366: I like how you said "summer camp atmosphere," because that was definitely captured—certainly in the scenes at night at the hospital with just the "freak" part of the cast there, hanging out. You said that about twenty pages into the script you were writing about this lead character with certain attributes, a certain accent. How did you get in touch with your leading man, Adam Pearson?

AS: Yeah, so I had written a character with neurofibromatosis, who was British. I don't know why. I was probably thinking of the *Elephant Man*, who had neurofibromatosis—possibly, there's a debate about what disease he had—so I was thinking of that. A soft-spoken

person, like Joseph Merrick was. And then, about twenty pages in, I saw *Under the Skin*, and there was an actor, with neurofibromatosis, who was British, and he was upstaging Scarlett Johansson, and I thought this seems like a good sign, maybe I can get this guy.

I don't write roles for people ever because it's a low budget film and you can get disappointed when people don't want to do it when there's not a lot of money involved. My first film I wrote a part for Mike Tyson, and I was sure he was going to do it and… I don't think we ever even got it to him; to this day it's a great disappointment to me, I still regret it, so to this day I don't do it. Nevertheless, after I'd seen Adam Pearson I started to write with a little bit of him in mind and hoped for the best. So we just sent it to him and a couple of days later Adam said he loved the script, and we Skyped, and were on the same page.

And he really loved it and he gives an amazing performance. I think people assume that he's kind of playing himself, but he's actually one of the biggest extroverts I've ever met: very much the life of the party, everybody loves him. He could be a cult leader if he wanted to. But in the film he's a very shy person, and in *Under the Skin* he was similar, so I think people assume that about him.

366: It certainly comes across as very natural, so I guess that speaks to his acting ability.

AS: Yeah, he's great. I think people always think he's playing a variation of himself, but in fact he's got a very wide range. And you see in the film, he has a couple scenes where he's extremely angry, screaming. That's also not him… not that I've seen.

366: You mentioned this first movie of yours, *Go Down Death*; from my understanding that got a limited release.

AS: "Limited," yeah, that's a polite term. It got distribution, but not much of a theatrical release. You can get it on iTunes, places like that.

366: Since I imagine not many people are going to know about it, what is it about? And what drew you to the subject matter?

AS: *Go Down Death* is a little more experimental. It's about a town that's threatened by an unseen force. Kind of a bunch of vignettes that are slightly related to each other, and it deals with some of the same issues as *Chained for Life*: disability and disfigurement, that's part of the film, but it's very anti-narrative. I wanted to play with narrative. This film, *Chained for Life*, also plays with narrative, it changes course, but it's a lot more narrative, more accessible in that way. And I think a lot of the lessons I learned in *Go Down Death*, as my first film, I applied to *Chained for Life*.

366: There was one scene that definitely got a lot of laughs: the German director's "Muppet" tirade. What was it that gave you that idea? Because it was nothing short of amazing.

AS: I was thinking and have observed, the only characters in a film who are introduced in a sort of surprise fashion—emerging from the shadows, turning around in a big chair, something like that—they are either people who are disfigured, hidden in the shadows and revealed at a certain point, or extremely famous kind of cameo actors, like Orson Welles. That sort of surprise element. And the film plays in general with comparing famous, beautiful people with disfigurement, and how in some ways they can relate to each other in terms of always being observed and exposed. And of course, Orson Welles did that a few times, like in *The Third Man* when he emerges from the shadows.

So that scene's the sort of logical conclusion of that observation. After I'd written about thirty pages of the script I noticed that Orson Welles kept popping up in various ways; I don't think it was intentional, but there are several references to him. I could guess, or have some theories about why that is, why my subconscious kept going to him, but it was really unintentional. But it certainly culminated in that scene.

366: Another scene that I think really tied up what I think you were trying to do with the movie was during the closing credits with the single shot of the "freak" characters sitting on the bus. I thought it was a perfect touch: "Oh, that looks so normal and tedious. These are just people and should be regarded as such."

AS: Oh yeah.

366: I'm getting a notice from our press liaison—but I've got one last question I like to pose to my interviewees, Your home town: where is it? And do you have a recommendation for a restaurant there?

AS: My original hometown is Minneapolis. I live in New York now, but "Al's Breakfast" in Minneapolis.

366: Well thank you for that recommendation and sharing your time. I wish you the best of luck with distribution and sharing that film with as many people as possible.

AS: Thank you.

Double Lover [*L'amant double*] (2017) ★★★1/2

DIRECTED BY: François Ozon

FEATURING: Marine Vacth, Jérémie Renier, Jacqueline Bisset, Myriam Boyer

PLOT: A young woman suffering from phantom pains in her stomach seeks the help of a psychiatrist, falls in love with him, and then comes to suspect he is harboring a secret about his past.

WHY IT WON'T MAKE THE LIST: Ozon's latest is a sexual psychothriller that falls into the category of "might have been shortlisted in the earlier days of this project, but with only forty slots remaining..." If you like movies that are mysterious and spice their eroticism with a sense of dangerous perversity, this is one to check out, Litsable or not. My theatrical viewing did include one walkout—usually a promising sign—but I do have to qualify it by saying that it was a little old lady who probably thought she was walking into a screening of the latest *Fifty Shades of Grey*.

COMMENTS: We have to be coy describing *Double Lover* so as not to reveal too much of the plot. Fortunately, the movie features an unreliable narrator, thereby lending itself to an unreliable review that may mislead. For example, it's safe to say (and perhaps even implied in the title) that *Double Lover* revolves around a love triangle. Or does it?

You see, Chloe, the protagonist, hallucinates freely. She first seeks psychiatric help for phantom pains in her belly that have no gynecological cause. (The film is sexually explicit, if not quite pornographic, but even more so it's gynecologically explicit—the very first shot is a speculum's-eye view of Chloe in stirrups receiving a very thorough internal exam). With nothing physically wrong with her, she's sent to Paul, a therapist who soon falls for her and ethically ends their professional relationship, moving his former patient into his apartment instead. Although Chloe seems cured, she still had lingering pains and mommy issues, and therefore seeks out another psychiatrist to plumb the depths of her soul. In this one, she

thinks she's found the perfect counterbalance to sweet-natured Paul…

With its theme of improbable doubles, the scenario is slightly Hitchcockian, though more explicitly hallucinatory. Other themes recall *Dead Ringers*, and a shocking dream sequence unabashedly references a similar sex dream found in Cronenberg's movie. The atmosphere is Lynchian, especially in the oft-oppressive sound design. The hallucinations are usually of the sort where someone shows up in a place where they could not possibly be, although there is a lovely moment when the abstract art at the museum Chloe works in as a guard bleeds into her oncoming dream. The tone is tense throughout, and the sex scenes can sometimes be difficult to watch as they get kinkier and play teasingly with questions of consent. If I had one reservation to the whole thing, it would be that the ending is too pat—although there's also the mandatory coda implying Chloe's turbulent psyche is not yet wholly calmed.

The acting is a high point. Marine Vacth, who might be Juliette Binoche's long lost twin, conveys fragility, but with a tough survivor's core. Jérémie Renier shows range, from the nurturing psychotherapist to a rampaging sexual predator. Jacqueline Bisset is a welcome sight, and neighbor Myriam Boyer, who keeps her beloved pet cat stuffed on the mantle in her long-departed and since untouched daughter's room, adds both light comic relief and an additional air of mystery.

François Ozon is a prolific, chameleonic filmmaker who alternates between slim, popular comedies like *Potiche* and more provocative, sexually charged thrillers like this (with the occasional magical realist fantasy like 2009's *Ricky* thrown into the mix). *Double Lover* was adapted (loosely) from the Joyce Carol Oates novel "Lives of the Twins." JCO approved.—Gregory J. Smalley

Fags in the Fast Lane (2017) ★★

DIRECTED BY: Josh Collins (as Sinbad Collins)

FEATURING: Chris Asimos, Oliver Bell, Matt Jones, Sasha Cuha, Airsh "King" Khan, Justine Jones, Aimee Nichols, Pugsley Buzzard, Luke Clayson, Kitten Natividad

PLOT: A gay superhero and his team go on a quest to retrieve a golden penis stolen by a gang of circus freaks.

WHY IT WON'T MAKE THE LIST: This cartoonish gay superhero grossout flick almost made *one* of our lists: the 10 Weirdest Movies of 2018. It's a big jump from one of the weirdest of the year to weirdest of all time, though, a leap the slight *Fags* isn't quite capable of making.

COMMENTS: When 69-year-old Russ Meyer-ex Kitten Natividad counts as your star power, you know you're aiming at a particular audience. *Fags* presumes (or at least hopes for) a level of familiarity with yesteryear's trash culture, although if you've seen one Troma movie you'll recognize the silly/offensive spirit. Obviously, John Waters is an inspiration (one of the better jokes is a Divine reference), but given the comic book design and heedless incoherence, I suspect Australia's Nazi-fighting comedy/adventure "Danger 5" was a more direct stylistic influence.

Set in an anything-goes world of freak show gangs, Aztec cults, and GILF brothels, the plot is bonkers. It begins in small-minded small-town "Dullsville," where dashing yachtsman Beau (AKA the "Cockslinger") and his beefy longtime companion Lump are brought in to handle a gang of homophobic thugs. ("The toughest gays in town," this avenging duo eschews limp wrists for pimp hands.) Soon, they find themselves chasing after jewels stolen from Kitten's retirement

home bordello, along with a mystical dildo. A buxom killer transvestite and a lethargic Indian eunuch join the team, along with young thug/hostage Squirt, who opens up to his queer side as the adventure continues. The team is opposed by burlesque queen Wanda the Giantess and her gang of freaks (including a bald gal with crab claws) and tailed by the local sheriff and his sadistic hacker assistant. The gang's adventures take them to a booby-trapped tiki truck stop, a gender-bending pagan temple, and into a freaky Freak Town final showdown. And that's just scratching the surface.

The plot moves quickly enough and takes itself with so little seriousness that you won't mind some suspect writing. Very few of the jokes land, tending towards the obvious, the juvenile, and the toilet-minded. (Baseball bat sodomy is not my favorite source of comedy, but at least no one can accuse *Fags* of being overly PC.) The plot makes little sense, but coherence was not a major point of emphasis. A melee at McBastard's Meat Pies has almost no visible motivation but lots of cheesy violence and crotch-kicking. At one point Lump is captured and tortured; it's not completely clear how he is abducted or how he escapes. Plot points were left on the cutting room floor. But the design—a grab bag of bizarre sets and costumes, low budget CGI, and animation both traditional and stop motion—are impressive, especially considering the available resources. Key set pieces include a psychedelic musical number sung by the castrated fakir and a trip into a swamp filled with stop-motion penis-themed vermin. And if that's not enough, a roadside performance by horror rockers "the Mummies" is thrown in for good measure.

It goes without saying that neither homophobes nor the easily grossed-out will want to encounter *Fags*, but if you're made of sterner stuff, you'll find it fast-paced fluff that satisfies your guilty desire for absurd sleaze served with a twist of retro pop-culture surrealism. It saw a very limited release in the U.S., followed by an equally limited DVD release.—Gregory J. Smalley

Hereditary (2018) ★★★★★

DIRECTED BY: Ari Aster

FEATURING: Toni Collette, Milly Shapiro, Gabriel Byrne

PLOT: Disturbing events unfold after the death of a family matriarch, culminating in a bizarrely violent pagan ritual infused with supernatural occurrences.

WHY IT MIGHT MAKE THE LIST: *Hereditary* equals or surpasses already Certified Weird films *The Wicker Man, Repulsion,* and *Don't Look Now* with creepy cult imagery, tightly wound drama, and an effective and disturbing finale. The heavily-researched occult detail makes the material surrounding guilt and loss linger. The exceptional effectiveness of *Hereditary*'s unique brand of personal tragedy transformed into cult devilry means it should be considered for the list.

COMMENTS: Like a coffin descending into a fresh grave, *Hereditary* sinks into a subconscious nightmare. The supernatural mystery at the core of the story is amplified by raw emotions of bereavement and guilt. While Colin Stetson's score highlights the creepy details to oppressive effect, the characters mechanize into roles of which they are unaware. Represented in miniature models built by lead character Annie, they ultimately fall prey to a bizarre set of encounters which, given the slow drip of small clues along the way, makes for an affecting, unforgettable experience.

The anxious and paranoid plot structure is highlighted by a web of sensory mechanics, like clicks and shimmers. *Hereditary* is often dour and unpleasant; but this allows more fun to be had with its exciting occult plot development. *Hereditary* doesn't merely bludgeon the audience with pop-psychology myths; it amplifies its revelations with painstakingly researched detail and pitch-perfect acting. The haunting images, abrupt sounds, and Toni Collette's riveting acting combine with the sensory flourishes to create a seamless whole with an unusually oppressive mood.

The audience shares Annie's emotions. Her avoidance of pain explodes into violence and disorientation, kick-started in an early scene when Annie asks her husband, "Should I be sadder?" after her mother's funeral. Her focus on crafting miniature replicas distracts her, but perhaps only furthers her destructive tendencies.

The personalities of the characters reflect their role in the madness. There's Peter, the laconic stoner subjected to hauntings; Charlie, the instrumental introvert, doomed from the start; and Steven, the helpless voice of reason. He's tired from having to stabilize his wife, Annie, the vulnerable choreographer of a larger family drama. They are a well-oiled machine for the benefit of manipulative, evil forces.

Hereditary has a precise funnel for its barbarism, with haunting, lingering images that are hyper-charged with family drama. The emphasis on specific emotional drama gives the film a living pulse, improving its ability to horrify. The droney

soundscapes and richly drawn villain give it a chance to surpass its influences as one of the weirdest possession/witchcraft movies of all time.

In addition to tightly wound drama, *Hereditary* weaves objects and artifacts into the plot. Annie is hyper-focused on her models, recreations of her depression. They are replicas, but also mechanical devices. They mirror events, but also lure Annie into the perils of self-reflection, which makes her more vulnerable to manipulation. Her daughter Charlie (Milly Shapiro) is also occupied with crafting small, lurid replicas, creative but ugly works that seriously improve *Hereditary* as a weird movie candidate. As Charlie mutilates dead birds, tinkers with bizarre objects, and prepares strange artifacts from earthen material, Annie retreats further into her own creations and loses touch with those around her. The drive to work is healthy, but ultimately saves nobody from the pain of loss.

Aster states that Nicolas Roeg's *Don't Look Now* was an influence, but *Hereditary* one-ups it in entertainment value by providing eerie and detailed puzzles, including thoroughly researched occult objects and lean details about a terrible, unseen evil.—Ryan Aarset

Hitler Lives! (2017) ★★1/2

DIRECTED BY: Stuart Rowsell

FEATURING: Morte, Jay Katz, Chris Sadrinna

PLOT: The deteriorating, practically zombified body of Adolf Hitler shuffles around a bunker deep underground, his nightmares and visions of past associates interrupted only by visits from a faithful henchman and his telecommunications with Dr. Mengele, who has unsettling plans to permanently immortalize the erstwhile Führer.

WHY IT MIGHT MAKE THE LIST: *Hitler Lives!* is definitely weird, with hallucinated marionette memories, decomposing visuals mimicking the decomposing Hitler, and an ending that cannot be un-watched (much like most of the movie). The lack of polish, although sometimes smacking of amateurism, is stylistically effective; kind of like if Jörg Buttgereit started a movie promised a tiny budget, but instead was given *no* budget.

COMMENTS: Wikipedia tells us that "Adelaide is the capital city of the state of South Australia, and the fifth-most populous city of Australia. In June 2016, Adelaide had an estimated resident population of 1,324,279." What that opening blurb does *not* mention is that one of those 1.3 million people was Adolf Hitler. Perhaps that is unsurprising, as the former dictator was busy slowly decomposing in an underground bunker in 2016. That, in brief, is the premise of Stuart Rowsell's zero-budget trash horror weirdness, *Hitler Lives!* In a string of un-unseeable scenes taking place over an unclear amount of time, we get to watch, in horror spiced with disgust, as Hitler shuffles around in mostly solitary agony.

Beginning topside, two construction workers zip down into a tunnel as one of them regales the other with an anecdote about his grandfather helping to transport Hitler from the Antarctic hideaway to which he escaped after Germany's fall. The colleague meets the once powerful demagogue, who is now scarcely able to move and hooked up to an ominous device. After the worker is killed to fuel Hitler's boiler, things get grislier as the dictator hallucinates, hacks, stumbles around, and is increasingly distressed about Doctor Mengele's new plan for their immortality.

So, we've got a few standard items here: Hitler did *not* die at the end of World War II; weird

science has come to the Führer's rescue; and at least one Nazi ended up in Argentina (Dr. Mengele). Rowsell, a special effects man by trade, twists those tropes into perhaps the least palatable presentation possible. Dorff's doomed colleague immediately smells gangrene upon entering the bunker, and we almost can, too. The atmosphere on-screen is stifling, the visuals as decayed and dripping as Adolf's rotting body. A video screen displays constant Nazi propaganda, and Hitler's wistful musings about Wagner are constantly interrupted by creepy, strangely-voiced marionettes of his past henchmen (Göring, von Ribbentrop, and Hess are among the Nazi superstars we see puppetized) as well as unnerving videophone calls from Doctor Mengele. And did I mention aliens? They appear very briefly, but allow for what is one of the most... memorable endings I've endured in a while.

As much as it was a trial at times, *Hitler Lives!* earns, through slime, ickiness, outlandishness, and puppetry, serious consideration for Canonically Weird status. I've mentioned it had no budget, which is a bit of a lie: a whopping 150,000 Australian dollars were funneled into this. Impressively small change, yes, particularly considering how thoroughly real (in its surreal, unsettling way) *Hitler Lives!* feels. Perhaps the weirdest thing of all, however—and I say this with considerable reservation—is that by the end, the movie somehow makes the viewer pity the walking corpse on display. This feeling dissipates quickly once one leaves the rancid bunker, but the fact that human sentiment could be so upended for 80 minutes is impressive. —Giles Edwards

How to Talk to Girls at Parties (2018) ★★1/2

DIRECTED BY: John Cameron Mitchell

FEATURING: Alex Sharp, Elle Fanning, Tom Brooke, Nicole Kidman

PLOT: An aspiring teenage punk in 1970s London meets a cute girl; only catch is, she's an alien.

WHY IT WON'T MAKE THE LIST: This light-hearted artistic fling between the offbeat talents of director John Cameron Mitchell and writer Neil Gaiman meets its quota of whimsical sweetness, but falls short on weirdness.

COMMENTS: I was completely alone in the theater on a Monday night screening of *How to Talk to Girls at Parties*. When I bought my ticket the summer job trainee cashier assumed I was asking to see *Life of the Party* (ouch!). But, while *Girls* is not a must-see cult hit, it's not a waste of time, either; at the least, it's an unconventional offering that could find a future audience of adventurous youngsters.

Girls is a period teen romantic comedy with the slightest tinge of punk and sci-fi flavor, more *Earth Girls Are Easy* than *Liquid Sky*. A trio of socially inept 1970s teen punks stumble into the wrong party while on the prowl for girls. While the fat kid and the self-appointed pick-up artist wander around scoping out the shapely bodies in tight latex unitards doing Cirque du Soleil routines to whale song electronica, the sweetest and most talented, Enn, stumbles upon a newly "manifested" alien Zan (Elle Fanning, who, God love her, is still seeking out the weirdest roles she can find rather than settling for a part as a minor X-Man character). After Enn explains his punk philosophy to the girl, Zan seeks, and is reluctantly granted, a dispensation to experience human life for 48 hours ("do more punk to me," she croons to Enn). The remainder of the plot arc is easy to guess: the mismatched pair court, with the normal teenage social awkwardness amplified by an alien culture clash, while Zan's "colony" (whom Enn and friends believe to be a cannibalistic California cult) pressure her to get her back into the fold. There's some mild weirdness along the way: an out-of-place psychedelic music video when Zan improvises a punk number onstage ("we must have been dosed," Enn reasons); alien sex practices best left undescribed; a conception scene with eggs like yellow party balloons and sperm that looks like a 3D model of a rhinovirus; Nicole Kidman as bitchy aging punk godmother Boadicea; and an underwhelming punks vs. aliens showdown that might have been huge if given a proper B-movie treatment. Overall, the movie has a good-natured, unthreatening-yet-rebellious spirit, and some sweet costuming (each alien colony sports its own sartorial theme). Still, the reveal of the ultimate nature of the alien cult(s) suggests many potentially more interesting stories than the John Hughes-y tale that actually unfolds.

Multiple reviewers complained that *Girls* "tries too hard" to be a "cult" movie. I find his criticism hard to grasp; it's probably a variation on the old "weird for weirdness' sake" saw. I suppose the argument is based on the premise that cult movies can only arise by happy accident when the director was actually trying to do something else; this can be easily disproven by dozens of examples (including one from this very same director)! Whether you think it succeeds or not, *Girls* isn't trying too hard; it's just trying to be what it is, which just happens to be something different from what critics and audiences expected.—Gregory J. Smalley

Inheritance (2017) ★★

DIRECTED BY: Tyler Savage

FEATURING: Chase Joliet, Sara Montez

PLOT: A carpenter inherits a northern California villa from the biological father he never knew; the place is haunted by family secrets.

WHY IT WON'T MAKE THE LIST: This indie psychological horror has only a few bare scraps of weirdness scattered throughout its infrequent dream sequences.

COMMENTS: When carpenter Ryan is told his biological father has died, his expression is detached and brooding. It won't change much throughout the rest of the movie. That's not to say Chase Joliet's performance is bad; it's just one-note, by design. *Inheritance* starts in a solemn mood and keeps it consistently gloomy from beginning to end. The movie barely cracks a smile, and never tells a joke. The emotions simmer, never quite boiling over into catharsis. Even the sex is serious. The tone is meant to convey a mix of subtle melancholy and lurking menace, but it often skirts too close to the borders of ennui.

The titular inheritance is a 2.5 million dollar villa on the northern California coast. The property is a windfall whose sale would supply a great nest egg for him and his fiancée Isi (Sara Montez) to start their life together; but the husband-to-be feels the need to linger in the home while silently working out his feelings about his biological heritage through a series of obliquely symbolic dreams of about his ill-fated parents and other ancestors. Ryan's psychology revolves around fear that he will turn out like his biological father—although we get few meaningful hints what dad was like—but he also his has issues with jealousy, and hints of ambivalence about fatherhood. He struggles as much with accepting his upcoming responsibilities as a family man as he obsesses over his biological heritage; Isi suspects the latter is distraction from the former. With our main character so closed off, it falls on Montez to provide some the movie with some life. This she does, literally and figuratively. Hers is the more appealing, and stronger, character.

The cinematography, courtesy of Drew Daniels (*It Comes at Night*), is the film's best asset, alternating bright beach scenes with well-lit nighttime dreamscapes. (In contrast to Ryan's clouded psyche, his home is about the sunniest haunted house you'll ever see.) Isolated shots are poetic; whiskey cascades over ice in slow motion, scored to the sound of ocean surf. *Inheritance* is well-crafted, but it's too slow and monotone for most audiences, with too little dramatic payoff. About one hour into the movie, when a ghostly figure tells Ryan "I trust you know what to do now," I caught dim echoes of *The Shining*. Then, I realized that by this point in Kubrick's ghost story, we'd already seen the blood in the elevator, the spooky twins, a foreboding Room 237, and Jack Nicholson starting to lose both his temper and his mind. *Inheritance* had yet to really get into gear, and although it tries to cram a lot of action into an effective final fifteen minutes, it isn't quite worth the leisurely trip it takes to get there. The movie has a sophisticated psychology and there's a lot of talent involved on both sides of the camera, but it doesn't quite achieve its ambitions.—Gregory J. Smalley

It Takes from Within (2017) ★★

DIRECTED BY: Lee Eubanks

FEATURING: James Feagin, Kristin Duarte, David Brownell

PLOT: A man and woman make preparations to attend a burial: existential dialogues and strange events happen along the way.

WHY IT WON'T MAKE THE LIST: Given the suffering on display, the film could just as easily be titled *Life Takes from Within*, tearing away at the character's insides. It's certainly weird, but also derivative of films that have done existential angst much more effectively.

COMMENTS: Drawing equally from David Lynch, Ingmar Bergman, Jim Jarmusch, and Samuel Beckett, this independent feature gets off to an engaging start with a largely wordless and beautifully lit sequence begging multiple interpretations and capturing the viewer's attention with its evocative and allusive nature. Sadly, it's downhill from that point on, with two opening exchanges between leads Feagin and Duarte setting the existential tone of the film and hinting at a "Waiting for Godot"-esque pairing without ever capitalizing on that potential. Feagin still believes in a "finish," a possible meaning to their existence, while Duarte has resigned herself to the pointlessness of creation and seeks distraction and amusement.

Capitalizing on the "Godot" relationship could have injected some much-needed humor into the proceedings, but sadly director Eubanks opts for the bleak, existential angst of a Bergman film, but without the dramatic weight of Bergman actors. With her fleshy, open features and "make the best of it" attitude, Duarte makes a fairly engaging lead, a sympathetic figure in stark contrast to Feagin's squinty scowl and petulant mewling. Eubanks has us follow this disagreeable combo for much of the run time. If the male lead had ached in a sympathetic manner, i.e. he was fighting for answers to the inertia of creation, then this film could have been tense and

engaging. Instead, we get a sullen crab spouting emo poetry, with the charisma of a wet dishcloth.

The sound design is alternatively haunting and engrossing or abrasive to the point of making the viewer feel ill. If the latter outcome was the endgame, then full points for counterintuitive filmmaking.

The film is dull to the point of distraction, and we are never given any reason to care about anyone. The characters are absurdist figures; we know nothing about them and can only take them at surface value. But on that surface no one is all that interesting. There is a very clever shot that uses panning and a dolly move to separate a café into three worlds, aided by distinctive sound design for each "world." It starts with Duarte and a random male chatting her up, then their conversation is swallowed up and the camera pans over to an old lady, arranging her meal using painting tools. Finally the camera pans round to a new couple in a booth, this one in the kooky Jarmusch mold, consisting of a woman learning French words and a man worried about the petrol they're burning through by constantly stopping at coffee shops. While the shot is inventive, it doesn't serve the themes or narrative of the film.

The film claims to take its inspiration from art house films of the 1960's and the black and white torment of films like *Persona*, *Fando y Lis* and *The Face of Another* are strongly reflected here. While *It Takes* achieves the tone of those films, it fails to register on their emotional level. Its pain is more akin to the whining of a brat with a skinned knee.—Bryan Pike

Like Me (2017) ★★

DIRECTED BY: Robert Mockler

FEATURING: Addison Timlin, Larry Fessenden, Ian Nelson

PLOT: A teenager embarks on a low-impact crime spree in support of her burgeoning social media presence, but feels pressured to escalate in the face of blistering online criticism.

WHY IT WON'T MAKE THE LIST: Off-kilter sound, picture, and editing all combine to keep viewers on unsteady footing throughout, but *Like Me* ends up being a lot like the cereal its heroine grossly consumes: empty calories, all color and no nutrition.

COMMENTS: To be a creator of any kind—whether your forum be art or music or performance or, God help you, a writer of online movie reviews—is to crave an audience. Even if you yourself want no part of the attendant fame and controversy, the compulsive need to be heard remains. Sia may hide behind surreal dance routines and bi-chromatic wigs, Banksy

might destroy his own work by remote control, even the mind behind the reboot of "Nancy" might prefer to fly under the radar, but they all still have something to say and want you to listen. You may have already noticed me, waving meekly at you in hopes that you will heed what I have to say about offbeat cinema.

Kiya, the teenage protagonist of Robert Mockler's debut feature, understands instinctively the importance of being heard, and she's coming to realize how it is equally valuable to have something to actually say. Twice, she asks another character to "Tell me a story," as if

she knows that she is an empty vessel who desperately needs something hearty and substantial to fill her up and give her meaning. She never really gets that need met, though, and instead fills her days with hopelessness and her nights with making videos of humiliating pranks which a portion of the population devours as rich content.

Mockler has real visual flair. His jittery camera, rapid-fire editing, random imagery, and electrified color palette all speak to a deliberate and ambitious cinematic strategy. He isn't shy about using his bag of tricks, most notably in a nightmare sequence where Kiya's beat-up clunker motors through a candy-colored underwater bubblescape in a 900-degree long take, like *Children of Men* on shrooms. But what soon becomes apparent is that the weirdness is less of a mission than it is joint compound; cinematic spackle smoothing over the emptier, more aimless stretches of the thin plot. Unusual imagery does help put us inside the mindset of our quixotic, sometimes drug-buzzed protagonist, but more often than that it's padding.

Like Me is undoubtedly titled ironically, as it's next to impossible to like anyone in it. As Kiya's online nemesis, Burt, spews venom at her online art project, it's possible to agree with his harsh assessment of the pointlessness of her efforts and the vapidity of those who would lavish their attention on her while simultaneously concluding that he is an obnoxious blowhard. Her hostage-collaborator, Marshall, is both a pitiable figure for his predicament (I kept worrying about his unattended motel) and a wretched, pathetic loser. Even a little girl we meet at a service station is corrupt, shooting everything she sees with a toy gun "because it's fun." And then Kiya herself, played with real movie magnetism by Addison Timlin, is strangely the most compelling of all, managing to be intriguing despite having no clear inner life whatsoever. Not likeable at all, mind you. But fascinating.

There's a lot of talent on display in *Like Me*, and enough of an understanding of the allure and the method of the wired world to give it verisimilitude rarely found in more mainstream films. But the whole of the movie is so much less than the sum of its parts; it can warn of the hollowness of our way of life or stoke incipient distaste for affirmation measured in followers and thumbs-ups. But once it has our attention with its sharp imagery and flowery language, nothing of consequence lingers. Which I guess is a red flag for all of us who insist on sharing our voices with the universe.—Shane Wilson

Luciferina (2018) ★★

DIRECTED BY: Gonzalo Calzada

FEATURING: Sofía Del Tuffo, Pedro Merlo, Malena Sánchez

PLOT: When Natalia is informed of her mother's dramatic death, she abandons her life at a convent to help her sister at home, and joins her sister and a group of her psychology class buddies in visiting an out-of-town shaman for some soul-cleansing, where things get darkly religious.

WHY IT WON'T MAKE THE LIST: The culminating "sexorcism" aside, *Luciferina* is as by-the-numbers as a young-people-make-bad-decisions-with-theological-overtones horror movie could be. It was only halfway through, during an intense birthing/exorcism set-piece, that I was even reminded that there was something "bigger" going on than a gaggle of college kids getting high on an ancient weed.

COMMENTS: I will make no secret of the apprehension I felt before watching this movie. It had been kicking around 366's internal review wish-list for about three weeks before I finally stepped forward to get it out of the way, and then it lingered in my DVD player for another week and a half before I finally dove into this 1-hour, 53-minute, 4.5-IMDB rated slice of feminist-Catholo-pagan horror. The good news is that it is actually an okay movie. The less-good news is that it never really rises above that level.

Natalia happily busies herself as a novice in an Argentinian convent that doubles as an outreach/care clinic for young drug (?) offenders. Her little world of religion and routine is scotched when the mother superior informs Natalia that her mother has died in some not-terribly-well-explained accident. Home she goes to find her father somewhat vegetative in the attic and her sister hooking up with one of those inexplicably angry young men that always seem to get the pretty girls. But there is some bonding, some bugs, and a party during which a trip to a shaman is discussed. Off they go into the outskirts of the nearby jungle and knock back some stuff that… makes the whole thing the Catholo-pagan-horror movie that it is.

Like *Baskin* and *Session 9* before it, *Luciferina* makes the unfortunate mistake of thinking it's a horror movie when actually it should have been a melodrama. I liked the college party people, other than the angry young man (and even his back-story, were it ever to be revealed, could have interested me). Instead, we get some hyper-religious imagery of various flavors, young people getting killed off in unpleasant ways, and some CGI fetus oddness bookending the movie. (That perhaps merits some clarification: from what I was able to decipher from the movie, the credits, and some research, the opening fetus is Natalia, a child of Satan, and the closing fetus sets up the sequel[?][5], and may *also* be a child of Satan, as conceived, perhaps, with his own child. I know, I know, but the Lord of Darkness is unlikely bound by human socio-sexual norms.)

And all this adds up to what? Like I said, this really should have been a story about an abused young woman (Natalia's sister) as she tries to work through her issues (and hopefully ditch her boyfriend) in the company of her charismatic psych-student buddies. Instead, we have *Luciferina,* a title that hits one over the head with its pretensions. The horror doesn't work (though thankfully the jump scares are few and far between), the religious angle is muddled at best (Natalia's ability to see a "glow" around people – or not – seems to accomplish little), and the less said about the possessed boy named Abel, the better. It was competent. It was well acted. It was well researched. It was also a waste of time and talent.—Giles Edwards

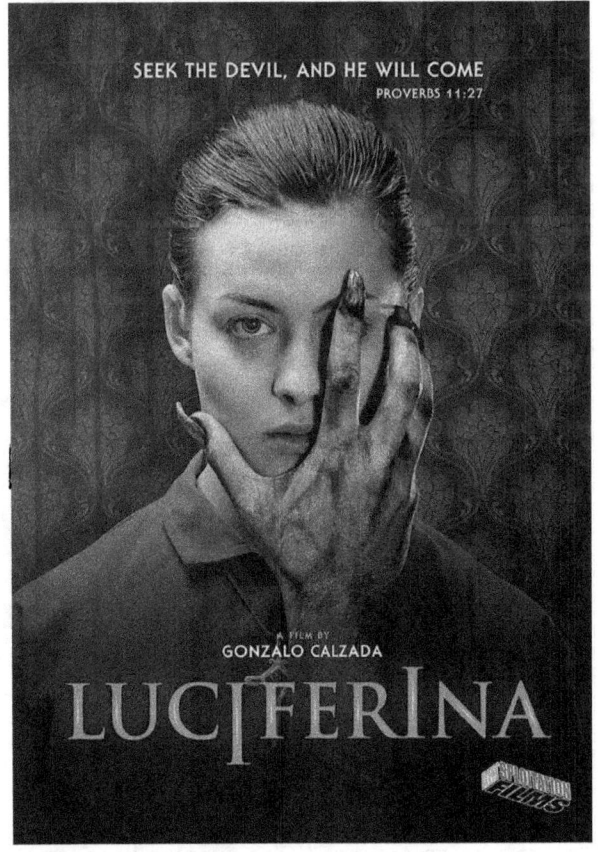

[5] *Luciferina* appears to be the first in a planned trilogy.

Luz (2018) ★★★★1/2

DIRECTED BY: Tilman Singer

FEATURING: Luana Velis, Jan Bluthardt, Julia Riedler

PLOT: A police psychotherapist gets drunk at a bar with an animated young woman who has recently been thrown out of a cab; back at the station, the young cabbie has turned herself in and the therapist gets summoned to recreate the incident.

WHY IT MIGHT MAKE THE LIST: Uncanny valley sound design keeps the viewer on the edge of his seat from the start as a barroom encounter, a police procedural, and a car-ride collide together in fits, bursts, and *very* extreme psychotherapy. This tightly packed little nightmare bursts at the seams with dark visions, psychological overlaps, and camera work that stays on the deeply menacing side of surreal.

COMMENTS: Good luck can play a big part in finding a truly amazing film. My path toward 366 began almost two decades ago when, by chance, I rented *The Cook, the Thief, his Wife, & Her Lover* from a little VHS rental place near my home. Naturally, being at a film festival like Fantasia, one is engineering the good luck, but I am still thankful (and surprised) that I went, by chance, to the press screening for the new German "psychothriller" (for lack of a better catch phrase) *Luz*. From the get-go I was glued to my seat; an odd compunction to have when the opening shot is of a bored police officer manning a desk.

The humdrum opening: Dr. Rossini (Jan Bluthardt) is quietly enjoying a drink at a near-empty bar. His pager beeps from time to time, as he is on-call; but he only needs to leave if "there's an emergency." One eventually arises, but only after another bar patron, an animatronically-twitchy young woman named Nora (Julia Riedler) gets him drunk. Sloshed, both from the drinks and her bizarre tale about a young woman named Luz (Luana Velis), he needs to get sober—and fast. Jump to the barroom bathroom where Nora seems to shake the drunkenness out of him, imbues him with a golden glow from her throat, and then collapses. Thus mended, off he goes.

Menacing from the start, *Luz* maintains an incredibly unsettling atmosphere as the police psychologist hypnotizes a very unstable—and very possibly possessed—cab-driver to recreate a fateful car ride. Going to incredible extremes, his analytic work morphs more and more into a violent interrogation-cum-exorcism. Recollection and reality violently collide as Dr. Rossini turns the screws further and further. Memories are impossibly conjured in the police station: Rossini adopts the persona of Nora, bloodying his face and putting on her stolen clothes, and all the while, a poor police translator is locked in a sound booth. Through an impeccably askew soundscape and the goth-prog-synth score, even the relatively quiet moments pulse unnaturally.

Using effectively only two sets, *Luz* crams an amazing amount of nightmarishly surreal drama into just seventy minutes—and Jan Bluthardt's performance as Dr. Rossini would make both Klaus Kinski and Erwin Leder proud. Presently, I find myself at a loss for words, so I'll leave this review saying that, due to the review embargo, I had to sit on this for a week before publishing it. By the time you read this, I may well have seen it a second time.—Giles Edwards

Madeleine's Madeleine (2018) ★★★1/2

DIRECTED BY: Josephine Decker

FEATURING: Helena Howard, Molly Parker, Miranda July

PLOT: A troubled 16-year old girl escapes her neurotic home life by immersing herself in an experimental theater troupe.

WHY IT WON'T MAKE THE LIST: Experimental director Josephine Decker's third film, the Sundance-selected *Madeline's Madeline,* is a promising and passionate shot across the bow of the timid indie drama scene, a collection of typical film festival narrative preoccupations—dysfunctional family dynamics, reflective meditations on the trials of the working artist—blurred by an experimental film lens. But for all its oddball virtues, it's of limited appeal, and I suspect it finds more favor with dramaheads looking for a weird-ish diversion from the ordinary than with weirdophiles looking for a little drama.

COMMENTS: *Madeline's Madeline* paints a portrait of three women. Madeline is a 16-year old with a natural gift for acting, an increasing impatience with her virginity, and a slowly-disclosed history of mental illness. The seriousness of her condition is somewhat suspect, since it's mainly suggested by her neurotic mother Regina, who comes off as a hypochondriac. Naturally, these two clash. Madeline's awkward attempts at erotic expression are more frustrating than fulfilling, but she finds meaning working with an experimental theater troupe—the kind that perform endless improvisations where the cast pretends to be sea turtles or explores "dream work" and never gets around to rehearsing an actual play. Director Evangeline, our third character, is working on a script to feature Madeline, but it never develops due to her endless digressions and exercises that sometimes become uncomfortably intimate. Madeline sees Evangeline as the mother she wishes she had, but their relationship is complicated by the director's egotism and subtle

authoritarianism. If she thinks she can constrain a force like Madeline, however, Evangeline is sadly mistaken: the teen proves advanced beyond her years at manipulation.

The story above is delivered in a series of vignettes; some are deliberately confusing, while others wouldn't seem out of place in *Ladybird*. The scenes are often broken up by disorienting montages: the lens wavers in and out of focus, shot from odd angles while the camera focuses on chins or foreheads or forks during conversations. The score is mostly *a capella* tribal chanting; very Greenwich Village-y, just like Evangeline's bohemian brand of performance art theater. It's Cubist filmmaking: individual scenes depict facets of the multilayered story, with details obscured or muddled, but the whole reveals a complete portrait of its subject seen from multiple angles. The ending is a psychedelic free-for-all encapsulating Madeline's rebellion against Evangeline's artistic authority: the girl stages a mutiny and turns rehearsal into an avant-garde haunted house and choreographed manifesto of independence.

Exemplary acting from the trio gives *Madeline* a leg up on similar experiments. July pushes her eccentric persona in a new, less precious direction. The troupe defers to Parker's character as its *de facto* leader, but she's more dilettante than genius, and her insecurities reveal weaknesses that Madeline instinctively exploits. We never get a handle on which of the three women is actually the craziest—although Madeline at least had the excuse of adolescent turmoil. 19-year old Helena Howard—who plays everything from a confused teen to a kitty cat to her own mother—makes everything watchable, grounding the sometimes flighty project and showing breakout star potential. Unfortunately, this experimental movie is destined to be little-seen, but producers and casting directors will take note of Howard. Like Madeline, her talent is too great to confine itself to underground niche movies; we hope she'll remember, and maybe even return to, her weird, arty roots years from now when she's a big star.

Madeline's Madeline made it from film festivals to VOD in 2018, and had a Blu-ray/DVD release in January 2019.—Gregory J. Smalley

Mom and Dad (2017) ★★★1/2

DIRECTED BY: Brian Taylor

FEATURING: Nicolas Cage, Selma Blair, Anne Winters, Zackary Arthur

PLOT: Parents all across the world suddenly snap and start trying to kill their kids, leading to an all-out generational battle royale.

WHY IT WON'T MAKE THE LIST: *Mom and Dad* is actually a challenging movie to comprehend on first grasp. There is nothing in the execution of this film that says "weird," but the premise alone is audaciously novel, and the tone is consistently off-rhythm. Maybe a list of "the 1000 strangest movies" would be a better fit for this movie.

COMMENTS: *Mom & Dad* focuses on suburban beehive hell and the nuclear family of Brent (Nicolas Cage) and Kendall (Selma Blair) and their two kids Carly (Anne Winters) and Josh (Zackary Arthur). While the family breakfasts, reports of parental filicide (that means killing your own kids) play on the news - the focus of this story. Throughout their day, the family, even the adults talking to each other, bicker in casual passive-aggressive ways, not a joyful scene to be had.

The whole world of *Mom & Dad* eventually has all the parents showing up early to pick up their kids from school—and it's not to take them out for ice cream! It turns into a spontaneous riot, with the too-few cops failing to keep order as parents leap fences and gates and start stone

cold assassinating their kids using any means at hand. Kids run, parents chase, bedlam, uh, bedlams. Talking heads on the news spread the same story, and of course no one knows why this is happening. A lengthy delivery room sequence with Kendall's sister picking today of all days to give birth terminates in a post-natal abortion as mom strangles the newborn. Elsewhere in the hospital, new parents press their faces against the glass of the maternity ward, locked out.

All this blurs by, less like a movie and more like an anthology of connected scenes. The kids of our central nuclear family return home to find their housekeeper Sun-Yi mopping up the blood from her own filicide. The kids have to fend for themselves against their own parents out to kill them and marshal defenses such as taking their parents' gun, which gives us a satirical recitation of home firearm statistics after a parent gets shot.

Speaking as one who favors the darkest side of humor… I'm a little let down, because there's not much dark humor here, except in the general concept. Cage does his Cagiest, and his trademark freakouts carry every scene he's in—singing the "Hokey Pokey" while demolishing his pool table with a sledgehammer after a minor marital dispute, that sort of thing—but he's not even in the bulk of the movie.

Mom & Dad does have some points in its favor. It is intelligently handled, has an original and daring premise, and explores that concept in depth. There's just enough Nicholas Cage to flavor it without overpowering it. The rest of the cast is competent; Selma Blair gets several good scenes. But… it seems not to know what it wants to be. It nibbles on some themes, like punk nihilism, anti-consumerism, and social parody of the generation gap, without committing to any of them.—Pete Trbovich

Molly (2017) ★★★

DIRECTED BY: Colinda Bongers, Thijs Meuwese

FEATURING: Julia Batelaan, Annelies Appelhof

PLOT: Gifted with supernatural powers, Molly survives as a scavenger in a post-apocalyptic world, while a warlord tries to capture her and force her to become his champion in deadly cage fights.

WHY IT WON'T MAKE THE LIST: *Molly*'s main—well, only—claim to weirdness is its namesake's superpowers and the fact that they're entirely unexplained. That's not enough to qualify it as a truly bizarre film, let alone one of the weirdest ever made. Still, although it may have mainstream genre aspirations, normals will never see *Molly* as one of their own.

COMMENTS: Focused more on kicking ass than worldbuilding, *Molly* throws you into its post-apocalyptic milieu without much explanation, trusting that you have seen enough *Mad Max* movies to know what's going on. Tropes like the barter-based economy and a scaled-down Thunderdome-style arena ground you. Other concepts are not fully explored: most significantly, Molly's telekinetic superpowers are not explained, although there are a few obscure hints, and the ending suggests that an (unlikely) sequel might explain more about her origins.

Molly's magical abilities are important because they level the playing field, helping to explain how this slip of a gal, not tipping the scales at much more than a hundred pounds, can slug it out toe-to-toe with the baddest asses in the Wasteland. She can be shrewd, but mostly she takes on crews of guys twice her size with nothing but kicks, punches, and swipes from her wicked handsaw. The final act is basically an extended thirty-minute melee as Molly carves her way through a small army of punk henchmen and drug-crazed zombie fighters on an oil rig turned floating fiefdom. Few of *Molly*'s

performers, including the lead, are especially athletic or polished; but the film uses their clumsiness to its advantage. The battles feel authentic—stumbling, bone-crunching brawls rather than precisely choreographed ballets. Clever editing, including invisible cuts to make a major battle appear to be done in a single take, helps. Sometimes the filmmakers shoot with a handheld camera to emphasize the chaos, and at other times use stable long shots; they aren't locked into a particular style, but go with whatever feels right for the scene. The pièce de résistance occurs when Molly finds herself hanging upside down over the fighting pit while supplicants claw at her from below. Molly—both character and film—survives by pure ingenuity.

Molly is imperfect, as befits its modest, ramshackle setting and humble heroine. Freckly Batelaan is appealing in the lead—although I kept wondering how she kept her thick glasses on through all the fights. The rest of the acting is iffy. The main villain is not over-the-top enough; his henchwoman, with her cybernetic arm, easily outshines him. The small budget is apparent throughout. But despite these handicaps, Molly manages to assemble an entertaining ninety minutes, and it does it the hard way—by making a fast-paced action film rather than relying on dialogue. Fight scenes are difficult to stage, and if Molly's crew can produce reasonable-looking ones on this meager budget, we can only imagine what they'd pull off with significant resources. As a rental, you could do a lot worse than Molly; and, as a filmmaker, you could do a lot worse your first time out than making a movie people could do a lot worse than renting.

Artsploitation Films released Molly straight to home video and video-on-demand. The DVD and Blu-ray come with thirty minutes of behind-the-scenes footage and a director's commentary from Thijs Meuwese, featurettes that will inspire fellow low budget filmmakers.—Gregory J. Smalley

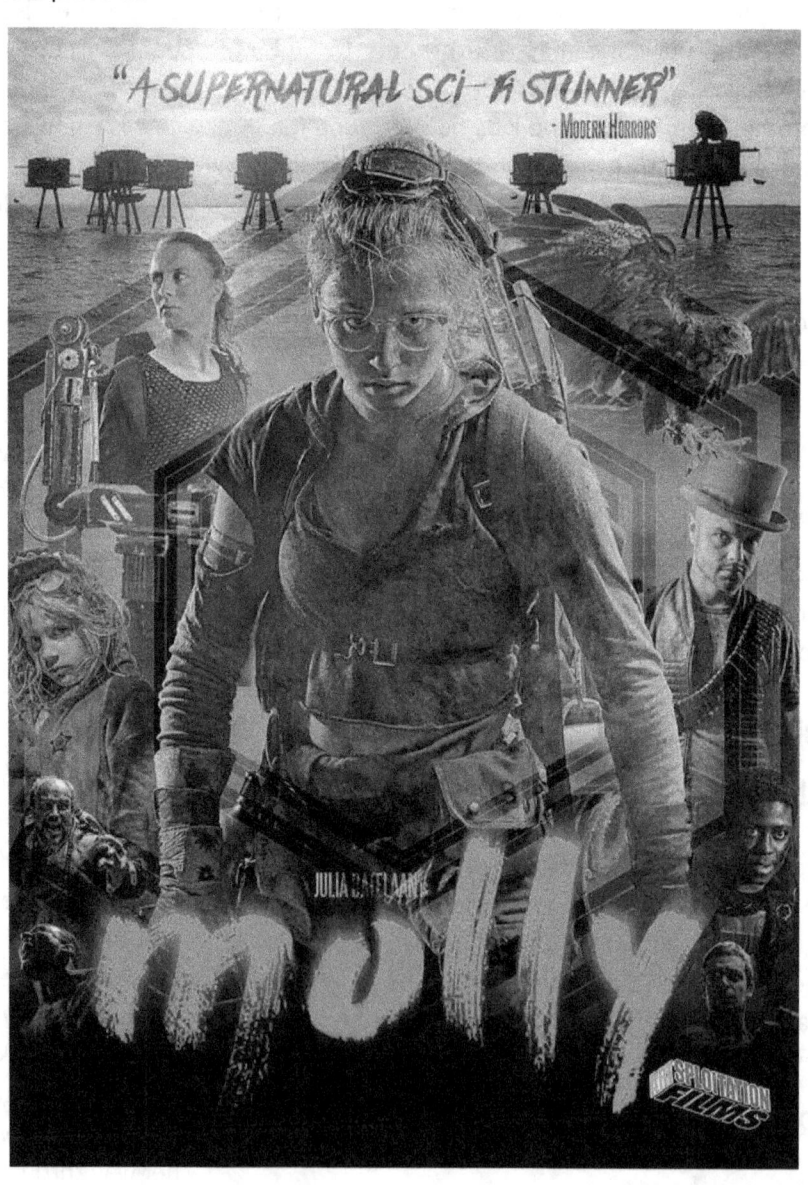

Night Is Short, Walk on Girl (2017) ★★★★

DIRECTED BY: Masaaki Yuasa

FEATURING: Voices of Kana Hanazawa, Gen Hoshino

PLOT: A shy, love-struck senior follows a peppy junior ("the Girl with Black Hair") from afar over an almost endless surreal night that includes philosophical drinking contests, an encounter with the God of Used Books, a peripatetic musical theater, and a cold epidemic.

WHY IT WON'T MAKE THE LIST: At this writing, there are only five slots remaining on the List. If not for that shortage, *Walk on Girl* might have a shot. Fortunately, in *Mind Game* (2004), we already have a slightly more famous, slightly better movie to represent Masaaki Yuasa on the List—but if he keeps making anime this weird, we may have to reconsider that hard 366 cap.

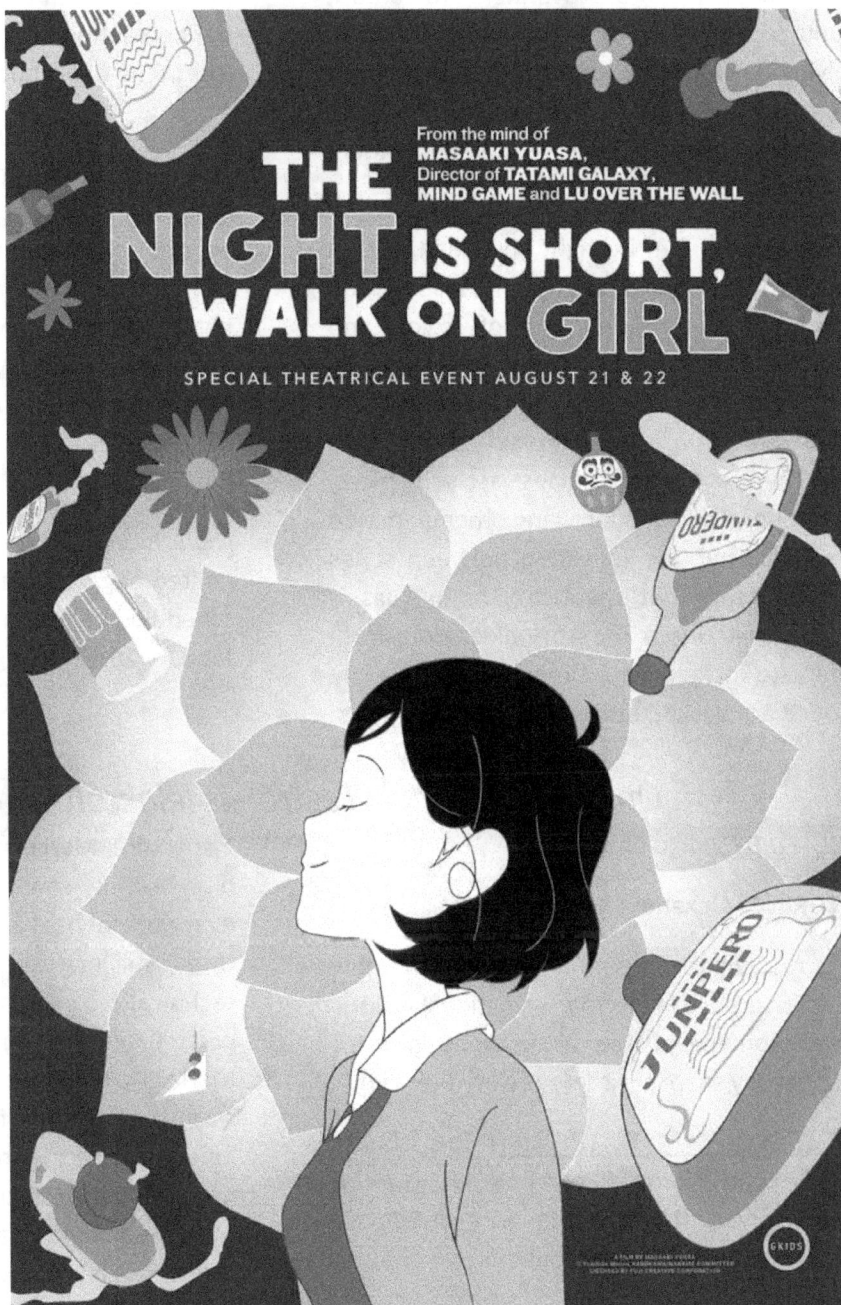

COMMENTS: A cross-dresser, a man who has vowed not to change his underwear, and a love-besotted student walk into a bar… Well, actually it's a wedding reception, not a bar, and *Night Is Short, Walk on Girl* is not a joke, although it is a comedy. Nevertheless, that is the opening setup for a yarn that will become a surrealistic nocturnal journey. The object of the student's affections is the Girl, who starts with her own romance-free agenda: she wants to experience adulthood, and figures the best way to do this is through a night of heavy drinking. As she meets perverts, sophists and fellow drinkers, the evening develops into a quest for a mysterious liquor known as Imitation Denki Bran, climaxing in a drinking contest against an elderly pessimist. Meanwhile, her admirer has his underwear stolen and discovers his friend leads a secret team of electronically-

omniscient high school hackers. And all that's just in the first 20-30 minutes; the not-so-short night has many more wonders to unfurl, including another competition (this time involving lava-eating), musical numbers from "The Codger of Monte Cristo" (with meta-lyrics referring to both the main plot and subplots), and a flying fever dream finale.

The look of the film is bright and clean, with a mild retro feel: space age graphics and clean modernism, with bold use of color and geometric motifs—especially flower petals, which go drifting through the canvases like blossoms falling off invisible psychedelic cherry trees. There are plenty of abstract sequences, split screens, hallucinations, and other animated digressions, but the transition between styles flows smoothly, not chaotically as in Yuasa's previous *Mind Game*. The story glides along from incident to incident in a similarly fluid fashion. Episodes are packed inside four major chapters: bar hopping, the used book fair, the play, and the cold that lays the entire neighborhood low. It's a pleasant structure to organize the anything-can-happen action and keep us from getting totally lost in the film's hubbub.

Night Is Short, Walk on Girl is weird, but light. The title character's girlish optimism sets a sprightly, happy tone. While her pursuer's actions sometimes verge on the stalkerish, we never doubt the purity of his affections, and we naturally root for the two to get together. *Girl*'s dream logic is totally blissed-out; someone must have spiked the imitation brandy with mescaline. It's a night well spent; you may even wish it was longer.

Night Is Short, Walk on Girl played theaters in a limited engagement over the past summer. It's scheduled to appear on DVD, Blu-ray and VOD in January 2019.—Gregory J. Smalley

On Body and Soul [*Teströl és lélekröl*] ★★★1/2

DIRECTED BY: Ildikó Enyedi

FEATURING: Alexandra Borbély, Géza Morcsányi

PLOT: A slaughterhouse manager and the new quality assurance inspector, a functional autistic savant woman, pursue a relationship after realizing they share the same dream (literally).

WHY IT WON'T MAKE THE LIST: The "shared dream" conceit, the film's only truly weird feature, serves little more than as a plot device to bring the unlikely lovers together.

COMMENTS: *On Body and Soul* begins with intimate footage of two deer tromping through a snowy woods by a lake. The buck tries to nuzzle the doe, but gets little response, as she meanders away searching for a tuft of grass. This opening segues into scenes of unsuspecting cattle at an abattoir being led to the killing floor. We then meet the new temporary meat quality inspector, Maria, a stand-offish but pretty blonde. She soon causes trouble by grading every side of beef a "B," because they are two to three millimeters fattier than regulations—technically correct, by the book, but also not what financial manager Endre wants to hear. Maria also has great difficulty choosing a place to sit in the cafeteria for lunch, searching out the loneliest corner, and when Endre tries to talk to her, their conversation is awkward and strange. At home at night, Maria arranges salt and pepper shakers on her kitchen counter and recreates the day's conversations, puzzling out their social significance. She's definitely not neurotypical.

The true plot is set in motion when, through an absurd contrivance (the theft of bull aphrodisiacs from the slaughterhouse), an outside psychiatrist is brought in, analyzes the workers' dreams as part of her profiling, and discovers, to her disbelief, that Endre and Maria

share the exact same dream night after night, of two deer in a snowy glade. Other than the romantic notion of two souls linked by fate and the thematic connection to the apparently thin line between bodied beasts and soulful people, the happenings in the dream glade don't intrude on the rest of the story, and are soon laid aside. Instead, Maria, conflicted by feelings for Endre she doesn't understand, sets out on an often-humorous journey to expand her experience of life beyond the narrow focus of her own mind. She observes lovers spooning at the park as if she were studying mating rituals at a zoo. She tries to understand the appeal of music (eventually finding a single song she likes) before connecting with her own body by discovering the pleasure of lying in the grass while a sprinkler waters her. Simple Endre, who has a womanizing past, can't figure this strange woman out, and tries several times to end the burgeoning relationship, despite their uncanny dream connection.

The attraction here is Alexandra Borbély's fascinating portrayal of Maria. She makes expressionlessness an art form while portraying a character type who is seldom, if ever, seen on screen—and if so, never in the role of a romantic lead. The philosophical implications never get too deep, and the film may be overlong for its slim storyline, but those looking for an offbeat (if not weird) arthouse romance should find this a tasty cup of meat.

The producers of On Body and Soul signed an exclusive contract to stream the film on Netflix, so it won't be available on home video or other platforms (in North America) for the foreseeable future.—Gregory J. Smalley

Paradox (2018) ★1/2

DIRECTED BY: Daryl Hannah

FEATURING: Neil Young, Lukas Nelson, Micah Nelson, Corey McCormick, Anthony LoGerfo, Tato Melgar, Willie Nelson

PLOT: "Many moons ago, in the future..." a gang of cowboy-style fellows scratch out an existence on a remote farm; they've been exiled there by women-folk, who have proven better stewards of the earth. And there's also a Neil Young concert.

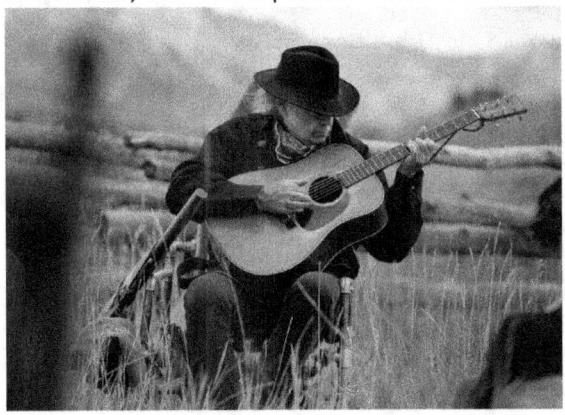

WHY IT WON'T MAKE THE LIST: This odd little film would conceivably make the cut (albeit waaay down the list) if it weren't for the fact that, mid-way through, it becomes a Neil Young concert movie for about ten minutes. During the narrative bit, though, performer Neil Young and director Daryl Hannah (yes, *that* Daryl Hannah) have assembled a passable bit of amateurish art-house and strangely compelling "W.T.F." meanderishness that's not without its charm.

COMMENTS: What do you get when you combine a legendary country star, an environmental activist director kicking around, and down-time? *Paradox* is one possible answer. Neil Young, in his 21st acting role, narrates and stars in this 60 + 15-minute[6] diversion, bringing along with him a couple of scions in Willie Nelson

[6]The "movie" itself is about an hour; unlike many people who might watch this, I could have done without the concert interlude lifted from Young's 2016 tour.

and other outlandishly talented musicians who, after all is said and done, make a decent fist of playing post-apocalyptic versions of themselves.

Daryl Hannah makes full use of every camera filter at her disposal and every little bit of editing trickery to render, visually, what might have once existed as a campfire tall-tale. Random shots of animals create an ambience that is both cute and natural, as well provide the occasional "What the...?" moment. (One shot with a very quizzical-looking deer seemingly watching over the action is particularly effective.) Our lads, of all ages, burn time talking, gambling, and digging up trash-treasure while waiting around for the "Gray Eagle": a bus full of women who, in *Paradox*'s loose narrative, are the Earth's stewards. And Neil Young looks cryptic. Then he wanders the land toting a rifle. Then he plays his guitar. Then he looks like he might partake in a quick-draw with Willie Nelson. You get the picture.

Stripped of its concert footage center, *Paradox* would have made a nice little entry in one of 366's appendices. But as this brief review has remarked, it's nothing more than the sum of its circumstances: Neil Young and company with a few days to kill, Daryl Hannah with a movie camera and time to spare, and an impromptu feel derived from the director's "one take" methodology. Lives will not be changed (though the occasional preachiness of *Paradox* suggests they wouldn't mind if they were), but the world isn't worse off for having this odd little digression into music, philosophy, allegory, and black hats.

Available exclusively on Netflix (at least for the time being).—Giles Edwards

Relaxer (2018) ★★★★

DIRECTED BY: Joel Potrykus

FEATURING: Joshua Burge, David Dastmalchian, Andre Hyland, Arin Bechdel, Amari Cheatom

PLOT: Abbie is a perennial failure at life, but he makes one final attempt to turn things around by accepting his brother's challenge to beat the unbeatable Pac-Man score, all while never moving from his seat on the couch.

WHY IT MIGHT MAKE THE LIST: Starting with a "gallon challenge" and ending not-quite-apocalyptically, the ordeals of a seated young man unspool without him ever leaving the couch, nor us ever leaving the room. All the thirst, sweat, and odors pile up as our entrapment goes on. And on. And on. Until something cosmically mystical occurs.

COMMENTS: It seems almost a rule that the most mild-mannered directors are the ones that come up with the most eccentric movies. Peter Greenaway has his very British affability; David Lynch has been a Midwestern swell-guy since childhood; and now there's rising star Joel Potrykus with his laid-back hipster self, who is somehow responsible for the giddily grinding post-slacker comedy, *Relaxer*. "Gross-out comedy," now that's a genre I'm familiar with. But a "charming gross-out transcendental comedy"? I can only presume that *Relaxer* is the first of that ground-breaking genre.

Oh my dear Abbie (Joshua Burge). We only ever see him covered with sweat (and more) cowering on a couch. From the start, he's enduring a sickening challenge, one of many put to him by his brother, which soon becomes *literally* sickening. The boy fails to keep the gallon of milk he's consumed inside after a... well, best not say what he added to the mix in a bit of bathroom desperation. His brother Cam (a wonderfully nasty David Dastmalchian) leaves in disgust, but not before giving Abbie one last ultimate challenge: the Pac-Man thing. The impossible perfect score Pac-Man thing. Abbie

cannot—and does not—leave his greasy spot on the leather couch during a six month ordeal in which things grow as strange as they grow unhygienic.

Among the venerable sources Potrykus hijacks ideas from are Buñuel, Kubrick, and, I swear, even the New Testament. The first is obvious, and the director even admitted to ripping off a lot of *The Exterminating Angel* in his remarks to the audience after the screening. Unlike our heroes therein, however, Abbie makes the wrong choice of what pipe to burst open for water—wonderfully fusing gross-out with the surrealism. *2001: A Space Odyssey* necessarily comes to mind toward the end, as Abbie breaks the sequence and rises to a higher plane as the masses outside seemingly cheer him on. As for the third reference, I'm possibly stretching things, but over his ordeal Abbie grows to look like a shaggy Jesus, and Simon of Cyrene makes a cameo in the form of Arin (Adina Howard), a friend who helps Abbie on his path toward the divine. What locked it for me was the final scene when Abbie-Jesus seemingly rises from the dead to be greeted by his long-sought Father.

Potrykus stated without shame that he made *Relaxer* for himself, but its elements suggest that this bizarre slice of late '90s throwback might reach more than expected. There's comedy, there's cinematic dexterity (the camera stretches to most every available piece of the room without looking like it's trying too hard), and even an epic feel to Abbie's journey from Novice couch potato to Master couch potato. Skipping surreptitiously from *Clerks*-style comedy to an outer-zone of awareness, *Relaxer* reaches for the impossible—typically with the aid of a grabber-arm.—Giles Edwards

The Man Behind the Couch – An Interview with Joel Potrykus

A lazy man with a movie-making mission, Joel Potrykus continues to tap the deep creative vein of Grand Rapids, MI with his fourth feature, *Relaxer*. We sat down together in Montreal during the Fantasia Film Festival.

366: I'm here with Joel Potrykus whose movie *Relaxer* debuted at Fantasia to much laughter and applause. I'll admit from the get-go that I'm not well prepared, so if you're feeling chatty about anything, feel free to continue talking at me.

JP: I'm never prepared, so we're on the same page.

366: Then I'll start with an easy question: other than the promise of fame and riches, what was it that got you into filmmaking?

JP: Shoot, well, it was really all about the fame and riches… I was a "VHS kid," and there was one summer, when I was ten, I broke my leg playing baseball, so I had to spend the whole summer in a cast up to my hip in the basement. It was so hot, and nothing to do, and we didn't have cable in the basement, so my dad would bring me five movies every day from the video store, whatever he picked, so I just spent a whole summer watching, like, two-hundred movies. And in there was *American Werewolf in London*, and that kind of changed a lot of things for me. Seeing that kind of blend of horror and comedy, and [director John] Landis going whatever direction he wanted.

Then when I was fourteen, I was really into the Doors, and I was at a birthday party where they rented that movie and Val Kilmer's at the beach saying, "Yeah, I'm going to film school right now!" When I was fourteen, I had never heard those two words connected to each-other: film school. And I was like, "That's where I'm going to go."

366: You're from Grand Rapids, Michigan. Do you have much to recommend about that part of the world?

JP: Yeah, dude, if you want to make a feature film, and don't want to spend a lot of money for permits, and asking the police if it's okay to close off the street, go to Grand Rapids, Michigan. We still make the movies there because it's really the only place... I have a manager in LA, and he's like, "What are you doing? Come to LA and direct TV, and pitch your big ideas..." So I guess maybe it's not fame and fortune I was ever after, because then I'd be out in LA. But I prefer to just hide out in Grand Rapids, that's the only place I know how to make films.

366: Well, maybe the fame and fortune will hunt you down. Your L.A. rep said you had big ideas to pitch. What are your big ideas?

JP: In my head they're big ideas, but I was recently tracked down by Amazon and I pitched the ideas, and I don't think they were very big. They're weird and small. [Amazon had] a specific budget range they need to hit, and it was ten-million dollars. I had no idea how to spend ten-million dollars, so I said "I could do this movie for two-hundred thousand..." And it seemed odd to me. They know I could make this movie that would look like it was made for ten million, maybe, like, five-hundred thousand—squeeze that dollar a lot further. I think there's so much waste in film-making that we just assume that ten-million equates to *A Good Movie People Will Like*. I just don't have that math. I'll make one-hundred movies for ten-million.

366: Influences?

JP: Jim Jarmusch. Then later I got into guys like Michael Haneke, and his long takes. Lindsay Anderson... *O Lucky Man!* Man, that movie is just... no rules. It goes everywhere. And then this guy, Alan Clarke, who did *Made in Britain* and *Scum*. [In *Made in Britain*] Tim Roth is this angry skin-head. Just totally nihilistic. With those movies, it's just cheap, angry, raw; that stuff really got me going.

366: Swinging toward *Relaxer* in particular, there was that 1999 Pac-Man challenge from Billy Mitchell. Now, before that came to your attention did you have an idea for this kind of story?

JP: No, not really. Now the seed of the story—because I really am a lazy film-maker—I just like to make it easier on myself, so the idea of shooting in one space, controlling the light, was really what I wanted to do. I was called by a distributor friend of mine who said, I have a bunch of money from a European company that wants to make series of features about the seven deadly sins. Which I thought was a really stupid idea, like schlock—straight for TV. But he said, you can pick the sin. So I immediately thought of "sloth." Like, what is the most lazy—a guy who literally spends the whole movie on the couch. That's kind of where that started. That was all I had. No video games. I didn't know what he was gonna do; maybe at one point, he was going to turn into the couch, just melt into it. And what would you be doing the whole time there? I was thinking video game. Video game. Video game.

And it just kind of went from there. I don't know why the whole "Y-2K" thing played into it; maybe I just wanted to deal with Y-2K because there aren't enough movies that do that. I think it's a really weird, fascinating thing.

366: I imagine we're similar in age, because I also remember the Y-2K thing.

JP: It was scary, man, for a while. It was crazy. My parents, they were like, "This is it! This is the end of the times that your grandparents always talk about! The Bible's predicted it." The computers were in control of the power-grid, and so everything — communication — was

going to collapse. Flights, traffic. In my head, it was going to be beautiful.

366: Now, the "challenges" thing that's the foundation of the movie: is that drawn from your own experiences?

JP: Yeah, we used to do—it's one of the special features on the DVD—there'd be, like, ten people, and we'd all show up with a gallon of milk, and everybody would throw five-dollars into a bucket, and someone would regulate, say, three minutes per glass, and the last person to throw up would get the pot. So we have a video, and I'm the second guy to go. The last guy to go was amazing: a total rush of milk, literally a whole gallon coming out of him, just blasting and blasting.

366: Joshua Burge, the lead actor, you've worked with him quite a bit. Have you known him a *very* long time, or just professionally?

JP: We actually went to college together, he's a musician. He was the guy who was at the coffee shop playing acoustic guitar and he kind of had Bob Dylan "rap," that was his thing. Turtleneck, this blazer, and a harmonica around his neck, and he was kind of in his own time and place and he did not fit in on a college campus when he was our age. And we ran into each-other once in a while. He formed a band, and I was a big fan of his band. Watching him on stage... on stage, he's a very charismatic performer, always shucking around and doing Motown moves up there. Pretty wild. And I thought, I'd love to put that—whatever he's got—in front of a camera, there might be a movie there.

The first movie we shot, "Coyote", was in Super-8, and I intentionally shot it with no dialogue because I didn't know if he could act. I just wanted to capture his physicality. And he kind of turned out to be the Bruce Campbell I'd always been looking for. He's my go-to guy, and lives in Grand Rapids still, and he's just, like, a friend. Making movies with friends. He's somebody who gets what I'm going for, and I get what he's going for.

366: Considering how he comes across in *Relaxer*, it's sort of difficult to imagine him the way you describe him.

JP: Yeah, there are videos of him online that I've shot—he's a wild character. Like Tom Waits, tearing the place up. "Chance Jones", that's the name of the band. They play once in a while. Our production designer, Mike, is the keyboard player. It's a small world in Grand Rapids.

366: Now the actor who plays the brother, Cam, is an "outsider". Was there anyone else you didn't...?

JP: That's David Dastmalchian... He's in *Ant-Man*, he's in *Blade Runner*. And I met him at SXSW, and I went to see him in *Animals*, and I thought, "That's the dude! That's Joker's henchman!" And as soon as I saw him, I said that's a guy that's got something that I want to work with. He's kind of similar to Josh, they have this unique face... But anyway, I walked up to him at SXSW and said, "I gotta make a movie with you one day"; he said, "I just saw *Buzzard*, I gotta make a movie with *you*, too." So from there we started talking and figuring things out. Once I got the idea for the brother in [*Relaxer*], he was the obvious choice.

And Andre Hyland, who played the character Dallas, he made a short film, "Funnel," that played before *Buzzard*, and I saw that guy and thought, that guy knows my world, that guy will get it. He's an improv artist and he just riffs like crazy. And he's a perfect fit for the movie.

366: It looks like we're getting to the close of this, but there's one question I like to pose to film-makers when I can, a final one: is there a home-town restaurant you could recommend?

JP: "Yester-Dog". The hot-dog place that *American Pie* called "Yester-Years." The writer from that is from Grand Rapids, so it's all secretly taking place in Grand Rapids though they had to change the names of everything. I don't eat meat any more, but if I do go back, if Y2K happens and I start eating meat again, I'm going to "Yester-Dog".

366: Well thank you very kindly for your recommendation and your time, Joel, it was a pleasure speaking with you.

JP: Thank you!

Rondo (2018) ★★★★1/2

DIRECTED BY: Drew Barnhardt

FEATURING: Luke Sorge, Brenna Otts, Reggie De Morton, Gena Shaw, Steve Van Beckum

PLOT: Paul has been dishonorably discharged from the military and relies on his sister's hospitality for a couch to crash on; when she recommends a therapist to help him with PTSD and alcohol addiction, he encounters a sordid world where revenge and unhealthy fantasy experiences can be bought for the right price.

WHY IT SHOULD MAKE THE LIST: *Rondo* unapologetically wrings the viewer through a stylized world of mannerist camerawork, Edward Hopper-esque lighting, gratuitous violence, and a purposely intrusive soundtrack. It plays like a bare bones revenge murder fest spiked with dubstep Greenaway.

COMMENTS: Even before its international premiere, *Rondo* was creating mumblings among reviewers who had seen it in the screening room. At the debut, the normally raucous Friday night crowd was uncharacteristically quiet in the theater. Then *Rondo* unleashed its singular form of magic. I was impressed at not only its vitality, violence, and humor, but also its incredible audacity. The director, Drew Barnhardt, started this project with the intention of making, without compromise, the movie he wanted to make. He succeeded spectacularly.

Rondo begins as the story of Paul (Luke Sorge), a young man dishonorably discharged from the army and shattered by PTSD. His daily life consists of drinking whiskey and lying on his sister's couch. Troubled by her brother's depression, his sister Jill (Brenna Otts) recommends a therapist who herself recommends that Paul should explore Denver's fetish scene. Provided with an address and a password, Paul visits an opulent apartment building in which he encounters two others who have been solicited for having intercourse with a doped-up businessman's wife. But don't worry, the role-playing and strange demands are all "part of the fun," insists Lurdell (Reggie De Morton), in a speech teaming with ominous guide-lines ("keep it on the plastic.") Paul has a cigarette out on the balcony while waiting his turn, looking inside at where the action is taking place. His bad habit ends up saving his life.

Rondo relies heavily on two non-diegetic sound techniques to keep the viewer detached from the goings-on. The first is an advertently intrusive hardcore electro-trance soundtrack that acts as a dissonant counterpoint to much of the on-screen action. Brooding scenes are imbued with a strange, unsettling energy with each musical cue; I could easily imagine *Rondo* slipping into melodrama otherwise. Narration also spikes the proceedings. With an officiousness of tone to compete with Colin Cantlie in *The Falls*, Steve Van Beckum simultaneously clarifies and

undercuts the narrative flow, adding another barrier between the audience and the action. Whenever his radio-style voice courses from the speakers, it purposely reminds us that *Rondo* is a movie, while at the same time anchoring us to the movie's world.

And that's just the sound. Stylistically, much of *Rondo* works like Peter Greenaway at his most formalistic. Scenes are designed more like paintings than real life. That's not to say that the action is missing, but more that Barnhardt knows what he wants us to look at, and goes to great lengths to make us do so. I mentioned Hopper earlier, and the candy-noir of his paintings springs up again and again. Then there's the story itself. Narrative twists are a convention for many of the movies we review; *Rondo*'s take is more of a narrative convulsion. Ultimately, the finale is the one that we necessarily had to reach, but the path there is like having our arm twisted behind our back (but, paradoxically, pleasantly so). In *Rondo*, baroque verbiage and baroque violence come together in a celebration of blood-sodden deadpan.—Giles Edwards

Snowflake [*Schneeflöckchen*] (2017) ★★★★★

DIRECTED BY: Adolfo J. Kolmerer

FEATURING: Reza Brojerdi, Erkan Acar, Xenia Assenza, David Masterson, Judith Hoersch, Alexander Schubert, David Gant

PLOT: In near-future Berlin, Javid and Tan find their fate preordained by a dentist's ever-changing movie script as they pursue vengeance for their family's deaths while in turn being pursued by hit men hired by the daughter of two bystanders they murdered while on their quest.

WHY IT MIGHT MAKE THE LIST: Imagine, if you will, the cross-section where *Delirious* and *Fight Club* meet *Adaptation* as an action-revenge-comedy littered with comic book energy and political commentary presented through the lens of a German director of commercials. *Snowflake* definitely has the chops to join its pals, even if the numbers game forces us to pass it over for the *official* 366 tally.

COMMENTS: I admittedly "like to like" movies; however, I generally don't like gushing about much of anything. That said, I beg your forgiveness if I fall into hagiographical tones over the next few paragraphs, as I have not been this much blown away by a movie for quite some time. Adolfo Kolmerer's feature debut, *Snowflake*, not only defies succinct description (other than strings of superlatives), it would perhaps defy logic if it weren't so expertly

crafted by the screenwriter and so deftly presented by the director.

Snowflake's story concerns a series of interlocking revenge-focused stories. Javid (Reza Brojerdi) and Tan (Erkan Acar) are two long-time friends whose families died during a fire, possibly lit on purpose by xenophobic forces in a close-to-now, chaotic Berlin. Eliana (Xenia Assenza) seeks vengeance on these men for having murdered her parents in a kebab restaurant. Eliana's bodyguard Carson (David Masterson) reluctantly agrees to introduce her to his estranged father (David Gant), who had been locked away for his homicidal-messianic tendencies, to help line up a string of unhinged murderers. Javid and Tan's troubles are compounded when they discover that all their actions—indeed, everyone's—seem to be determined by a dentist (Alexander Schubert) who dabbles in screenwriting. Hovering in the background is a vigilante superhero, a guardian angel nightclub singer, and a rather nasty bunch of neo-fascists aiming to stage a comeback.

Snowflake definitely has its own "feel", while at the same time it tips its hat to its predecessors. Tarantino, obviously; he seems to be credited now with influencing all manner of roaming-narrative crime movies. Charlie Kaufman, too; the dentist-cum-puppet-master not only directs the action from his laptop, but in several sticky situations finds that his characters have tracked him down to make demands. (This leads to a number of the film's funny moments, such as when Tan demands of him, "Think of us as the producers and you as the screenwriter. We give you an idea, and you have to make it work, no matter how stupid it is.") *Snowflake*'s political tones unfold slowly, beginning with some seemingly incongruous footage of an interview with an ex-police commissioner expounding on his nationalist ideas, and ending with the discovery of a hidden training facility for just-about-Nazi super-soldiers.

Ultimately, *Snowflake* stands as its own movie. Using a bold style while slavishly following scripted narrative logic, Kolmerer continued to amaze me at every twist and turn. I was so engrossed during the on-screen action in one scene that I had actually totally forgotten the "artificiality" of the whole narrative construct. By the film's end I was left with a pleasantly extreme feeling of frisson, and perhaps even a shortness of breath. In order to keep myself brief, there are countless things I haven't been able to touch upon. But I ask you to take my word for it that *Snowflake* is as beautiful and unique as its namesake, as well as a Damn sight more hilarious than a crystal of frozen water.—Giles Edwards

Crystalline Structures: Director Adolfo J. Kolmerer on *Snowflake*

Snowflake director Adolfo J. Kolmerer was kind enough to answer a few questions submitted by 366 Weird Movies staff via email.

366: William James is credited as "guest director" ("gast-regie"). What was his role in the production?

AK: William James is not only the guest director, he is one of the editors and the creator of Hyper Electro Man[7]. William is one of my closest friends and collaborators, we have been working together for a long time. He wanted to do Hyper Electro Man as a short film and direct it. We decided to put the storyline in the film and I asked him to direct it.

366: *Snowflake* was made independently on a very low budget— how did you convince so many people to work without immediate pay?

[7] The superhero character in the film.

AK: I think we convinced them with the crazy ideas the script was offering. I promised them that I would finish the film, that it will be remarkable and different. It was a lot of energy that we invested into convincing people to help us not only the ones in front of the camera, I'm happy that at the end everyone is happy with the result and they are proud of being part of this unique and mostly wild ride.

366: Did your previous work in making commercials influence *Snowflake*? Commercial directors are often obliged to make a small budget look big.

AK: Well, what we spent in *Snowflake* is a quarter of the budget of a normal commercial, but yes, that's something important that I learned while doing commercials, which is to find a way, always! To work under massive pressure and stay focused. Of course shooting a film is a different job but I think it helps a lot to have experience in both.

366: With so many characters, who do you see as the primary protagonist of the story (if there is one)?

AK: I developed a different kind of love for everyone, but the primary are TAN, JAVID, ELIANA and CARSON.

366: Is Hauke (synonym for "warrior") Winter based on anyone in particular, or just representative of the rising fringe in German politics?

AK: Hauke is based in Populism, the men of power that disguise themselves as victims of the system to get to power (Left and Right wing). It is very sad to see what is happening in the world right now. No continent is safe from their own Hauke.

366: Did you know screenwriter Arend Remmers before beginning this project? How did the script come to you?

AK: I was involved on the project since the beginning, the writer Arend Remmers is one of my best friends. *Snowflake* was born out of frustration because of failed past projects, that never got done because of financing and producers trying to make our stories more conventional, so Arend and I decided to do a bonkers film and break the rules, but only under one condition: we have to do it ourselves together with our friends, so we don't have to compromise, that meant no fancy production companies or any budget. We have known each other for 8 years now, we worked together in many small projects before *Snowflake*. Now Arend is one of the most brilliant writers in Germany, he is not afraid of breaking rules and changing the form, which I love. I am like that too, so we work together very well! We are like brothers, we respect each other's opinions and share the same film DNA.

366: Why was "dentist" the day job for the in-movie screenwriter?

AK: Because a friend of ours is a dentist and said "you can shoot here." Everything in the movie is based on Robert Rodriguez's rule: "Use what you have."

366: How did you go about casting someone to portray a character with the real name of the actual screenwriter?

AK: Alexander Schubert, who plays Arend Remmers, is a friend of ours. I remember we pitched him his character and what he does and he was very excited. When we told him that his name is Arend he went crazy and started laughing. He took the job on the spot, ha.

366: Did you consider a cameo role for the real Arend Remmers?

AK: No, ha, my Arend is too shy, it would give me a headache to direct him.

Suspiria (2018) ★★★★

DIRECTED BY: Luca Guadagnino

FEATURING: Dakota Johnson, Tilda Swinton, Mia Goth

PLOT: A coven of witches in Berlin in 1977 run a modern dance troupe.

WHY IT WON'T MAKE THE LIST: There's only room for one *Suspiria* on the List. That doesn't mean you want to pass on this very different, and slightly weird, remake, however, if for no other reason than to see the classic story reimagined in a dramatically different style.

COMMENTS: *Suspiria* (2018) keeps the title, the notion of a coven of dancing witches, and some of the character names from Dario Argento's Expressionist giallo classic—and that's about it. Director Luca Guadagnino spent his capital from the Oscar-nominated *Call Me by Your Name* on an unlikely remake of a 1970s cult Italian horror film. That was a strange enough choice, but then

he promised to give us a *Suspiria* as it might have been made by Rainer Fassbinder. So, where the first film was an Expressionist fairy tale, the update becomes a character-driven drama. The innocent young ballet students of the original are now professional adult dancers. The characters now have elaborate backstories: Susie is a refugee from a repressive Mennonite upbringing, while the psychiatrist, previously a minor character, is now is the secondary protagonist, an old man haunted by his country's Nazi past. The witches themselves are more detailed, with Tilda Swinton's ghostly Madame Blanc a major presence, and the script even delves into internal coven politics. The story is set in "a divided Berlin" in 1977 (the year of *Suspiria*'s release), with the Cold War and the German Autumn terror campaigns playing in the background. And the feminist script even makes a shout out to the #metoo movement when the witches chastise the psychiatrist for "not believing" women.

The original was a largely plotless, irrational spook show; there is, if anything, too much plot in the remake. It's not entirely clear how all of the themes, both personal and political, are intended to connect, but puzzling them out is one of the film's pleasures. The many subplots make for a horror film that's overlong at two-and-a-half hours, but when it's at its best, it has moments of witchy intensity that match Argento. An early cringer sees a dancer mutilated in a mirrored room as she's telekinetically jerked about. The witches send nightmares full of worms and organs to plague Susie. The performance of the postmodern "Volk," with the dancers draped in blood-red ropes and a pentagram nonchalantly taped to the floor, is a stunner. And the climax, when the coven finally unleashes the ritual they have been building to, is full of spouting blood, nude contortionists, and diabolical betrayals—it's well worth the wait. It won't displace Argento's masterpiece in horror fans' hearts, but at least this arty take on *Suspiria* shows the proper way to do a remake—take themes from the original and refashion them into something stylistically new.

I believe this is one of the rare movies to fail the reverse-Bechdel test: there is no moment where two men have a conversation that is not about a woman.

The Jessica Harper cameo you assumed would be here is indeed here. Dakota Johnson, previously known as the *Shades of Grey* chick, suggests that she can be a serious actress. Tilda Swinton deserves some Best Supporting Actress chatter for her performance, but it's a long shot; Best Makeup has a better chance at a nom.—Gregory J. Smalley

"Tokyo Vampire Hotel" ★★★1/2

DIRECTED BY: Sion Sono

FEATURING: Ami Tomite, Kaho, Shinnosuke Mitsushima, Megumi Kagurazaka

PLOT: A clan of vampires captures a group of humans in their hotel fortress, planning to turn them into a generational food supply; however, their enemies have birthed an avenger during a cosmic convergence, and the final battle between the two warring forces is at hand.

WHY IT WON'T MAKE THE LIST: *Tokyo Vampire Hotel* is built upon a foundation of gore and slapstick with bold production design, but the story works better at a character level than in its showier elements.

COMMENTS: Sion Sono's take on the vampire legend has a lot going on. After opening with a violent chase straight out of an 80s Hollywood action movie, *Tokyo Vampire Hotel* quickly fractures into a character study of two heroines:

Manami, an orphan raised to vanquish an entire race of vampires, and K, the underground defender whose unrequited love is co-opted for the violent means of others. Their tales are set against the backdrop of the candy-colored, blood-drenched world of the titular hotel, populated by eccentric characters that include a vampire princess who keeps shrinking into nothingness, a dreadlocked hepcat whose father sold him to the vampires as a baby in exchange for becoming Japan's prime minister, and a maternal figure who may be housing the entire hotel within her nether regions. Add a ballroom of lovelorn humans, a hippie Romanian cult connected to Tokyo by tunnel, and a late-series time jump that almost completely restarts the story, and the effect is downright dizzying. It's legitimately weird, but after a while becomes the Mad Lib kind of weird: oddness via dissonance.

Which only makes it all the more astonishing that Sono later carved this 400-minute epic into a feature-length version of his tale. While the complex story and the deep characterization make it inconceivable that you could cut into the body without harming the patient, there is also much that cries out to be trimmed. The story fleshes out an otherwise incomprehensible battle of outré characterizations, but the full-length *Tokyo Vampire Hotel* remains a flabby affair, especially considering the many story elements that aren't explored at all.

There's a lot to like in *Tokyo Vampire Hotel*, led by Kaho, who is riveting in the role of K. Tightly wound but deeply emotional, she gets many chances to be awesome, culminating in a brilliant fight scene where she takes out a battalion of vampires in a hotel hallway. The visuals are consistently compelling, whether the colors are eye-popping or drained out. And that insanely catchy theme song by tricot sums up the whole series' mood in a tight minute.

But in the end, it's kind of a mess. Sono is awash in storylines, but unable to commit to the 2 or 3 that are most alluring. He told *The Japan Times* that his Amazon overlords gave him a lot of freedom. "There are a lot of things you can't do on television, but (with this series) it's totally different… they weren't very strict with their rules." He took that opportunity and ran wild with it, and the result is unequivocally unusual and fascinating. But maybe with a couple more rules, it could have been great.—Shane Wilson

Under the Silver Lake (2018) ★★★★★

DIRECTED BY: David Robert Mitchell

FEATURING: Andrew Garfield, Riley Keough, Patrick Fischler, Jimmi Simpson, David Yow, Jeremy Bobb

PLOT: Doc Sportello's grand-son, Sam, is going to be — wait, no. Disheveled loafer Sam is going to be kicked out of his apartment in five days for (criminally overdue) back-rent. Instead of fixing his domestic problem, he becomes embroiled in perhaps the biggest cover-up that has ever bamboozled the Golden State.

WHY IT MIGHT MAKE THE LIST: A serial dog murderer, a conspiracist 'zine drawn to life, a map in a box of "Space Nuggets," Jesus and the Brides of Dracula, palatial tombs, the Owl Woman, symbolic Chess moves, the Homeless King, and a mysterious Songwriter all come crashing down on a shiftless 30-something loser with a knack for crypticism. Barking women, *Purgatory* parties, and one bad cookie lock *Under the Silver Lake* into a realm of supreme strangeness reminiscent of that beach dream you had after reading Pynchon.

COMMENTS: Call it poor form of me, but I felt obliged to skip a second screening to hustle back and write about David Mitchell's newest film. During the movie, variations on what to call it skipped around my brain, but ultimately I reckoned that *Inherent Goonies* best encapsulates the mood. This bizarre crime drama on barbiturates; this ambling post-Slacker comedy; this magnificent quest—somehow the director weds the listless protagonist with the adolescent adventure-stylings of "The Hardy Boys." Jammed throughout are enough threads to sew yourself a nice cardigan to protect you from the sun while you're strolling through the over-baked landscape of sorta-now-ish California.

Perched on his apartment's balcony, Sam (Andrew Garfield) has a good view of his attractive older neighbor—a constantly topless bird fancier. Suddenly, a young beauty (Riley Keough) with a dog and a boombox catches his eye. They meet, they get high together, and then she disappears mysteriously in the middle of the night. Quietly curious and uncannily focused, Sam pursues the mystery at his own ambling pace, encountering an underground 'zine artist (Patrick Fischler) who sets him on the right path and a coterie of über-hipster musicians whose songs are encoded with secret messages, before meeting the benevolent Homeless King (David Yow) by the grave of James Dean. What follows is an odyssey of unpleasant discovery as Sam finds that, for the rich, the world is a *very* different kind of place than it is for everyone else.

I've already hinted at the *Inherent Vice* connections, and even if it were only Andrew Garfield's Joaquin Phoenix-channeling performance, *Under the Silver Lake* would still be an odd duck. But David Mitchell keeps shoveling on more ducks at every turn. I don't know where else I'd find cryptography and Hollywood history so intertwined. I don't know where else I'd find the Purgatory club—the kind of place where you might hang out between the Black and White Lodges. And I don't know where else California's bright lights and beautiful people could find themselves crashing so violently into luxuriant subterranean twilight. Mitchell even drops some suggestions that Sam could be a burnt-out, alternate time-line Peter Parker.

Fortunately for us, our knight-errant keeps it together on his perilous mission seeking the maiden fair. The movie is epic in length and epic in scope, unveiling new side roads for Sam to shuffle along: sometimes in jeans, sometimes in pajamas. When an ultimate truth is discovered, Mitchell isn't satisfied, and somehow manages to unveil an even ultimater truth. For reasons beyond my understanding, *Under the Silver Lake* was poorly received at Cannes. Perhaps it's just not their kind of movie. Thank the heavens above for the Fantasia Film Festival: Mitchell's latest effort found just the right kind of people there. With *Under the Silver Lake*, we fly very close to the sun; but unlike Icarus, we manage to crash comfortably on to our hot neighbor's bed.—Giles Edwards

Violence Voyager (2018) ★★1/2

DIRECTED BY: Ujicha

FEATURING: Voices of Saki Fujita, Shigeo Takahashi, Naoki Tanaka, Naoki, Aoi Yûki

PLOT: Two young friends investigate a mysterious adventure park, only to find that the owner wants them for some icky science.

WHY IT MIGHT MAKE THE LIST: The cartoon style is singularly discombobulating. Unlike more typical examples (whether drawn or computer generated), the movie's "animation" is more akin to a picture book with pop-ups and pull-tabs, with occasional doses of squirted liquids and a couple of fiery scenes. Then there's the story, pulled out from some terrible organic-horror closet, in which the young "park" visitors face violence and mutations that were made more distressing by the cardboard cut-outs that they're made up of.

COMMENTS: My right-hand neighbor was at a loss for words after the screening; my left-hand neighbor wanted to confirm just what it was he had seen. Me, I spent the better part of *Violence Voyager* with what a quirky-quizzical expression. Ujicha's "cartoon" is something that, somewhere inside my mind, I enjoyed, while at the same time leaving me at a total loss as to whom I might possibly recommend it.

Bobby and Akkun are school chums who have a penchant for adventuring in the woods and mountains near their small Japanese village. Bobby, whose father is American, is out-going, eager to help, and always curious; Akkun is a local lad who might otherwise be a loner, and is quite loyal to Bobby. When the two come across a theme park—the titular "Violence Voyager"—Bobby is keen and Akkun is apprehensive. They are given an orientation video and suit up for what is pitched as a harmless adventure. But some way into their escapade, they encounter an unconscious girl, who upon awakening tells them she's been stuck in the park for days. Further exploration leads them to a "Robot Graveyard" and *other* children. Eventually, a bird-beaked cyborg (?) creature subdues them and they are dragged to a subterranean lab.

It took some getting used to, but eventually the moving cardboard pseudo-animation seemed somehow real. It's akin to how an imaginative child looking at story-book pictures might see them move. So there's this simplicity and innocence established at the beginning, but then things start going Horribly Wrong. Disintegrating paper kids, icky ooze guns, and perhaps the most disgusting "mother" character I've ever seen utterly warp the naïve sentiments embodied in the visual style. Further hitting the viewer upside the head is the never-say-die chirpiness of Bobby, who is unflinching when faced with the array of mad scientist evil, robot-boy creepiness, and, again, whatever the heck that "mother" thing is supposed to be. As a bonus, the narrator intones at the end that Bobby's struggles are just beginning, before assuring him, "Be strong, Bobby! You can do it, Bobby!"

Then the credits began to roll and I took at peek at my neighbors. Ultimately, the question has to be asked, did this work as a movie? Somehow, it did. However, the follow-up question is a tougher one: is this a movie that deserves to be seen? For that, I'm at a loss. Obviously I've seen it, and others have. There was even laughter at the numerous, strangely comical bits. And it's apparent a lot of work, thought, and artistry went into it. I mentioned earlier that I couldn't think of anyone that I might recommend *Violence Voyager* to; there is one fellow, but he's an odd one. So to anyone who feels that she or he might be an odd one, I dedicate this review and say: "Go ahead. Give it a look. (I practically dare you.)"—Giles Edwards

The Wild Boys [Les garçons sauvages] ★★★

DIRECTED BY: Bertrand Mandico

FEATURING: Anaël Snoek, Sam Louwyck, Vimala Pons, Elina Löwensohn, Lola Créton

PLOT: After raping and accidentally murdering their literature teacher, five miscreant boys are sent to sea for discipline, under the supervision of a flinty captain.

WHY IT MIGHT MAKE THE LIST: *The Wilds Boys* is, in many ways, easy to dismiss as pretentious French arthouse fare. That said, it's an occasionally unnerving bit of cinema that hovers strangely between too little coherency and too much exposition while maintaining a fearlessness that would be hard to find Stateside.

COMMENTS: To get a feel for the nature of this beast, it may be worth noting that this movie disappeared from Amazon Prime's video library after I had added it to my watch list. iTunes proved itself the braver host, however, and I watched Mandico's feature debut on my desktop instead of my widescreen television. That might have been for the best, as it created an intimacy that would have been lacking otherwise. And if nothing else, *The Wild Boys* is a very intimate movie—teeming with claustrophobia, dreamy violence, grit, and trans-female/trans-feminist sermonizing.

Five upper class boys get drunk, rape, and inadvertently murder their literature teacher, perhaps at the behest of "Trevor", a sequin-bejeweled god-demon they all fear. During a dreamy trial, replete with a space-Expressionist prosecutor, cosmic background, and two near-nude man pillars, each lad provides unconvincing, doctored testimony. They are convicted, but kept at their respective estates until a suitable punishment can be determined.

Enter the captain: gruff, bearded, and severe. With a young woman and a younger man on a rope in his entourage, he explains to the boys' assembled parents that he has a fail-safe method for fixing their sons' defiant, cruel, and rape-y behavior. He cannot, however, guarantee that all the boys will survive. Despite this, the parents approve of the plan, and the boys are sent off to sea. As warned, the boys do not survive their ordeal—as boys.

The film's disorienting nature is on display right at the beginning: a wild boy, a self-inflicted head wound, Aleksey German-style camera, and lustful sailors. The dark fairy tale feel is augmented by the largely black and white photography and the choice of rounding the edges of our field of vision throughout. There is visual chaos, most troublingly during the rape scene. This violation looks like it could have come from straight from a nightmare—and immediately explains why *The Wild Boys* is unrated. Hereabouts, it would have gotten at least an "X" rating. (I was prompted to wonder, "Can showing teenage boys with erections be child pornography even if the boys are played by of-age women with realistic prosthetics?")

The director's choice to veer into the direction he does—that, were the world populated exclusively by women, there'd be much less violence—is a little hackneyed. But at the same time he seems to undermine this thesis by depicting the murder of innocent sailors at the hands of "converts." Mandico's film is still worth a view for the curious, as it is unlike any other dissection of these issues I've seen. As for its straight-up weird cred, here are some things to which I bore witness: captain's map-tattooed member; open-faced uterus gun holster; cactus ambrosia-jizz plant. Yep.—Giles Edwards

"World of Tomorrow Episode Two: The Burden of Other People's Thoughts" (2017) ★★★★

DIRECTED BY: Don Hertzfeldt

FEATURING: Voices of Julia Pott, Winona Mae

PLOT: "Episode Two" picks up some time after the events of the first film, with a previously unmentioned spare Emily clone seeking out the original Emily Prime: this "back-up copy," distinguished only by a 6 on her forehead, travels back through time to capture Emily Prime's memories, as she will never receive third generation Emily's memories due to the Earth having exploded, thus destroying Emily's bloodline...

WHY IT WON'T MAKE THE LIST: The original "World of Tomorrow" remains a long shot due to its short running length, and this sequel only improves on that aspect by about five minutes. It is equal, but not superior, to the quality of the first episode, and as a result will not be a List contender.

COMMENTS: "World of Tomorrow" arose from audio recordings of Don Hertzfeldt's niece, Winona Mae, then four years old, rearranged to form a script. The recordings for this sequel were made when WInona was five, and Hertzfeldt found the dialogue more difficult to sculpt: "It turns out that writing a story around the unscripted audio of a four-year-old is pretty easy compared to writing around the unscripted audio of a five-year-old. Where once I had short and expressive reactions that could be gracefully edited, suddenly I was facing down long, rambling monologues from a small crazy person." Difficult or no, Hertzfeldt crafted another elegant and funny work that captures the melancholy of the original, while narrowing the focus of the narrative.

Where the first short took us to robot mining colonies and museums where living clones aged on display, here Hertzfeldt limits our gaze to back-up clone "6's" experiences. We see the planet where 6 grew up and the friendship she formed with Felecia, back-up clone 5. Together Emily Prime and 6 explore 6's memories. A particularly poignant moment comes when Prime discovers a shining thing in a stream, which 6 identifies as "a glimmer of hope," something that has become rare to 6. 6 informs Prime that her mind used to be young and idealistic, but she hasn't "seen a new glimmer of hope… in many years." Scenes like these conjure up the wistfulness for childhood that characterized the first film, that yearning for dreams that went unrealized.

The disconnect between Prime and her clone's perceptions of the same moment informed the original's comedy, and this element returns in the sequel. Prime doesn't understand the significance of much of what 6 describes, and her innocent, childish reactions are often hilarious. When 6 plaintively asks Prime if she recognizes the planet where Felecia is exiled, Prime suggests it might be "near Kitty land?" In between these moments of disconnect, Hertzfeldt expertly weaves affecting dialogue as characters move across a backdrop of digitally conjured imagery. This feast of kinetic eye candy takes the form of swirling, nebulous particles, replacing the geometric patterns of the first episode.

Does Hertzfeldt's description of a difficult birth equal a flawed outing? No, there are no major sequel shortcomings here: "The Burden of Other People's Dreams" captures the tone and aesthetic of the first, pushing them in a slightly

different direction. Perhaps the plot is less than the first film's full course meal (the glimpses of the larger world and story sidelines are missed), but ultimately "Episode Two" is even more intimate and affecting due to its limited scope. Without distractions from her story, we come to genuinely feel for 6, so that when the film reaches its climax and her consciousness dissolves, we are moved on the same level as we would watching a live action film. The emotive power of Hertzfeldt's films continues to be the strongest element of his uncompromising, independent oeuvre.

"World of Tomorrow, Episode Two" is available exclusively on Vimeo on Demand.—Bryan Pike

Zama (2017) ★★

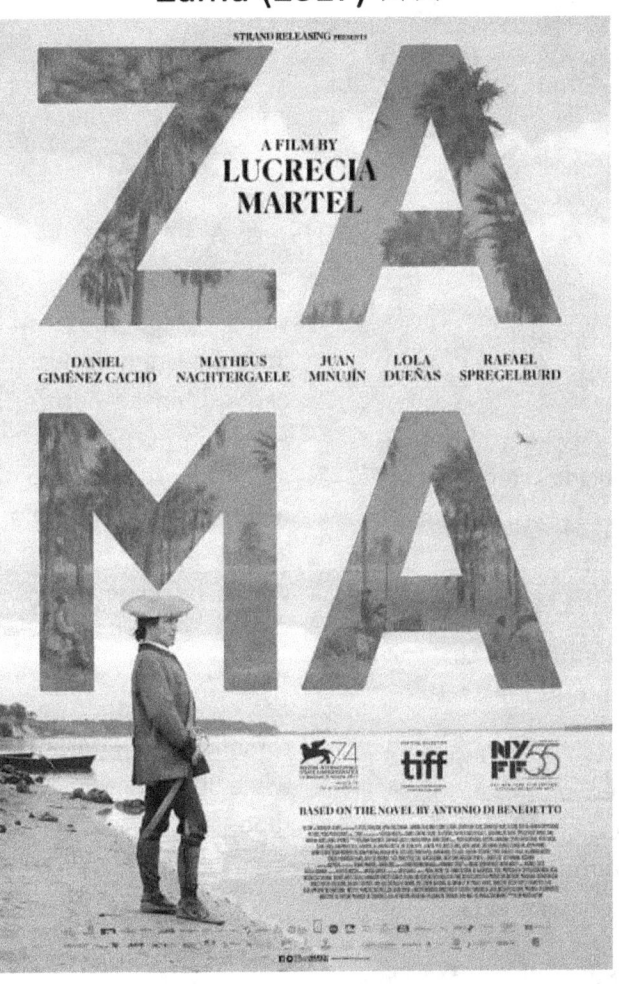

DIRECTED BY: Lucrecia Martel

FEATURING: Daniel Giménez Cacho

PLOT: A Spanish magistrate at an Amazonian outpost in Argentina longs for a transfer so he can return to his family.

WHY IT WON'T MAKE THE LIST: It's subtly strange, but we prefer much more strangeness and less subtlety.

COMMENTS: Form follows theme in *Zama*, a movie about a man waiting for a transfer that never comes, in which the viewer waits for a reason to keep watching that never arrives. If one is looking for things to praise, the usual arthouse accoutrements easy enough to point out: the wild Amazonian locations, the widescreen cinematography that captures it, and Daniel Giménez Cacho's performance as the weary, increasingly resigned magistrate. After that, I fear, you're pretty much on your own.

Zama has many plot oddments but next to no plot. It may too effectively capture the feeling of being trapped in a stifling, dull job while wishing you were somewhere else. It's a series of mostly middling anecdotes with little connection, vague developments that often mystify without involving. A young boy declares our hero Zama is "a god who was born old and can't die." Zama secretly courts a fellow official's wife. Anachronistic Hawaiian exotica music plays (admittedly, this sounds pretty cool). A black messenger repeatedly shows up with instructions for Zama; he doesn't wear pants. Zama gets into a fight with a Spanish emissary for reasons that aren't entirely clear. The governor promises to write a letter requesting a transfer for the magistrate, but never gets around to it. A llama wanders onto the set and the actors ignore it and continue the scene. (This shot impressed many critics, maybe because they were eager to praise

the film but couldn't find much else going on to talk about.) We learn that Zama has a bastard son. The colonists play dice; a geode is offered to cover a bet, but Zama insists it's worthless. Zama hears a minor character's thoughts. Zama catches a fever and moves to a hovel. He betrays a friend, hoping to get a letter of recommendation. Things pick up a little at the very end when he grows a beard and joins an expedition to hunt down the outlaw Vicuña, whom he has spent the movie insisting is dead. Then Zama dies. I don't know what to make of these events, but I'm not inspired to make the effort.

While other critics raved about *Zama*'s anti-colonialist ethos and poetic aesthetic, I side with general audiences in thinking that this one is—to put it bluntly—boring. It would benefit from cutting thirty minutes off of its meandering front end. Perhaps the problem is that it's too faithful an adaptation of its 1956 source novel—*Zama*'s meditative pace seems like it would read better on the page than it plays onscreen.--Gregory J. Smalley

Zen Dog (2016) ★★1/2

DIRECTED BY: Rick Darge

FEATURING: Kyle Gallner, Adam Hershman, Celia Diane

PLOT: A young virtual reality entrepreneur explores strange herbs and lucid dreaming in an attempt to shake himself out of his rut.

WHY IT WON'T MAKE THE LIST: *Zen Dog* is an earnest, low budget curiosity that dreams big, but doesn't dial up the weird as much as it might—for fear of drowning out its message.

COMMENTS: I read Allan Watts' "The Way of Zen " when I was eighteen, then promptly forgot about it. That's not a knock on Watts, but a testament to how good a communicator he was: read one book, and you feel enlightened.

Zen Dog is structured around one of Watts' thought experiments, which begins "I wonder what you would do, if you had the power to dream at night any dream you wanted to dream…" Kyle Gallner's "Mud" is a twenty-something virtual-reality entrepreneur pushing headsets that will allow users to tour Hawaii or Paris without leaving their living rooms. He's also having a recurring nightmare about slaving in a corporate office building. Cue dorky cousin Dwayne, a professional student who arrives on spring break to crash on Mud's couch and introduce him to lucid dreaming (aided by an exotic Chinese herb/drug nicknamed "maya"). Although purportedly a harmless natural sleep aid, the maya sure acts like a powerful hallucinogen—plus, it's addictive. But it does enable Mud to enter his lucid dreamspace, where he begins to live the life he's secretly always wanted—one where he's a vagabond wandering around America in a VW bug borrowed from Ken Kesey, meeting and romancing a (literal!) manic pixie dream girl while listening to Watts lectures on cassette tape.

The scenario sounds like a groovy neo-hippie fantasia, and without Watts' voice to guide us, it probably would play as naive. But Watts' ruminations, though simplified, are legitimately profound nuggets of wisdom: the idea that our entire ego-structure is a facade designed to inhibit our ability to be in the here and now. Compressed into several nights of dreaming, Mud travels through stages of enlightenment, from flirtations with hedonism to romantic attachment to mindblowing cosmic journeys—but ends up with the wisdom that, although his ego is a part of him, he does not have to allow it to make him miserable.

Despite its low budget, the acting and technical aspects of the film are serviceable-to-good. *Zen Dog* puts today's democratizing computer technology to excellent use, achieving psychedelic effects—double images, pinpoint editing, rainbow saturation—with ease and facility. Scenes shot in San Francisco, Reno, Chicago, and the flat prairies of middle America add additional production value. Allan Watts' son Mark served as an executive producer and licensed his father's extensive audio archives for the film, and *Zen Dog* works best as an introduction to Watts' philosophy—a noble purpose for a budget effort. It's not every movie in which the characters drop acid while inside a lucid dream itself induced by a hallucinogenic herb—and where that far-out, *Inception*y scenario actually makes sense as part of a sophisticated theme positing that life itself is a dream which we can take control of, if we only realize we're dreaming. *Zen Dog* isn't ashamed to let its freak flag fly, and, like a guileless puppy, its enthusiasm can lighten a stern heart.—Gregory J. Smalley

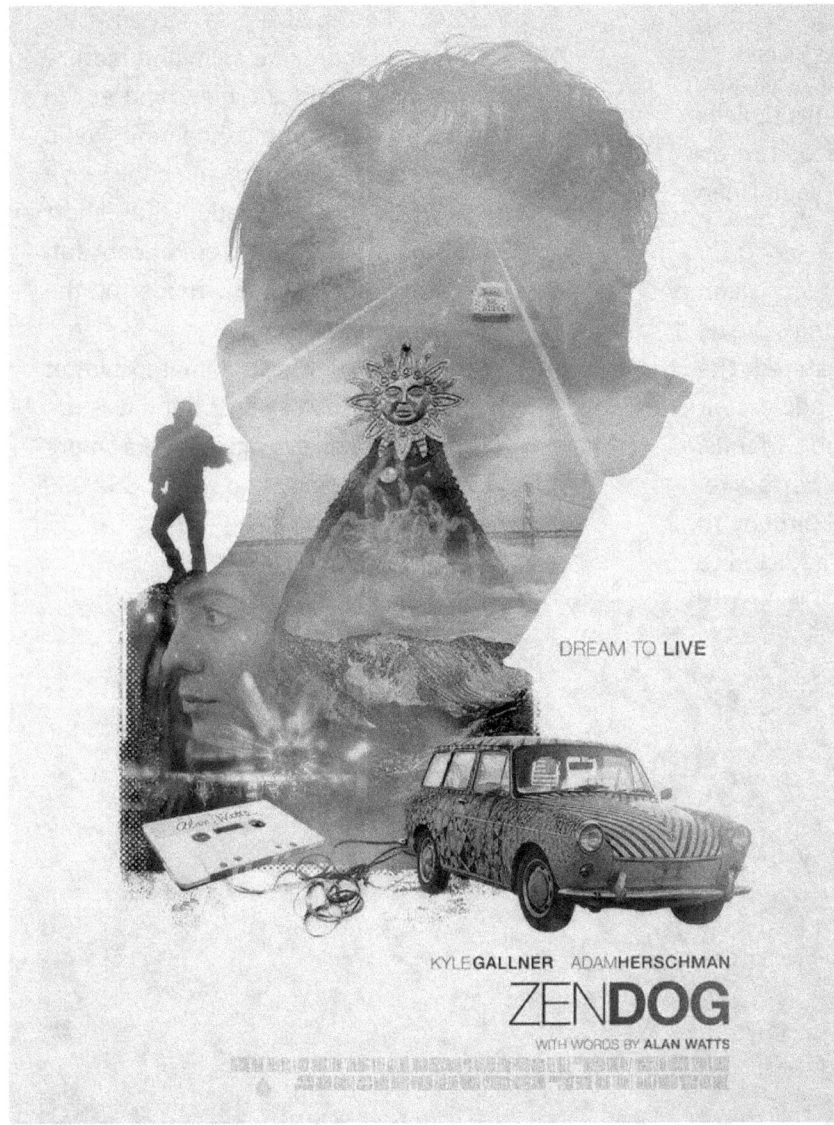

WEIRDEST HOME VIDEO RELEASES OF 2018

Birdboy (2015) ★★★★

Psiconautas, los Niños Olvidados; AKA *Psyconauts: The Forgotten Children*

"Our passions are the gift of nature, and the main spring of human actions; without them, man would be like a bird without wings, or a ship without sails."–"The Parlour Companion" (1818)

DIRECTED BY: Alberto Vázquez, Pedro Rivero

FEATURING: Voices of Andrea Alzuri, Félix Arcarazo, Eba Ojanguren. Josu Cubero; Lauren Weintraub, Jake Paque, Sofia Bryant, Dean Flanagan (English dub)

PLOT: This fable takes place on an island inhabited by anthropomorphic animals years after a nuclear disaster has devastated the ecology and economy. Dinky, an adolescent mouse, plans to run away with her friends, hoping to leave the island and find a better life. She desperately wants her boyfriend Birdboy to accompany her, but the feral child is addicted to pills and too absorbed in his own problems to join the small crew.

BACKGROUND:

- *Birdboy: The Forgotten Children* began life as a graphic novel by Alberto Vázquez. Pedro Rivera, a screenwriter who had directed one animated feature at that time, read the book and got in contact with Vázquez to see if he would be interested in adapting the book into a movie. The two made the short "Birdboy" in 2011 as a proof of concept, then were able to raise funds for the feature film.
- *Psiconautas* won best animated film at Spain's 2016 Goya awards but it was not a financial success, grossing a mere $13,000 in Spain and only $52,000 worldwide.

INDELIBLE IMAGE: When Birdboy's adolescent brain finally breaks and his horde of shadowy bat demons break loose, flocking up his lighthouse lair and coalescing into a dark dragon with glowing red eyes and a vicious pincer beak.

THREE WEIRD THINGS: Abused alarm clock; adopted luchador pup; addicted nose spider

WHAT MAKES IT WEIRD: *Birdboy* is the story of cute, drug-addicted baby animals stranded on a dystopian, post-apocalyptic island. It's got talking alarm clocks, piggy banks, and inflatable ducks, all of whom have tragic stories to tell. It's not afraid to give a puppy a rifle, or put one in a skintight leather mask. But for all of this sarcastic nihilism, it's not a black comedy, but an empathetic fable and an immersive spectacle, told through beautiful and often psychedelic animation.

COMMENTS: *Birdboy* is, honestly, a pretty easy sell. It's got cute adolescent truant animals with adorable big round heads who take drugs while roaming a post-apocalyptic junkyard and being hunted by a tribe of feral rats. It's in Spanish. It has throwaway blasphemy and senseless cruelty to anthropomorphic objects to keep you amused. And it ends in a rapturous blast of redemptive violence as a giant shadow-bird-demon breathes cleansing green fire on a horde of lost souls and tears them limb from limb. Add trippy scenes of glowing firefly souls floating around the Tree of Life for a psychedelic cocktail that will leave you buzzing after the credits roll.

Well, OK, your grandma probably wouldn't like it. And I wouldn't recommend taking your six-year-old niece to see it in her Cinderella costume. But despite the glib, if superficially accurate, description above, *Birdboy* isn't a sick nihilist joke played for offensive laughs at its characters' expense. Its heart overflows with empathy for these forgotten children. Dinky is our primary charge: squabbling with her hypocritically religious parents, stealing their "happy pills" (for Birdboy, not herself), and willing to risk anything to escape the dystopian island. She drags along a timid, bullied fox (so much the eternal victim that he doesn't even have a proper name) and psychotic bunny Sandra, who has shadowy devils on her shoulders that advise her to hurt the weak. The battered Birdboy, with his huge dilated black eyeballs set in a skull of a face and his tie hanging slack around his neck, is almost more of a symbol of the suffering of innocents than a real character. He is a feral, almost mythic presence who haunts the island and whom the corrupt puppy police have scapegoated as the source of the local drug trade. Birdboy is not a dealer, however, but an addict, compelled to swallow pills despite the fact that when he does he suffers nightmarish hallucinations which usually end with him being consumed by bats. He's an orphan, persecuted, mute, haunted, sick, addicted, and (usually) flightless. He's the forgotten bastard child of all the island's sins.

Vázquez's original graphic novel was inspired by Spain's economic meltdown in the early 1980s, but knowledge of that time and place is not necessary to identify with the world of poverty, squalor and hypocrisy *Birdboy* paints. *Birdboy* is a fable, in the classical sense: it uses animals as characters. This choice makes it abstract and universal. The movie devotes as much of its brief run-time to developing its strange world as it does its characters or its simple plot. Restricting the action to one self-contained, isolated island creates an inside world that we get to know intimately, and suggests an unknown outside world, a promised land across the sea where the characters can imagine a better life. Their real world, however, is a dump. Half the island is literally junked, hemmed in by ever-shifting mountains of garbage that render maps useless and ruled by gangs of glue-huffing teenage rats. The civilized hemisphere is a repressive society of autocrats, fascists who scapegoat and hunt innocents like Birdboy. It's no land for children.

Sandra has been driven prematurely mad, while forgotten outcasts like Birdboy retreat into self-abuse. With the fishing industry devastated, a young pig sells drugs to keep his addicted mother medicated. The line between people and objects is broken: alarm clocks and inflatable duckies have free will, interior lives, and even mothers, although the higher caste of animals take out their frustrations on them and treat them as rubbish (with the exception of the empathetic young fox, who takes pity on a piggy bank who pleads for his life after being emptied). The contrast between the Disneyesque animals and their sordid surroundings, amplified by hallucinations alternately nightmarish and pastoral, is a refracted vision of the suffering of innocent children everywhere pummeled by poverty and neglect.

The world is nightmarish, but the film is beautiful. Vázquez has a different color scheme for each mood. The idyllic opening is imagined as geometric shadows against a rosy background that grows an angrier red as the nuclear threat swells. That look presages Birdboy's nastier drug hallucinations, where barbed shadow monsters roar against a blood-red background and pick at his torso with their sharp beaks. With its charming baby bunnies and piggies and mousies, "normal" reality could have been taken straight out of a Sunday comic strip, except for the "fake brother" puppy who wears a Mexican wrestler's mask and humps Dinky's adopted father's leg. On the poorer side of town, the same cute beings have a seedier, more ragged look and missing limbs, and the junkyard backgrounds are sketched in dingier shades of brown. Birdboy, lonely soul that he is, is frequently shown dwarfed by the Expressionist landscapes, as when he stands before a forest of chiaroscuro trees drained of color. For every depressive or frightening hellscape, however, there is a corresponding Arcadia; Birdboy knows of a cave where fireflies light the way to a secret grove where a verdant lime-green meadow and a healing pool of blue front a giant tree of love. Birdboy's suppressed fury erupts in a final scene of bloody horror and revenge, but the film ends in that hopeful forest of glowing acorns.

Birdboy begins with a prologue which explains that this world wasn't always the way it is now; once the air was clean and the ocean thrived with fish. Maybe not, however; the prologue's unnamed narrator (Birdboy's father?) speaks glowingly of the paradisiacal past, but the images we see show grim workers marching with downcast eyes to slave at the local nuclear power plant. Perhaps it's just the disillusionment of an elder looking back at an imaginary golden age of his youth, when the world's ugliness was hidden from him. An old man prowling the dump for copper to trade for food—which he will then, in turn, trade for copper—tells the wandering children that he used to have a life, but things didn't turn out the way he planned. "Things never turn out the way you plan," he adds sagely. Compared to her psychotic, bullied, drug-addled friends, Dinky is a relatively prosperous suburban girl who merely hates her square parents and harbors a crush on a bad boy. That is a character the audience can relate to. At twelve, few of us hear sinister voices in our heads like Sandra, or are prematurely homeless drug addicts like Birdboy. But we are all starting to develop the consciousness that such evils exist in the world. We are all developing plans to break away and hoping to start a better life for ourselves away from the failures of our elders. And we are all also starting to learn that making a better life is harder than wishing for a better life, that solving problems is tougher than identifying them. For all its black humor and potentially distancing fantasy, *Birdboy* succeeds because it loves these sad children and appreciates their hope. In Spanish *The Forgotten Children* translates to *los niños olvidados*, a title that begs comparisons to Luis Buñuel's melancholy cycle-of-poverty classic *Los Olvidados*. Vazquez and Rivero show an empathy

and humanism, filtered through bold and bitter imaginations, that justifies a choice of title that might have seemed almost presumptuous.

HOME VIDEO INFO: Shout! Factory releases most of GKIDS acquisitions, and so it is with *Birdboy, the Forgotten Children*, which is available as of 2018 in either in a Blu-ray/DVD combo pack or solo DVD. The transfer is beautiful, reverently reproducing the hand-drawn artwork that spans the entire color spectrum. You can watch the film either in subtitled Spanish or in a (not bad) new English-language dub. Extras include dubbed and subtitled versions of the U.S. trailer; twelve minutes of interviews with Rivera and Vázquez; the original 2011 "Birdboy" short, a prequel done in a more primitive (but equally imaginative) animation style; and Vázquez's award-winning 2016 black and white short "Decorado," which is significantly more surreal than *Birdboy*, features "sexy" mermaids and a skid-row version of Donald Duck, and is exclusive to this disc.

The feature is also available to rent or purchase on demand.—Gregory J. Smalley

Liquid Sky (1982) ★★★

DIRECTED BY: Slava Tsukerman

FEATURING: Anne Carlisle, Otto von Wernherr, Paula E. Sheppard, Susan Doukas, Bob Brady

PLOT: A tiny alien flying saucer lands on top of the Empire State Building, directly across from the penthouse where drug-scarfing New Wave fashion model Margaret spends her nights bedding partners of both sexes. A German UFO scientist who has tracked this manifestation takes up residence in an apartment across from Margaret, spying on her through a telescope. Margaret's sex partners begin to die off as the aliens harvest the endorphins released during their orgasms.

BACKGROUND:

- Slava Tsukerman was a Russian Jew who trained as an engineer before switching to filmmaking. He made mostly documentaries in the Soviet Union and Israel before emigrating to the U.S. to make features. He began developing *Liquid Sky* after funding for a sci-fi film that would have starred Andy Warhol and Klaus Kinski fell through.
- Co-writer Anne Carlisle, who starts as a fashion model in the film, was a fashion model in real life. Most of the actors were art-scene punks drawn from bohemian casting director Bob Brady's acting classes, and most played some version of themselves.
- Many repeat the claim that *Liquid Sky* was chosen as the title of the film because it was slang for heroin, but according to Tsukerman he encountered the term as a metaphor for euphoria in his research, and junkies only began to refer to the drug as "liquid sky" after the movie became a cult hit.
- Made with an estimated budget of half a million dollars, *Liquid Sky* grossed more than $1.7 million in 1983.
- In a 2014 interview Tsukerman announced his intentions to make *Liquid Sky 2*, but no news has emerged on that front since.

INDELIBLE IMAGE: New Wave fashion shows? Neon sculptures? Flying saucers hovering in front of the Empire State Building? Margaret's fluorescent face paint under a blacklight? All excellent choices. But we had to go with alien-eye-vision, rendered through technology that looks like a cross between malfunctioning army ranger night-vision goggles and News at 11's

stormtracker radarscope, but with a Day-Glo color scheme, and often looking like it's peering through a microscope aimed at a dividing zygote.

THREE WEIRD THINGS: UFO/heroin connection; spontaneous hateful beat eulogy; prayer to the Empire State Building

WHAT MAKES IT WEIRD: *Liquid Sky* is like an alien's attempt at making a film set in the No-Wave Greenwich Village art scene in 1982, if their only previous exposure to movies was the works of John Waters, Ken Russell, and Rinse Dream. Neon, nasty, and occasionally tedious, but there's nothing else quite like it.

COMMENTS: *Liquid Sky* is about aliens, and it might as well have been made by aliens. In fact, it *was* made by an alien, though a terrestrial one—Slave Tsukerman, a recent Russian émigré who found himself, incongruously, embedded in the hedonistic world of downtown scene punks. Using a Soviet-trained crew and a cast of No Wave acting students and oddballs, he created an ironic, askew paean to the New York art scene, circa 1982. It is soaked in neon, scored to primitive synthesizers pumping out vaguely disco beats, and told with all the tenderness and compassion of a junkie looking to score at 2 AM. *Liquid Sky* alternates between nihilistic monologues, New Wave fashion shows, joyless sex scenes, deadpan campy dialogue ("Are you sure this has to do with UFOs? It looks like two women just killed a man"), and 8-bit psychedelia, reinventing the 80s NYC punk scene as an amoral, paranoid sci-fi fairy tale dreamt up by an NYU art school dropout during a heroin nod.

Liquid Sky is set during one of the counterculture's periodic identity crises, as it moved from the dusty anger of the 70s punk movement into the glitzier, more aesthetically-oriented 80s scene. The music had morphed from angry three-chord guitar riffs to alienated synthesized bloops; the fashion sense had changed from safety pins to neon face paint. But the "fuck you" attitude was the same: anger, drugs, sex, and the cynical live-for-today nihilism common to almost every generation of disaffected young bohemians. It was post-disco, pre-AIDS time, but the seeds of the coming crisis can be seen in the reckless behavior of its nervy scenesters. They snort coke, shoot horse, sleep around, dance robotically all night, and play at dress-up with the clueless arrogance of those who think they're creating art rather than fashion. Anne Carlisle, cast as the "it" girl of the Reagan counter-revolution, looks waifish and wan, hiding her vulnerability behind geometric face paint and a bad attitude. The acting is far from *Liquid Sky*'s strong point; but, playing her androgynous double Jimmy, the perpetually strung-out "beautiful boy" with cheekbones David Bowie would have killed for, Carlisle embodies the sort of narcissism basted with fashionable ennui that makes *Liquid Sky*'s hustlers seem so phony and despicable.

Everyone in *Liquid Sky* is out for themselves, angling to create a private heaven within their own neurons and/or genitals. Besides Margaret and Jimmy, there's Adrian, Margaret's cruel and possessive live-in lover, drug dealer, and sometime performance artist who sings the monotonous and vapid "Me and My Rhythm Box" for a crowd of narcotized zombies. She constantly degrades and tries to control Margaret. There's a California hustler who likes to shove Quaaludes down his partner's throat before making love. Their fashion scene collaborators, seen mainly in a long combination penthouse party/photoshoot, are every bit as callous and shallow as the principals, cheering on catfights and encouraging public fornication. The alleged adults aren't much better. Margaret's ex-hippy acting coach (played by her real life acting teacher) crosses a few professional lines with his pupil, who may be young enough to be his granddaughter. Jimmy's shrimp-obsessed mom is a MILF on the make, eager to seduce the German UFO scientist who wants to use her pad

to set up his spy telescope to observe the tiny aliens who have landed on the Empire State Building. That character, Johann, may be the most sympathetic and altruistic of all, except that he's so wrapped up in his studies that he blatantly ignores the many murders taking place in the apartment across the street while scribbling notes in his notepad. The data's just too good; he gets a bigger thrill from alien voyeurism than from the woman in a kimono sitting on his lap and discussing orgasms. (He's therefore more than a bit of a stand-in for the director, also a stranger to America and a dispassionate observer of its depraved excesses.) The aliens, harvesting these degenerates for the euphoriants they produce, may be just as amoral as the humans; but at least they have the excuse of preying outside their own species. It's fair to say that *Liquid Sky* takes a dim view of its characters; whether it restricts its cynicism to the art scene, or sees it as a broader criticism of Americans or even of humanity, is up to you to judge.

But whatever *Liquid Sky* lacks in likable characters, it makes up for in visual and conceptual razzle-dazzle. The plot itself, sliding merrily along its aliens/orgasms/heroin axis, is bizarre enough. But the outré lifestyles and sleazy soap opera dynamics of the coked-up cast of marginalized performance artists dominate, at times shuffling the alien invasion off into a subplot. Margaret sleeps around with a troupe of shady weirdos. Her drug-dealing gal pal Adrian is one of the oddest, and most dangerous, of the bunch, delivering a heinous and blood-curdling rhyming eulogy for one of Margaret's unintended victims. The supporting cast of fashionistas are suitably bizarre in appearance. The wardrobe is 80s New Wave, but oversized and exaggerated: the men wear outrageous blazers with bizarre collars and protrusions, and Margaret goes through a series of spandex miniskirts that would make ZZ Top do a triple-take. The makeup, both men's and women's, consist of blocks and stripes drawn on faces in the brightest shades available: pinks, oranges, purples, bursting off kabuki-white foundations. Margaret and Adrian's apartment, where most of the action takes place, is a riot of mirrors and tinsel and neon signs, with a strange blank mask surrounded by overlapping neon halos hanging above her mattress. All of the interiors were painstakingly lit by neon lights, and the background doodads change color according to the time of day: yellow for daylight scenes, shifting into turquoise and purple at night. There is always something voguish in the frame to catch the eye. The film opens on that mask, with the camera pulling back to show the entire apartment, then traveling out the window to show the New York skyline. A cheesy glowing dinner plate of a flying saucer materializes in front of the Empire State Building, alternating with shots of big-haired, wide-shouldered extras from a New Wave music video dancing in a sweaty warehouse of a discotheque. Queue the heat-image alien-vision, which looks like a space age update of a 1967 psychedelic light show. A synthetic trumpet blasts a repetitive march, accompanied by a drum machine, interrupted by "Space Invaders" sound effects when the aliens get busy dissecting brains. At times, as in this lengthy opening, *Liquid Sky* seems more like an art installation with a movie surrounding it for support than like an exercise in narrative filmmaking.

Obviously, this is all a very strange farrago indeed. The flights of sci-fi fantasy are grounded in some very real punk nastiness. As previously mentioned, almost all the characters are unsympathetic. Margaret becomes our heroine by default. She is trapped in a kind of hell on earth—a downtown art purgatory—without realizing it until the very end of the story. In a climactic monologue, she explains how she fled her bourgeois Connecticut "Mayflower stock" upbringing for the big city, seeking transcendence from convention in drugs,

bisexual experiments, and art. But these avenues all proved as unfulfilling as the fantasy of weekend barbecue dinners with her lawyer husband she was weaned on would have been. One key to her story is that, despite all the sex she has, she is anorgasmic. This may be because she is constantly being raped, either by actual force or through persistent coercion. But it is a key plot point, because Margaret's failure to find sexual satisfaction is what keeps her alive; the aliens never harvest her because her brain won't release the pleasure chemicals they are collecting. It also allows her to use sex to kill those who wrong or offend her, which turns out to be just about everyone she knows. In the end, she dons a wedding dress and flees to the roof, pleading to be taken away by the aliens. Tsukerman calls *Liquid Sky* a postmodern Cinderella story where the abused punk princess' Prince Charming is a little green man from outer space. The end result turns out to be something even weirder than that wild premise would suggest.

HOME VIDEO INFO: For many year since release, *Liquid Sky* was accessible only on VHS or a poor-quality, low-availability DVD edition. That changed in 2018 with Vinegar Syndrome's deluxe restoration and release, in a Blu-ray/DVD combo pack. In brief, the massive extras include a commentary track from Tsukerman and Carlisle (which is honestly not the best—at one point, the 77-year old director falls asleep and can be heard snoring!); a short introduction from Tsukerman; a fifteen-minute interview with the director and a nine-minute interview with Carlisle; an hour-long retrospective documentary; a 37-minute post-screening Q&A with Tsukerman, Carlisle, and co-composer Clive Smith; 12-minutes of outtakes (silent, but scored to the film's electronic soundtrack); a ten-minute alternate opening; almost twelve minutes of (very poorly preserved) Betamax rehearsal footage; five versions of the trailer; a stills gallery; and an isolated soundtrack.

Liquid Sky is also available on video-on-demand, or free with an Amazon Prime subscription.—Gregory J. Smalley

Mind Game (2004) ★★★★1/2

"Your life is a result of your own decisions."–text message briefly glimpsed in the opening scenes of *Mind Game*

"There's a lot of randomness in the decisions people make."–Daniel Kahneman, psychologist

DIRECTED BY: Masaaki Yuasa

FEATURING: Voices of Kôji Imada, Sayaka Maeda, Takashi Fujii, Seiko Takuma

PLOT: Aspiring manga artist Nishi meets his schoolboy crush Myon on the subway and realizes he still loves her. They go to eat at her family's noodle shop, but two yakuza break in, demanding repayment of loans, and in the ensuing scuffle kill the cowardly Nishi. In the afterlife, Nishi meets God, but decides he's not done living and returns to earth, where he becomes a hero by rescuing Myon and her sister, then is swallowed by a whale and shacks up with the old hermit who lives in its belly.

BACKGROUND:

- Based on a manga by Robin Nishi.

- This was Masaaki Yuasa's feature film debut as a director. He had worked as an animator since 1990. He also had a big role in producing the Certified Weird short feature *Cat Soup* (2001), working as co-writer, co-producer and animation director.

- Animation director Kôji Morimoto's credits as an animator include *Akira* (1988) and *Kiki's Delivery Service* (1989).

- *Mind Game* won the equivalent of Best Animated Feature at Japan's Media Arts Festival (placing ahead of *Howl's Moving Castle*) and was named Best Film at the 2004 Fantasia Festival (narrowly beating out *Survive Style 5+*).

- Despite its accolades, *Mind Game* never had an official U.S. premier or home video release until 2018. It nevertheless developed a cult following with the few people who managed to see it and spread word of the find to their friends.

- *Mind Game* was the winner of 366 Weird Movies' final readers' choice poll.

INDELIBLE IMAGE: God, the cigarette smoking fish. Seriously, how many movies dare to literally depict God on-screen? Now, subtract the ones that show Him as a bearded old white guy or George Burns, and ask yourself the question again.

THREE WEIRD THINGS: God's many cartoon faces; gay ex-yakuza in a whale; external translucent womb

WHAT MAKES IT WEIRD: *Mind Game* is trippy and surreal—the plot and the animation style both change every few minutes—but a sense of mystical wonder and an elusive wisdom underlies the whole crazy game. Put your seat belt on, this is going to be a bumpy ride.

COMMENTS: *Mind Game* begins with a stakeout in the rain; a man follows a woman into a subway. Then, one minute into the film, everything changes. Ominous low stings moan, and we are treated to a confusing two-and-a-half-minute montage. We see a bridge and a shot of a big-nosed baby staring at it in wonder, then hookers, a Christian church with a mural of souls writhing in Hell, sepia scenes where a boy superhero with a helmet antenna faces off against 20s-style mobsters with Tommy guns, disco dancing, kids petting a dog, older kids secretly passing notes at school, video games, a ringing phone, sent emails, and soccer players, among other random but weighty images. Then a white flower appears, and upon each petal Latin letters appear spelling out M-I-N-D-G-A-M-E. At the end of *Mind Game*, we see the same stakeout scene, which plays to a slightly different conclusion, followed by an almost identical (but even longer) montage. Some of the shots from before appear in different color schemes and many new ones are thrown in, and it's now scored to a happy J-pop jingle. When that second montage appears, some of the images will make sense, others will seem just as arbitrary as when you saw them the first time, and you'll likely be just as baffled as you were at the beginning.

So settle in. You're going to be confused by *Mind Game*. It won't help that the animation style keeps changing with every new scene. The most notable stylistic choice is that sometimes the hand-drawn characters are replaced by photographs of actors, which are crudely animated in an almost flip book fashion. Sometimes they carry on short dialogues this way; in one scene, a photograph of an actor appears isolated in a mirror against the cel backdrop. Some scenes look like mock Disney, some like Saturday morning cartoons, some resemble other anime, and some are like abstract art installments from the 1960s. Lighting schemes are usually dramatic and unreal, some in noirish monochrome gray shadows, others looking like they've been hand-tinted with dried blood. The afterlife is cybernetic; Nishi's soul is a glowing blue line drawing in a void that fills with static, low res pixels, and polygon meshes. The quintessence of this style, naturally, is God himself, who changes appearance (and accent) once per second: from a Japanese Jerry Garcia through a fishbowl-

headed clown and a topless woman. *Mind Game*'s ever-morphing world was clearly made in this mutable deity's fickle image.

Yes, this is a weird movie. Between the impenetrable but oddly poignant montages and the meetings with a sarcastic Almighty who taunts his creations by text are an almost countless number of odd, whimsical fantasies that break up the already confusing narrative. Anything can happen in *Mind Game*—especially after you die. The previously feckless Nishi grows a spine after his brains are blown out, and races backwards through the tunnel of light to resume his earthly existence. Now he's a superhero, able to turn the tables of his yakuza tormentors and escape with his love and her sister in a stolen convertible. After an improbable car chase which involves a call from a mob boss with a tiny robotic dog on his shoulder and a gangster who can run 120 mph, Nishi and company are swallowed by a whale and settle down in its guts with a friendly old hermit who makes excellent sushi. There, the quartet enjoy wondrous hallucinations, including dancing a water ballet to Liszt with an aquatic dinosaur, an interlude that might be a *Fantastic Planet* tribute, and Nishi's fantasy of being a successful manga artist at a book signing at a magical futurist amusement park, among other sights your eyes may not believe (including some almost inexplicable sexual imagery).

If you're intrigued by this description, you should probably stop reading this review now and go watch *Mind Game*. I'm afraid that I've given away too much already. Pulling this movie apart is something you only want to do after you've seen it; it will never have the same impact as that first viewing, when *Mind Game* throws styles, ideas, and shards of plot at you so fast that it overwhelms you and your own mind starts to shut down. If you've already seen it and are still confused, I can offer a smidgen of guidance. The basic plot of the "real world" story is simple enough, although Yuasa chops it up as much as he can. Aspiring manga artist Nishi is in love with Myon, who has a boyfriend but still carries a torch for him; soon after meeting her again he is killed by an unhinged yakuza who's been wronged by Myon's father. Everything that happens afterwards appears to be a deathbed hallucination, although you may take it at face value if you choose. What is more confusing, however, are the opening and closing structures, which I alluded to in the opening paragraph. The movie begins with the two yakuza—the senior one, whom I will refer to as the "sad yakuza," and his soccer-playing hot head. They stalk Myon and eventually follow her to her family's noodle shop. Immediately after this introductory bit of plot comes that first montage, which contains elements of the story we will encounter later and backstories of characters we have yet to meet, along with some shots whose meaning may never become clear. Nevertheless, with a lot of effort, you can determine that both sequences incorporate flashbacks from the life of the old man in the whale, Myon's father, Nishi and Myon's childhood, and the soccer-playing yakuza, along with some pop culture references to set the time frame. The "Time Boy" character (modeled after Astroboy) who appears was a favorite of both the sad yakuza and the old man, and had the ability to turn back time. When Nishi defies God and returns to Earth, he goes back in time a few seconds before he was killed in order to turn the tables on the yakuza. He lives out a fantasy of heroism by rescuing Myon, then has a long respite inside the whale, where he hides out from the world and lives in dreams. But he grows bored, and another montage shows him missing things in the mundane world, as do Yang and Myon in turn. They determine to flee this dream life and re-enter the real world. More flashbacks and fantasies accompany their escape. When Nishi finally sees the city of Osaka after escaping from the whale, he imagines people going about their daily lives, including a scene where an

architect builds one of the skyscrapers he sees. Time flows backwards and forwards, and he has visions of possible alternate futures for Myon, Yang, and the old man (for example, Yang becomes an artist, or a wrestler, or an astronaut). Then, suddenly, we are back where the movie started: with the sad yakuza staking out Myon. He seems jolted when we arrive at this scene, as if he had just awoken from a dream. He sends the soccer-playing yakuza after Myon, but this time the hoodlum loses track of her (meaning that he will not follow her to the shop and kill Nishi). Meanwhile, the sad yakuza leaves the scene, and as he backs up his car the city changes from a grey night to a brilliant day, suggesting that reality has been reset by his decision to leave. Then the movie's title appears in the clouds, and an extended version of the opening montage plays. Does that clear things up?

Probably not too much. The movie's overall theme, however, seems simple enough: embrace the wonder of life in all its variety. Nishi's motivation to leave the whale is the thought that "There's so much out there. So many people, living different lives!" His character takes a journey of enlightenment. He begins too afraid to tell Myon his feelings, and he cowers before the powerful yakuza. This cowardice leads to his death, and then to his decision to embrace life and be reborn. He then experiences a fantasy of power, living like an outlaw, which proves a false path. So next he withdraws from life and holes up in the belly of the whale; a lotus-eaters' retreat, a world of private fantasies, pleasures, and stories. This life grows boring because it's too ego-centered and divorced from his community. It also expresses his deeper fear: the fear of failure. While hiding out, he only tells his manga plots to his close confidants, not releasing them to the world where they, and he, might be judged. When he gives up that part of his ego, he is free to leave: "it's not about who's better, who's not." He wants to live in the real world even if he's "one big loser," appreciating existence without being ruled by either fear or ambition. It's a very Buddhist perspective. And there is another level to it. When the end of the movie suddenly wrapped around itself and returned, with a jolt, to where it began with the sad yakuza, I suddenly wondered if it had been *his* story all along—the yakuza's daydream as he sat in his car waiting for Myon to appear. It's not, but nor is it Nishi's story alone. It's the story of all. *Mind Game* happens in one individual's mind, but it throws so much at you—life, death, the real and the unreal, made-up stories, real histories—because it is encompassing the entire world. "It's a melting pot," as Nishi says at his epiphany. This is another Buddhist concept: that we are not unique, but we are part of the whole, one ripple in a long series. Nishi is at the center, but everyone whose life touches his—and even those unseen—are a part of the same continuum of existence. This is why they all share equal billing in the bracketing montages, along with many strangers. It's all the same story, the human story. And it ends with the words "this story has no end."

HOME VIDEO INFO: Once unavailable in the U.S., Shout! Factory (in collaboration with GKids) unleashed *Mind Game* on home video in a DVD/Blu-ray combo pack in 2018. Besides the pristine presentation of the mind-blowing feature film, the set includes production art galleries and the U.S. release trailer. There is no running director's commentary, but a separate featurette includes Masaaki Yuasa describing selected scenes for thirty minutes. Yuasa pauses the film, rewinds it, or goes frame-by-frame so he can finish his thoughts before resuming the presentation; therefore, it takes him a half hour to discuss about fifteen minutes of film. He covers much of the last third of the movie, from the time Nishi decides to leave the whale until the title "Mind Game" comes up (excluding the mysterious epilogue). On your own, it would be

impossible to figure out many of the subtle narrative connections—some occurring in one-second flashbacks and fantasies, involving unrevealed or barely hinted at backstories—that the director explains here. The fact that the film works so well without this information just goes to show that having everything spelled out for you is supplemental, not essential, to appreciating this work of art.

The Blu-ray is the same as the DVD except that it includes a full-length animatic for animation geeks. (An "animatic" is a working draft of the animation, to be fleshed out later; in this case, it's displayed in a smaller box in the lower right-hand corner of the screen so you can compare the differences between the preliminary and finished version.) It's an interesting addition to the set, although not something most people will access very often.

If you don't need any of those bells and whistle, but just want to have your mind blown, you can buy or rent the film on-demand.—Gregory J. Smalley

OLDER MOVIES DEBUTING ON HOME VIDEO IN 2018

Moon Child (1989) ★★1/2

El Niño de la Luna

DIRECTED BY: Agustí Villaronga

FEATURING: Enrique Saldaña, Maribel Martin, Lisa Gerrard, David Sust

PLOT: A young orphan is brought to a special institute where the proprietors are attempting to create the conditions for the birth of a spawn of the dark underworld.

WHY IT WON'T MAKE THE LIST: Inspired by a novel by legendary occultist Aleister Crowley, *Moon Child* excels at mood, finding an intriguingly off-kilter vibe and riding it from beginning to end. But while the film offers situations and set pieces that may raise an eyebrow, the fantastical premises are addressed in a logical, rational fashion that keeps things too reasonable to be among the truly weird.

COMMENTS: A friend of mine once picked up a side job writing T-shirt slogans. At the height of the world's obsession with Harry Potter,

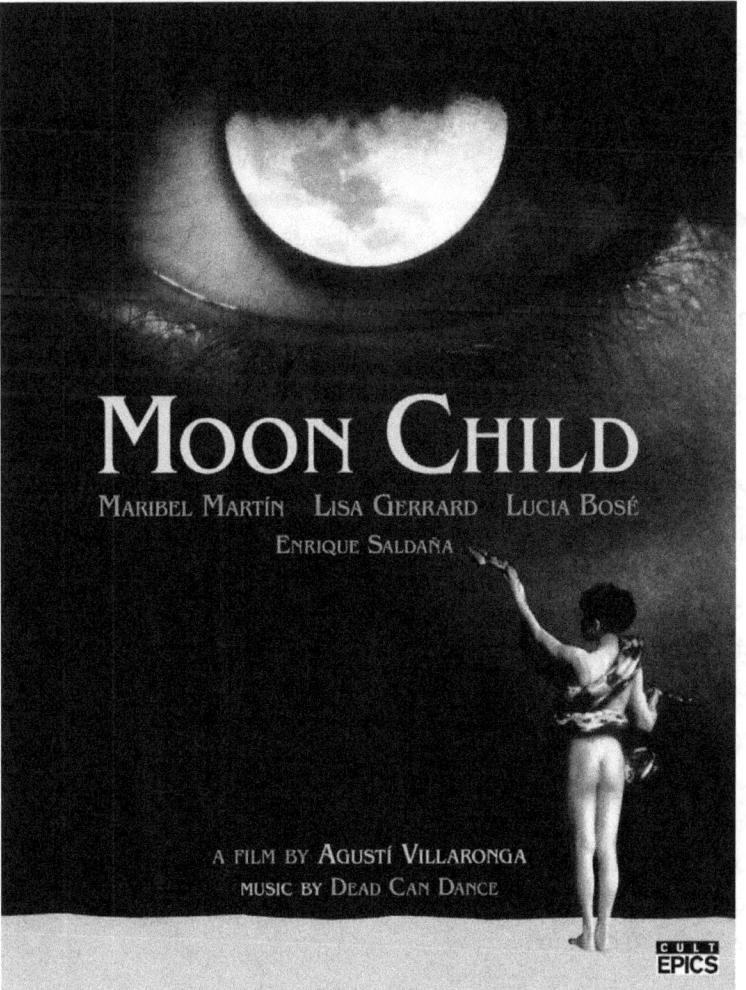

he made a tidy sum with the pithy observation, "Not all orphans are wizards." *Moon Child* suggests an intriguing alternative: some orphans are the supernatural impetus for the birth of a world-destroying offspring of Satan.

This isn't left up to interpretation. Young David (Saldaña) has been having strange and powerful dreams when a mysterious woman comes to test him. She represents an occult institution trying to engineer the perfect conditions and genetic bloodlines to trigger the birth of the spawn of the lord of the underworld. That goal dovetails nicely with the aims of the orphaned David, who has been trying to understand his place in the world. Perhaps the birth of a Moon Child is a win-win.

There's an oddness and even a little humor in the cult's methodical efforts to summon the devil. While supernatural powers are abundant at the resort-like outpost, the search for the right genetic donors is far less promising. The simple Georgina

and the vision-challenged Edgar are finally selected. This culminates in the film's unquestionable centerpiece, in which the couple consummates their expected Moon Child parentage on an altar beneath the bright rays of the moon. It's part of *Moon Child*'s awkward charm that David is witness to this whole inappropriate display, but is interested exclusively in the implications for his own situation, oblivious to the very adult activities transpiring.

Much of the film hinges on the performance of two novice actors, who acquit themselves decently. Child actor Saldaña approaches everything with a wide-eyed, slack-jawed gape, but fortunately for him, the proceedings are sufficiently shocking to justify his one emotional register. For her part, Gerrard (half of the dream-pop duo Dead Can Dance, who also provide the atmospheric score) holds her own in a part that demands much of a first-time performer, including vomiting, a sandstorm, some slapstick during a lecture, and a very exposed sex scene. They do fine, and but are also aided by the film itself, with maintains an intriguing yet unsettling air that serves them well.

In fact, most of what *Moon Child* is, in the end, is atmosphere. As the setting moves to more exotic locales and as David gains more understanding and encounters new obstacles, the unifying force for the film remains a general feeling of unease. That pays off in a finale that is at once unexpected while fitting perfectly with the overall sense of dread. Not all orphans are wizards, it's true. Some of them are so much more.—Shane Wilson

Kaleidoscope (2016) ★★★

DIRECTED BY: Rupert Jones

FEATURING: Toby Jones, Sinead Matthews, Anne Reid

PLOT: A lonely ex-con tries to muddle through life and find romance, but it seems his mother is determined to reassert her domination over him.

WHY IT WON'T MAKE THE LIST: *Kaleidoscope* toys around with perception and time in a... kaleidoscopic kind of way, but everything gets wrapped up pretty nicely (a little *too* nicely for the likes of us). It must be said, though, that the protagonist's mother cranks up the creepy factor to within throwing distance of serious consideration.

COMMENTS: Maintaining a constant sense of unease while also being sweet is a tough balancing act for a movie, and such films often pass by unnoticed. It can be hard both to find the time to watch the right movies and to find the right movies to fill your time. *Kaleidoscope* is as understated as its melancholy protagonist, and it's easy to miss: it's foreign, low budget, and its biggest star is a niche (albeit incredibly talented) character actor. I would never have watched this if I weren't a "366" reviewer; having done so, I suspect it will be right up the alley of many "366" followers.

Carl (Toby Jones) is a lonely fellow living quietly in a clapped-out council estate. Tonight, though, is special, as he's arranged a date with an outgoing young woman named Abby (Sinead Matthews), making the rendezvous at the appropriately named bar "Lust." Returning to his flat afterwards, they chat, share drinks (he's a teetotaler, though), and even dance together (that's right: you get to see Toby Jones dancing to dubstep in a shirt as loud as the music). But then Carl gets an unwanted phone message from his mother, his drink gets spiked, and Abby may only have gone on the date in order to case the joint. The next morning, Carl awakens to find

himself on his couch not remembering much. Details slowly coalesce, suggesting he may have murdered—again. Panicking, the last thing he needs is a surprise visit from his hated mother (Anne Reid). Of course, she arrives.

The ickiness of Carl's mother is hard to overstate. Anne Reid's performance is about as knockout as a low-key psychodrama will allow. She's excessively sweet (she cooks for her son, cleans his apartment, and even offers him a £90,000 check by way of apology… for something) while being surreptitiously domineering (Carl is obliged at one point to bandage her injured leg after cleaning it up). And she has a history of—probably—taking advantage of him sexually. This leaves the viewer finding her by turns unpleasant and staggeringly creepy. There was one scene in particular that started out merely as uncomfortable before going so far as to force me to shout at the television, *"Oh God, No!"* (That, dear reader, is quite an achievement.)

While other reviewers have had the misfortune of reviewing deservedly forgotten movies, I've typically lucked out with watching ones that merely fell below the radar and stuck there. *Kaleidoscope* is nothing earth shattering, but it doesn't need to be. In the same "Mother-as-Monster" genre as Hitchcock's *Psycho*, it tells the tale of a child being broken by the very person who should have been his protector. As his hallucinated dead father assures him ("I don't blame you. She filled your mind with poison"), Carl is hardly responsible for the collapse of his life. *Kaleidoscope*, with its subdued shatter-view, nicely toys with the audience in a far more congenial way than Carl's mother toyed with him.—Giles Edwards

The Relationtrip (2017) ★★★

DIRECTED BY: C.A. Gabriel, Renée Felice Smith

FEATURING: Matt Bush, Renée Felice Smith, voice of Eric Christian Olsen

PLOT: A couple of neurotic, directionless twentysomethings take a weekend trip that turns into a fantastical, compressed version of a relationship.

WHY IT WON'T MAKE THE LIST: It's a reasonably hip genre twist with a few clever (and borderline surreal) ideas. *The Relationtrip* pleasantly tweaks the romantic comedy formula, but takes care not to twist it so hard that it can't snap back into shape in time for the expected resolution.

COMMENTS: Stop me if you've heard this one. Depressed twentysomething loser plays video games all day. Is talked into going to a party full of strangers where he does something embarrassing. Cute girl there approaches him. They bond. Go out for tacos. Witty repartee. They complain about all their friends getting all married and boring. They dare each other to take a trip together—but promise they'll stay just friends. They fall in love. A secret emerges that threatens their budding romance. They break up. They each have an epiphany about how fear and insecurity keeps them from finding happiness. A speech demonstrating personal growth. They get back together.

OK, maybe you have. But have you heard these? The couple peel each other's' faces off at breakfast. They lie in a hammock that turns into a cocoon. Turns out the girl is a never-nude. There's a dead angel stripper stag film. A visit from a giant mommy. A couple's counselor in a pillow fort. A brawl with an abusive beer-drinking puppet.

The Relationtrip takes the pop-psychology clichés of screen (and real) relationships and serves them up as big, absurd, literal metaphors. It's an idea that's clever enough to be amusing without being subversive. It's a parody, not a

satire, and the movie still believes in love and in overcoming all its expected obstacles. The young actors are good-looking and likable, although their constant armor of hipster irony can grow wearisome. The concept is high enough that I can't help but wonder whether this might have been a box office hit with better-known leads, a quirkier best friend confidant, a killer one-liner or two, and a script that dialed back the surrealism just a tad. And a less clunky title, of course.

Although the word "weird" gets bandied around a lot in discussions of this one—they even stuck it in the official synopsis—you're not going to mistake *Relationtrip* for Alejandro Jodorowsky does *When Harry Met Sally* or anything. On the other hand, if you're a 366 Weird Movies reader, you're probably not a fan of formulaic romantic comedies; this is an alternative that you're likely to find tolerable, and maybe even involving.

The co-writers/co-directors are a real-life couple. You might recognize Renée Felice Smith from "NCIS: Los Angeles."—Gregory J. Smalley

The Shape of Water (2017) ★★★★1/2

DIRECTED BY: Guillermo del Toro

FEATURING: Sally Hawkins, Michael Shannon, Richard Jenkins, Michael Stuhlbarg, Octavia Spencer, Doug Jones

PLOT: Against a Cold War backdrop, a mute cleaning woman forms a relationship with an aquatic creature she finds imprisoned in a military facility.

WHY IT WON'T MAKE THE LIST: Although *Water* gets points for its bizarre premise—which is just enough to get it onto our radar screen—the execution is *almost* unfailingly conventional. It does feature 2017's weirdest musical number outside of *The Lure*, however.

COMMENTS: Give Guillermo del Toro great actors, cinematographer Dan Laustsen, and the right script, and magic is assured. After an over-extended stay in Hobbiton and some near-misses (*Pacific Rim*, *Crimson Peak*) the pop-fabulist is back on track with a unique vision that draws on the auteur's twin loves of classic horror and fairy tales (the high-concept tagline is "*Creature from the Black Lagoon* meets *Beauty and the Beast*").

It's a nice role, done nicely, for Sally Hawkins, who conquers the challenge of playing dowdy, mute cleaning woman Elisa while showing moments of passion and even sexiness—all while acting opposite a guy in a fish suit. Michael Shannon doesn't stretch in his role as a sadistic army colonel and vivisectionist, but his innate unhingedness is well-suited to villainy. Richard Jenkins, as Hawkins' closeted next door neighbor, has his own solid subplot, while Octavia Spencer rounds out the main cast with a bit of light comic relief. Del Toro perhaps humanizes his amphibious monster a bit too much in order to make the inter-species relationship palatable to general audiences, although he does play up the ick (or "ich") factor every now and then with girl talk discussions of the gill-man's genital quirks. The Cold War setting adds a tension and texture that would be missing if the story were set in the present day.

Water may not be terribly deep—it's little more than an ode to unconventionality, and maybe a disguised metaphor for the love that dare not speak its name—but it's delivered with elegance and panache. It isn't weird, except perhaps by Academy Award winner standards.—Gregory J. Smalley

Take It out in Trade (1970) ★

DIRECTED BY: Edward D. Wood, Jr.

FEATURING: Edward D. Wood, Jr., Michael Donovan O'Donnell, Monica Gayle, Nona Carver, Donna Stanley

PLOT: Shirley is missing, forcing her parents to hire totally inept Private Dick Mac McGregor, who also happens to be a sex fiend.

WHY IT WON'T MAKE THE LIST: *Take It out In Trade* just came too late in the game, and we already have earlier, even weirder Wood (*Glen or Glenda*) in the canon.

COMMENTS: Whoever would have guessed that Ed Wood's Holy Grail, his directorial swan song, *Take it out in Trade* (1970), would be discovered, restored, and given such a gorgeous Blu-ray treatment by American Film Genre Archives (AFGA), in collaboration with Something Weird Video?

As this is from Wood's later period, his budget seems to be down to about the $1.50 range. Also, like Wood's later output, it's a sexploitation flick, with astoundingly gratuitous nudity. Still, there's a degree of renewed Woodian energy, although there is no mistaking that Wood here is in an advanced decline from serious alcoholism.

In typical Woodian narration, MacGregor (O'Donnell) informs us: "Sex is where I come in. Dead or alive, sex is always in need of my services. A service to which I sincerely apply myself wholeheartedly---sometimes even in the daylight hours." Indeed, he hardly does any detective work, being repeatedly distracted by sex.

Wood himself shows up in drag, wearing... drum roll, please... a lime green angora sweater, topped by huge blue fake pearls. He looks bad---splotchy and bloated---but there's a twinkle alive through all that self-destruction. Looking for Shirley, McGregor takes one international holiday after another, flying into wherever (cue stock plane footage), looking for naked people (stock nudie films and new nudie footage), flying back, checking his office, getting bored, and flying to a new destination to see more naked people. Countries are represented by the barest minimum establishing shots, such as one of a continental dandy sipping wine. McGregor's reactions are cartoonish, the jokes are groan-inducing, and the pacing is napalmed due to Wood's padding to reach feature length. He apparently hoped against hope that it would all work, because he bragged in the trailer, "This one won't be ignored by the box office." Of course, it was.

The twist is that when McGregor finally tires of bug-eyed reactions to naked people and goes to look for Shirley, it turns out that she's a hooker. Cue Wood's bizarro assessment of the sex trade. Shirley's not in the gutter, she's having fun, and indeed, what better way to make a living than being paid to have sex, which she enjoys?

Wood's views of square sex are like Aunt Ida's from *Female Trouble*, minus the cynicism. With its cheapo international adventures, *Take It out in Trade* has an undeniable charm. With its acceptance of "deviants," it could almost be seen as a sequel of sorts to *Glen or Glenda*. It's a shockingly progressive and nicely optimistic world view: accepting every brand of "deviants," from trans couples to heroin addicts.

When Wood himself gets in drag, he's enjoying the hell out of himself again, and it's contagious when he does.

AFGA/Something Weird restored every minute they had access to, and although one wishes that about a half hour of footage would have remained lost, it's a bona fide find and release.—Alfred Eaker

Vampire Clay (2017) ★★★

Chi o sû nendo

DIRECTED BY: Sôichi Umezawa

FEATURING: Asuka Kurosawa, Shinoda Ryo, Tsuda Kanji

PLOT: Students in a rural Japanese clay workshop accidentally awaken a possessed being crafted by a failed sculptor who died under mysterious circumstances.

WHY IT WON'T MAKE THE LIST: Sôichi Umezawa gets a tip of the 366 Weird Hat for his creative directorial debut, but its Cronenberg-in-clay trappings are firmly in the realm of a (somewhat) standard scary movie.

COMMENTS: "Understated" and "body-horror" rarely sit side-by-side as descriptors, but Sôichi Umezawa pulls off this fairly impressive parlor trick with aplomb in his directorial debut. Primarily known for his make-up effects (and best known to us for his work on *The ABCs of Death 2*), Umezawa spins us a yarn set in an unlikely place (a rural clay-sculpting academy) about an unlikely antagonist (a creepy-cute blood golem thing). The action, such as it is, fits into that Horror Genre Standard Time of under ninety minutes. The result? A fairly memorable outing that won't burn your entire evening.

Sensei Yuri Aina (Kurosawa Asuka) runs a very small school for aspiring sculptors somewhere in not-Tokyo, Japan. When she is forced to set up shop in an abandoned painter's studio after finding her own workshop damaged by an earthquake, she unearths a bag of dried powder while digging in the studio's garden. Thinking nothing of it, she places it in her school. Young up-and-comer Kaori (Shinoda Ryo), fresh from a stint at art school in totally-Tokyo, Japan, is one of Aina's pupils. Kaori's bucket of clay is used by another student, which prompts Kaori to re-hydrate the powdery remnants that Aina had put aside. Life returns to the cursed clay at the first spritz of water, and soon the students fall prey to a malevolent, inhuman force.

All told, there are just eight characters in this melodrama about rejection, competition, and the evils of industrial waste. The back-story of the evil clay beast is sufficiently over-the-top without slipping into giggle territory; I actually found myself rather moved by the tale of the failed sculptor who literally put his lifeblood into "Kakame", the smiling vampire golem. The attacks on the students (who comprise five of the film's eight characters) are all clever—think Cronenberg in high school art class. I imagine creativity and patience were Umezawa's watchwords, as the budget for this movie must have been on the very low side. In one particularly unsettling bit, Kaori's chief rival gets enveloped by the clay monster and tries to communicate to the other students the next day from within a sculpture. Other bits of violence—both gruesome and creative—are found throughout. The end veers heavily into the "Apocalypse-as-Revenge" genre, in perhaps a personal attack by the director on those who may have doubted his talents in the past.

Now that Sôichi Umezawa has proven he can maintain a feature-length narrative as well as scare his audience, I'm hopeful he'll move on to some more challenging material. *Vampire Clay* takes you on a quick journey into one of the few remaining unexplored corners of the Gotta-Have-Blood monster genre while laying the ground-work for what will hopefully be a fuller career in weirdo-creepy motion pictures.—Giles Edwards

2018 HOME VIDEO RE-RELEASES/BLU-RAY UPGRADES

"A Trip to the Moon" (1902) ★★★★★

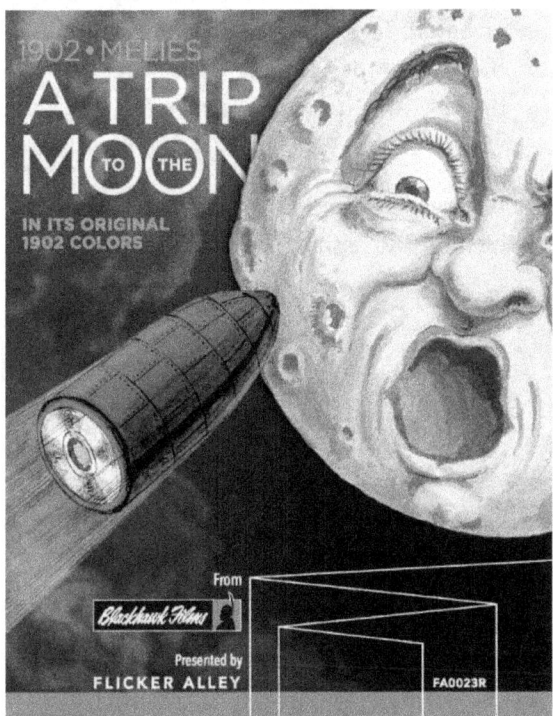

DIRECTED BY: Georges Méliès

FEATURING: Georges Méliès, Bleuette Bernon, Victor André

PLOT: Scientists (all dressed in wizard robes), aided by the army (women in tight short shorts) shoot a rocket to the moon, land in its eye, and are forced underground where they encounter a crazed crab king and his bug-like subjects, fight off their attackers, whack the king with an umbrella/mushroom that causes him to vanish in a puff of smoke, make it back to the rocket, and become heroes to their naysayers.

WHY IT DIDN'T MAKE THE LIST: At about 16 minutes, it's too short. Shorts have to be extremely weird to take a slot away from a feature films.

COMMENTS: New viewers may be surprised at the level of wit in "A Trip to the Moon," which is based in part off elements found in both H.G. Wells and Jules Verne. At roughly 15 minutes, it's remarkable not for its plot (although it is one of the earliest narrative films), but for its aesthetics, made all the more stunning in color. The rapid editing is a marvel, as are the hand-painted sets and the optical illusions typically found in Méliès' oeuvre.

For years, there was no known copy of Méliès' hand-colored classic "Trip to the Moon," until a nitrate print was discovered in Spain in 1993. Its condition was so deteriorated that it was believed to be unworkable. However, in 2010, 108 years after its release, Lobster Films undertook one of its most ambitious film restorations to date. Working with 13,000 frames, they premiered their digitized reconstruction a year later at the Cannes Film Festival with a new soundtrack by Nicolas Godin and Jean Dunckel.

Given its age, this film has been consigned to subpar home video releases over the last two decades. That has changed with Flicker Alley's new Blu-ray release. The Flicker release also features "The Extraordinary Voyage," an informative and dramatic 65 minute documentary about the film's labor-heavy restoration. It's so well-constructed as to be almost mandatory after seeing the film.

Also included is:

- The black and white version (the only one I saw in my youth), which is well-restored, but surprisingly not quite to the level of the preferred (and much more surreal) hand-colored edition. The biggest attraction in this version is the alternative piano score by Frederick Hodges and a voice-over narration by

Melies himself; oddly, neither are available in the color print.

- A twelve-minute interview with the band AIR who provided a new musical score. It's surprisingly effective in not being overcooked (as is often the case with restoring silent films). While the music is certainly postmodern, the band is sensitive and erudite in paying homage to Melies' film.
- Two additional Melies shorts: "The Astronomer's Dream" (1898) and the surreally erotic "Eclipse: The Courtship of the Sun and the Moon" (1907). Neither film attains "Trip"'s level of wonder, but both are recommended in their own right. However, the latter does gives credence to period criticism that by this time Melies was repeating himself and a certain sense of fatigue was setting in.
- A gorgeous, scholarly 25 page book that includes an essay, drawings, and stills.

Flicker Alley's Blu-ray is essential.—Alfred Eaker

Black Cobra Woman [AKA Emanuelle and the Deadly Black Cobra] (1976) ★

Eva Negra

DIRECTED BY: Joe D'Amato

FEATURING: Laura Gemser, Jack Palance, Gabriele Tinti

PLOT: An exotic dancer moves in with the wealthy, snake-obsessed Judas Carmichael; a series of murders-by-snakebite follow—but is Judas responsible?

WHY IT WON'T MAKE THE LIST: In spite of its herpetological conceit, Black Cobra Woman quickly turns into a run-of-the-mill revenge story—aside from one particularly memorable scene.

COMMENTS: The exploitation film lives and dies by its ability to shock, and this one dies a long, slow death. *Black Cobra Woman*'s only saving grace is its grotesque finale, in which its main villain dies by anal snake-rape. Even that scene is tamer than it sounds, however, and it takes 90 minutes of Hong Kong stock footage to get there. Jack Palance looks bored.

Kino Lorber released this obscurity (through its Code Red subsidiary) on Blu-ray in 2018, with no notable extras.—John Francis Klingle

Ichi the Killer (2001) ★★1/2

Koroshiya 1

DIRECTED BY: Takashi Miike

FEATURING: Tadanobu Asano, Nao Ohmori, Shinya Tsukamoto

PLOT: A sadomasochistic Yakuza relishes being hunted by a mysterious hitman named Ichi, hoping the killer will bring him to undreamed of heights of pain.

WHY IT WON'T MAKE THE LIST: *Ichi* is strange, for sure, but as important as it was in developing Takashi Miike's cult and bringing his work before more round-eyes, it values gruesomeness and shock value over pure weirdness.

COMMENTS: *Ichi* is notorious for its violence and sadism, and rightfully so; but, as a Takashi Miike joint, it bears an undeniable brand of quality and style. Also, as is typical with Miike, it's uneven, almost by design, changing from yakuza intrigue to gross-out torture fest to campy black comedy at the crack of the director's whip. Tadanobu Asano gives a cool, cult star-making performance as Kakihara, the ruthlessly sadomasochistic villain with dyed blonde hair and unexplained facial scars that have carved his face into a perma-Joker grin. But although torture and gore is pervasive and extreme throughout *Ichi*—including a man hanging suspended from hooks dug into his skin, among other atrocities—the violence in Miike's masterpiece *Audition* is far more harrowing and meaningful, because fleshed-out human beings whom we can care about suffer (and inflict) it, instead of pain being just a sick exhibition occurring between caricatures.

Ichi the Killer is one of those canonical cult movies (like *Donnie Darko*) that is constantly being restored, tinkered with and reissued in new editions. The latest on offer is the 2018 Blu-ray from Well Go USA, which bills itself as the "definitive remastered edition." While it is reportedly an improvement on the 2010 Blu from Tokyo Shock, it lacks any significant supplemental features aside from the decade-old commentary track from Miike and original manga writer Hideo Yamamoto, recycled from an old DVD release. As is the case with any release, it should go without saying to beware the English-language dub.—Gregory J. Smalley

Mishima: A Life in Four Chapters (1985) ★★★★1/2

DIRECTED BY: Paul Schrader

CAST: Ken Ogata, Yasosuke Bando, Masayuki Shionoya, Toshiyuki Nagashima

PLOT. The life and works of celebrated Japanese writer Yukio Mishima are portrayed through a triptych of styles: events from his past life are in black and white, his last day is in color, and renditions of segments of three of his novels—"The Temple of the Golden Pavilion," "Kyoko's House" and "Runaway Horses"—are staged like plays on elaborate studio sets.

WHY IT WON'T MAKE THE LIST: While the film's narrative doesn't strictly follow the conventions of a biopic, it's not very strange either. The eccentric novel adaptations provide most of the weirdness, but their context is a rational exploration of the writer's imaginarium and the subjects that most haunted him.

COMMENTS: Paul Schrader captures the essence of Japanese traditionalist writer Yukio Mishima in an unconventional biopic that feels like a guided tour through the author's mind. Blending black and white memories with dreamy lush reenactments of segments from three of his novels, plus a straightforward account of his last day, what emerges is a coherent portrait of the author and his main artistic preoccupations, such as the nature of beauty, the self, and the traditional samurai values of feudal Japan, contrasted with the nation's current state of materialism. The film is accessible to those unfamiliar with Mishima (although, naturally, more rewarding to readers), while encouraging further exploration. As a fan of Mishima (which may give me a slight bias towards Schrader's film), I couldn't be more satisfied by such a devoted and organic portrait.—Rafael Moreira

Monty Python's The Meaning of Life (1983) ★★★★

DIRECTED BY: Terry Jones, Terry Gilliam ("The Crimson Permanent Assurance" and animated sequences)

FEATURING: Graham Chapman, John Cleese, Eric Idle, Terry Jones, Michael Palin, Terry Gilliam

PLOT: Monty Python discusses life, from the sanctity of every sperm to the rudeness of the Grim Reaper, in a series of sketches.

WHY IT MADE THE LIST: Monty Python were *the* pioneers of modern surreal comedy; without the groundwork they laid, there would be nothing to show on "Adult Swim." Python is too important to weird culture to go unrecognized on a list like this, and *The Meaning of Life* is their weirdest big screen work, the equivalent of an R-rated "Flying Circus" episode with nudity, blasphemy, grossout humor, absurdity, and, of course, fish.

COMMENTS: Although the Pythons are essentially all on the same sketchy page in this swan song/shameless cash grab, Terry Gilliam provides a bit of a "White Album" vibe to the proceedings by going off to do his own thing with his segment, "The Crimson Permanent Assurance," a bit about elderly workers literally mutinying at an insurance concern/future pirate ship; it grew so long and tonally distinct that it had to be split off from the main film to play as an introductory short. Among the succeeding sketches, *The Meaning of Life* features the most unapologetically and outlandishly surreal bit in the Python canon: a little intermissory lark called "Find the Fish" starring three characters straight out of a Salvador Dalí painting (if Dalí had painted punk transvestites with faucets attached to their nipples) wondering "where is the fish?" *The Meaning of Life* promises to "sort it all out," but it only depicts a banal human existence that's full of vanity, senseless obedience to authority, craven cowering ("forgive us, oh Lord, for this, our dreadful toadying..."), bullying, infighting, lying, missing fish, absurd bureaucracy, gluttony, lust, and the amazingly dumb answers people come up with to try to find meaning in life, all capped off, in the best case scenario, by an unimaginative afterlife of bourgeois boredom in a tropical hotel lounge. Uneven, occasionally startling, vulgar, clever, bizarre, pointless, and frequently hilarious... that is *The Meaning of Life* (both the movie, and the abstract concept).

As is usual with Python discs, *The Meaning of Life* 30th Anniversary Blu-ray is packed with extras and gewgaws. It features a commentary by Terry Gilliam and Terry Jones and a second "commentary," "Soundtrack for the Lonely," which is just the sound of a guy (Palin) settling into a chair, pouring a drink, sniffing, and occasionally muttering to himself (but keep listening, in case something else happens). There's also a short introduction by Eric Idle, who recites the poem used to pitch the film to Universal; the deleted scenes (mostly extended versions, but there are two completely new sketches including the absurd "Adventures of Martin Luther"); a 49-minute "making of" featurette; "Education Tips," a six-minute comic short starring Cleese and Palin; "Un Film de John Cleese," Cleese's re-cut of the trailer; "Remastering the Masterpiece," a tongue-in-cheek description of the restoration process from Gilliam and Jones; "Song and Dance," a featurette on the musical numbers; "Songs Unsung," with alternate versions of the showstoppers; various trailers and promos; a 3-minute "Virtual Reunion"; and "What Fish Think," a 16-minute shot of an aquarium with the surviving Pythons describing their aquatic thoughts. Finally, if all that's not enough, there's an hour-long reunion of the cast (sans the late Graham Chapman and with busy Eric Idle chiming in via Skype). And the Terry Gilliam-style animated menus are a treat to watch in

themselves. *Monty Python's The Meaning of Life* is also available for purchase or rental on-demand; personally, given how cheap the Blu-ray is (ten bucks at the time of this writing) I'd spring for the disc in this case, but you can live your own life in your own way if you want to.—Gregory J. Smalley

Scarlet Diva (2000) ★★1/2

DIRECTED BY: Asia Argento

FEATURING: Asia Argento, Jean Shepherd, Joe Coleman

PLOT: A hot young Italian actress has dirty sex, encounters Hollywood scumbags, and does too much Special K while looking for true love.

WHY IT WON'T MAKE THE LIST: This semi-hallucinatory semi-autobiography, the directorial debut of Dario Argento's actress daughter, is merely a curiosity, though frequently an outlandish and entertaining one. It's made with all the taste and subtlety you would expect from a woman with an angel tattooed over her crotch.

COMMENTS: *Scarlet Diva* is an experimental art movie that wouldn't have been out of place on "Cinemax After Dark." It is timely because, among its many unsavory anecdotes, it includes a fictionalized version of the actress' real-life sexual abuse at the hands of now disgraced producer Harvey Weinstein. Yet that episode is only one of the many chaotic tales in this rambling confessional that plays like a trashy tell-all bestseller brought to life by an ambitious film student who hadn't quite decided whether she wants to direct for the arthouse or for the late night cable market. So you get a hog-tied nude roommate, childhood flashbacks, a puking scene, dream sequences, a drug trip complete with an out-of-body experience, a religious bestiality icon, aerobics in leopard-skin panties, screaming into the void, an encounter with a horny heroin-addicted genius, and Asia nude shaving her underarms while Nina Simone sings "Wild is the Wind."

Film Movement Classics treats *Diva* like a Criterion-worthy masterpiece. There are tons of supplements, including an 8-minute "making of" featurette; an archival Asia Argento interview; multiple versions of the trailer, including an 8-minute promo; and an odd piece called "Eye of the Cyclops" where Joe Coleman talks about his role in the film while showing us his titular conceptual art piece. It's capped off by a personal, somewhat uncomfortable commentary track where Argento almost breaks into tears at times, curses at Weinstein, and refuses to discuss certain painful scenes in detail.—Gregory J. Smalley

The Texas Chainsaw Massacre: The Next Generation (1994) ★★

DIRECTED BY: Kim Henkel

FEATURING: Renee Zellweger, Matthew McConaughey, Robert Jacks

PLOT: Teenagers leave prom, get in accident, get lost, meet cannibal slaughter family.

WHY IT WON'T MAKE THE LIST: There are many ways to get onto the List of 366 Weirdest Movies Ever Made. Stir-frying the original movie in your franchise with some sprinklings from Robert Anton Wilson's spice rack, alas, is not a sufficiently potent recipe.

COMMENTS: This iteration of the classic hack-n-slash horror series takes no chances and makes no effort beyond the bare minimum. It deliberately doesn't take itself seriously, while trodding over a plot almost identical to the original. It has a few humorous moments but

overall seems to be made with a spirit of self-loathing. The one unique twist, explaining there's a secret government conspiracy behind the backwoods cannibal family which is how they never get arrested for their crimes, is not enough to keep this chainsaw from running out of gas.

Despite its generally poor reputation, in 2018 Scream Factory released *TCM:TNG* in a lavish Blu-ray "Collector's Edition" with two versions of the film (theatrical and director's cut), director's commentary, and multiple interviews.—Pete Trbovich

True Stories (1986) ★★★★1/2

DIRECTED BY: David Byrne

FEATURING: David Byrne, John Goodman, Swoosie Kurtz, Spalding Gray

PLOT: An eager outsider (Byrne) visits the fictional town of Virgil, Texas as they prepare for the state's 150th anniversary with a "Celebration of Specialness."

WHY IT MADE THE LIST: His goofy, gangly persona—so out of place in the rural Texas setting—is already weird enough, but really Byrne is exposing the weirdness of everyday life, with eccentric characters, loud costumes, eclectic musical numbers, and a lot of fourth wall breaking. It's a strange merging of artistic experimentation and down-to-earth themes; the combined effect is both charming and bizarre.

COMMENTS: With little driving narrative and various documentary-like snippets, *True Stories* plays out as a hodgepodge of anthropological study, quirky comedy, rock musical, and cultural time capsule. The film is a visual kaleidoscope of kitschy '80s Americana style, while offering an eclectic Talking Heads soundtrack that pulls in various local sounds from Mexican zydeco accordions to Southern guitar twangs. But what really stands out about it is David Byrne's genuine eagerness, his honest interest in everyone he meets. He reminds us that even a seemingly ordinary small town is populated by oddballs and dreamers, artists and conspiracy theorists, loners and lovers.

HOME VIDEO INFO: Criterion's 2018 DVD and Blu-ray shows a restored 4K digital transfer, supervised by David Byrne and cinematographer Ed Lachman, with 5.1 surround DTS-HD Master Audio soundtrack. Along with deleted scenes, there is also a new making-of documentary featuring various folks associated with the film, a documentary about graphic designer Tibor Kalman and his influence on David Byrne, and a short about the fictional town of Virgil, TX. The CD that accompanies the Blu-ray contains the film's complete soundtrack, available for the first time. This bonus is Blu-ray only; the CD does not ship with the DVD version of the film. The booklet is designed as a tabloid newspaper, with new essays, a 1986 piece by Spalding Gray, and clippings from *Weekly World News* that inspired the film.—Alex Kittle

Underground (1995) ★★★★★

DIRECTED BY: Emir Kusturica

FEATURING: Predrag Manojlovic, Lazar Ristovski, Mirjana Jokovic, Ernst Stötzner, Slavko Stimac, Srdjan Todorovic

PLOT: Marko, a corrupt Communist party functionary and black-market arms dealer, hides his partner Blacky in an underground compound, tricking him and his coterie into believing that World War II never ended while they continue to

crank out rifles and grenades.

WHY IT MADE THE LIST: Up until the third act, *Underground* plays as an absurd, Balkanized satire---a far wilder ride than the average moviegoer is accustomed to, but not a film that went all the way to "weird." That final half-hour, however, pulls out all of reality's stops, sending the film off into a nightmarishly surreal conclusion, then soldiering on to a more conciliatory mystical ending. It's the perfect, weird way to cap off a world cinema masterpiece.

COMMENTS: *Underground* is a strange combination of nostalgia for the vanished Yugoslavia (it begins with the line "once upon a time there was a country," which is also the title of the television version) and of satire largely centered on the corruption of the same vanished Yugoslavia. The film is split into three chapters set in three different historical periods: there's "War" (which begins with the Nazi bombing and subsequent occupation of Belgrade); "Cold War" (the Communist era); and "War" (again), the short, horrific finale set in the then-raging Yugoslav wars. Despite the fever dream finale featuring a burning wheelchair that moves under its own power, you need not fear a downer ending, because *Underground* finishes with an oddly satisfying epilogue to its own epilogue: a vision of Yugoslavian heaven, which naturally takes the shape of a drunken feast, with everyone young and virile again and dancing to a brass band. *Underground* is fast-paced, funny, epic, antic, melancholy, and full of irrepressible life, packed with characters and set pieces that linger in the memory and overflowing with ideas, incidents, and hyperbole, an instant classic combining carnivalesque spectacle with historical substance.

In 2018 Kino Classics released the ultimate version of *Underground*, including the six-episode, three-plus hour television version ("Once There Was a Country") alongside the theatrical cut. The DVD set is three discs; the Blu-ray release hosts the film itself in the high-def format, but provides the TV version and supplements on two discs. As might be expected, the extended story has both its pluses and minuses. On the negative side, there are a lot of subplots that add little to the overall story, but only make the already overstuffed tale feel more bloated. The satire is slightly diluted as the story at times becomes more of a Scorsese-style gangster tale with a comic spin. Marko and Natalija's sex scene is greatly lengthened, and is far more disturbingly sadomasochistic than the version that made the film; like many of the extended scenes, I find this to be a kind of unfortunate sabotage of the lighter tone of the theatrical version. On the positive side, some of the new inclusions do add meaningful context: more details about the arms trading subplot, and the moving death of Natalija's brother (a minor character who simply disappears from the film version). Also, the television cut makes Ivan more of a central character, fleshing out the period between his escape through the tunnels and his incarceration in Berlin. Perhaps the biggest differences in the longer version is that the more time we spend with Marko and Blacky, the less sympathetic they become. The extra features are behind-the-scenes footage; interviews with the director, the three stars, and the production designer; and the meaty 75-minute 1996 making-of documentary *Shooting Days*. Naturally, the trailer and an informative booklet essay from Kusturica expert Giorgio Bertellini cap off an impressively comprehensive release. It is a must-buy for *Underground* fans.—Gregory J. Smalley

Urusei Yatsura 2: Beautiful Dreamer (1984) ★★★1/2

DIRECTED BY: Mamoru Oshii

FEATURING: Voices of Toshio Furukawa, Fumi Hirano, Machiko Washio, Akira Kamiya, Takuya Fujioka; Wayne Grayson (as Vinnie Penna), Roxanne Beck, Marnie Head, Draidyl Roberts (English dub)

PLOT: A group of Japanese teenagers--including a flying alien girl--suddenly realize that the day before school starts is repeating itself over and over; things get even stranger when they investigate.

WHY IT MADE THE LIST: *Beautiful Dreamer* co-stars an amorous flying turquoise-haired alien in a tiger-striped bikini. Not only is that not the weirdest thing in the movie, it's the touchstone of normality in a film that drops the romantic slapstick conventions of the TV series it was adapted from in favor of a mind-bending trip, bearing its characters into dreamlike worlds on the back of a cosmic turtle.

COMMENTS: What would happen if you took a beloved Japanese sitcom-style cartoon about a boy-crazy alien and turned it into a feature-length "Twilight Zone" episode? The answer is *Urusei Yatsura 2: Beautiful Dreamer*. An American pop culture analogy might be if a young Darren Aronofsky had directed a feature film version of "The Simpsons" as a serious psychological thriller, while staying true to the characters and sense of humor. With *Beautiful Dreamer*, Oshii hit a sweet spot between the popular and the esoteric, balancing flippant romantic comedy with a degree of darkness that sometimes threatens to take the film into the dark thickets of fairy tales; but no matter how far that turtle plot carries the dreamers, they will return from the Dragon Palace back to where they started.

The enduring popularity of the "Urusei Yatsura" franchise in general, and the excellence of this installment in particular, has kept *Beautiful Dreamer* in print both in Japan and overseas. In 2018 it received a "collector's edition" DVD and Blu-ray release from Diskotek Media. I'm skeptical about the added value of putting an unrestored 1984 movie out in hi-def (DVD should do just fine), but those who insist on the format should be pleased that they no longer have to turn to Japanese sources. Viewers have the option to watch in the original Japanese or in the vintage English language dub, which goes back to the days of VHS. Unfortunately the voice acting often leaves something to be desired: Nurse Sakura's line readings are particularly uninspired, which is a shame since she is the voice of reason and the authority explaining what's actually going on. A great commentary by director Oshii headlines the extras (tip: listen to the English dub while reading the commentary in subtitles). Other features include both the original Japanese and English language VHS trailers and a selection of digital "liner notes" (a tradition for the "Urusei Yatsura" releases) explaining the history of the release and pointing out Japanese cultural references (like the legend of Urashima Tarō) that would otherwise go over most Westerners' heads. There's even the original English dub credits, for obsessive completists. *Beautiful Dreamer* is also available on-demand (free for Amazon Prime subscribers). At the time of this writing the dubbed version was also available to watch for free (with commercials) on Crackle. There's no guarantee that will still be true by the time you read this, of course.—Gregory J. Smalley

BONUS/MISCELLANEOUS CONTENT

Alfred Eaker vs. the Summer Blockbusters

Ed. Note: Each year, curmudgeonly critic Alfred Eaker posts a poll asking 366 Weird Movies' readers to send him to a Summer Blockbuster (or two, or three), and agrees to abide by their decision and report on what he sees. Here is 2018's version of his ongoing experiment in cinematic masochism.

Slender Man (2018) is a movie that shouldn't be watched alone. Not because it's scary, but rather, if one has to suffer through a movie this wretched, you might as well have someone to suffer through it with.

I am tempted to leave this review at that and call it a day because it rather sums it up. However, since 366 Weird Movie readers inexplicably voted to send me to this dung heap more than any other movie in the 2018 summer blockbuster poll, I might as well give your money's worth, and count it as my penance for all the readers that I've pissed off over the last nine years.

I do recall some reader was shocked that I had never heard of the Slender Man. A co-worker (a clown actor—I mean, he literally plays a clown) who saw it before me texted that the movie was "ratchet," but it was worth seeing because the girl was "thicc." I thought I had detected a couple of typos. After he texted back ROTFL, I deduced I had better Google a millennial translator. Job done, I texted him back that this is why I sometimes feel, if you're under 40, I'm probably going to hate you. (Not really, of course. Overall, I think millennials are a better lot than my baggage-saturated generation.)

Back to the movie, if we must.

Humphrey Bogart once complained that Hollywood intentionally putting out bad movies was like Ford intentionally putting out bad cars. Sylvain White's *Slender Man* is such a case. It's lazy filmmaking at its worst. This is White's fourth American film, and although he is mostly known through television work, he has the distinction of helming a string of American feature film flops. One would think that would deter producers. Not at all, especially when their sole concern is to cash in on an internet-based urban legend, a lot of yawn-inducing fan fiction, and a 2014 fan stabbing, which was detailed in the 2016 documentary *Beware the Slender Man* (that received mixed reviews). White, who has made his reputation mostly for small screen work and the 2013 French thriller *Mark of Angels*, had to have known David Birke's script was a derivative waste. This is not going to help his resume.

Even producers were aware this is a rotten egg, extending their review blackout date by 24 hours.

The film had potential; all of which was flippantly squandered. When the 7-foot tall actor at the haunted house I work for took the guise of Slender Man to pass out fliers last season, throngs of people freaked out, and it made the news. The actor didn't actually do anything. He just walked around in the mask and suit. The scare factor lies in people's perception from the social media history. The film unwisely focuses too much on the character, bringing him to life through a scenario we've seen countless times before: a group of vapid teens, hearing about the legend, Google "Slender Man" (no, I'm not kidding) and close their eyes, ding go the church bells, and lo and behold, he is summoned forth through what looks 10th generation Photoshop FX ripped off from *The Ring*. Of course, the teens fill every stereotypical prototype, and can't die

soon enough. One of the brood gets kidnapped by Slender Man and what follows is a brief detective subplot that has all the horror of Snoopy playing Sherlock Holmes.

Slender Man apparently likes modern technology because he somehow makes cellphones squeak, messes with the kids' jams, and even sends really wacky (and badly edited) video footage to potential victims. The hair on the nape of my neck was standing on end. Actually, it was the cinema air conditioner (we are in our third week of a 100 degree weather). How does Slender Man do all this? Why does he do all this? These are questions that the world may never know.

And of course, just when you run and turn the corner, bam! Slender Man is there! But, even the jump scares are few and far between. At least Freddy had that in his worst outings. *Slender Man* commits not one, but two cardinal genre sins: it's a scary movie that's not scary, and it's a total bore to boot. As for the "thicc" chick (how do you pronounce that? Does it rhyme?), I have no idea which "chick," the clown actor was referring to but, maybe that's because I'm in my mid-fifties.

"*Slender Man* is so bad…"

"How bad is he?"

Slender Man is so bad, that fanboys aren't even claiming there's a critical conspiracy to make fun of the character.

Slender Man is so bad, that for once audiences and critics actually agree.

Slender Man is so bad, that I actually saw four patrons (there weren't many to begin with) walk out within a half hour.

Slender Man is so bad, that our House of Shadows actor, who's been playing Slender Man for three years, had plans to use the occasion of the film's opening weekend to dress again as the character and pass out fliers.

Then, he saw the movie …

…and promptly canceled his plans.

If readers overwhelmingly picked this movie because they thought it was going to be "cool" (or insert whatever millennial slang one uses), you utterly failed.

However, if readers picked *Slender Man* as a form of sadistic revenge upon me, they triumphed.

* * *

Every year that 366 Weird movie readers have sent me to the summer blockbusters, I've managed to actually see one good, or at least remotely passable, movie picked from the poll. Not so in 2018. All three picks, including *The Meg*, scraped the barrel's bottom. 366 readers found the summer goldmine of blockbuster feces, but didn't even bother to spot me for a pack of peanut butter M&Ms to alleviate their sadism in sending me to both *Slender Man* and *The Meg* in one weekend. As this may be (or not) our last summer blockbuster together, I'll thank you for not sending me out with a bang, but rather feeling like Bela Lugosi barely getting through a trilogy of Ed Wood Jr. embarrassments. Actually, neither movie was as fun as a Wood opus. If only he were still around to inject some inspired lunacy. That's the problem with *The Meg*; it neither realizes its dumbness, nor is it dumb enough. It's not hard to imagine the boardroom scenario: "We're going to do a shark movie. *Jaws* made a ton of money."

"The last few Jaws movies were flops."

"Yeah, so we're going to change the name to *The Meg*."

"'The Meg'?"

"Yeah, like the Megalodon. So, see instead of it being a 25 foot great white, it'll be a 75 foot prehistoric shark."

"So, kind of like *Jurassic Park* meets *Jaws*?"

"Exactly. We throw in a good looking cast and we'll make a killing."

And it is making a killing, because as long as something is marketed right, Americans will consume anything that is fed to them. In his TV and film career, spanning 25 years, director John Turteltaub has been consistent in never once having an original thought or producing an original work. In short, he's a hack, and if he has anything resembling a style, it is his derivativeness.

In an interview with Collider, Turteltaub defends his excrement with "I didn't set out to win any awards," which is the paint-by-numbers auto-response for something embarrassingly bad. Although he did admit that he wanted it to be "R" rated (it might have helped) and hinted at a lot of studio interference, he also had the chutzpah to claim he didn't pander to audiences, before then talking about the ways in which he *did* pander to audiences. I wouldn't doubt studio interference, but I doubt it would have been much better had the studio left him alone to craft his masterpiece.

Usually, the legitimate complaint about *Jaws* rip-offs is that they take Stephen Spielberg's reworking of Melville's story about three men, one of whom is an Ahab-like character, facing a community terror, and turn it into a slasher film focused on a shark who is a replacement for Michael Meyers. Still, with as little as Turteltaub had to work with from the screenplay (Jan and Eric Hoeber and Dean Georgaris adapting the "reportedly" superior novel by Steve Alten), it might have been smarter to focus more on the beast. Instead, he makes the movie a star vehicle for stud muffin Jason Statham as Jonas (you know; the Bible guy in the belly of the whale).

While Statham is no Robert Shaw, he does have adolescent charisma that would do, if only the movie supplied him plenty of shark ass to kick.

There's an early nod to submarine-in-peril melodramas (e.g. *Gray Lady Down*) that requires an expert rescuer. Of course that would be Jonas, but he has a haunted past. The portrayal of inner torment, however, is a mere sketch that can't offer the pathos of a U.S.S Indianapolis experience or anything in the way of Old Testament lessons. Then, the movie makes a fatal mistake. It spends the next half on... nothing. Instead of offering anything in the way of characters, there's a lot of techno mumbo jumbo, mixed with occasionally cheesy dialogue, including about a half minute of a half-baked sermon about the immorality of hunting whales, etc.

Clichéd archetypes abound; the shady billionaire financier, the joker sidekick, and a potential romance with a marine biologist (Bingbing Li) who, despite being smart-as-a-whip, needs rescued a lot by he-man Jonas.

Then, there's the shark, which is a complete CGI failure. Spielberg's mechanical shark Bruce, for all its off-screen malfunctioning, felt threatening. That is not the case with the Meg, which looks like a souped-up version of the 70s Saturday morning cartoon "Jabberjaw." She whizzes by, and we never actually sense her there.

The late-in-the-film big set piece is a blatant rip-off of the beach scene in *Jaws*. For a moment, it looks like it's either going to one-up the original source, with an ocean-full of primary colored balloons and lifejackets and a poor tyke about to prove that the world is one big restaurant; either that, or turn into U.S.S Indianapolis-meets-*Godzilla*. But, it's too late in the game, and the movie chickens out of going either direction. The scene, like the film itself, evaporates.

I vividly remember seeing *Jaws* on its opening weekend in 1975. Dad took us to see it, and the

theater employees were busy cleaning up from the previous audience where someone had vomited. Everything in *Jaws*—from the two guys on the pier complaining about a wife's roast, to Scheider's famous improvised, sweaty line, to the interplay between Dreyfuss and Shaw (most people don't get the beer can image today since beer cans in 1975 were made of a harder aluminum, not tin)—all of it seemed intimate, which heightened the horror.

Comparatively, *The Meg* is an adolescent cartoon, and not even a fun one at that.

* * *

Brian Henson has daddy issues, Melissa McCarthy continues to commit career suicide, and *The Happytime Murders* may be the worst movie of the decade. For those in a hurry, you can go now. I wouldn't blame you one damned bit if you did. For the rest of my fellow masochists, I'll elaborate, and make it mercifully briefer than this movie's torturous 90 minute running time.

The first time I read about *The Happytime Murders*, the description was a single sentence that went something like: "A movie about a serial killer who preys on Muppets." My initial thought was, that premise is so weird, how can it go wrong?

Oh, it went wrong. Apparently Brian Henson feels that he doesn't measure up to daddy, so much so that he's gone the distance to butcher his pop's legacy and intentionally produce something so wretched as to provoke Jim's ghost. I hope it worked, because nothing else did in this mess, which is essentially the Muppets go *Porkys* with a few murders and fish-out-of-water Melissa thrown in. At least *Porkys* had a few (very) strained laughs, and Melissa's previous "blockbuster," the *Back to School* rip-off terribly directed by hubby Ben Falcone is, comparatively, an endurable fun fest. *Meet the Feebles* (1989) this is not. Congrats should possibly go to Ben now that Henson has now replaced you as your wife's worst director. However, since Ben is this film's producer….

Henson has no idea what to do with his premise, and resorts to gags like Muppet sperm (silly string) and S&M puppet porn parlors. McCarthy is not only back to fat jokes, but after a confused Muppet offers her oral sex, she quips "I wish I had a dick for you to suck." Yuk. Yuk.

But see, she's kind of a Muppet herself because, after being wounded in a sort of backstory shootout, it turns out she received a liver transplant from a dead Muppet, and the reason for that revelation? If you find out, don't bother to share.

There's a paper-thin parody of film noir detectives and a half-assed, insincere allegory of puppets as abused and oppressed minorities; which is blatantly condescending, as is the endless barrage of caricatures and stereotypes.

McCarthy is essentially rehashing her crude cop from Paul Feig's *The Heat* (2013) and doing it much more poorly here. She clearly cannot distinguish between a good script and a bad script, and since audiences seem to tend to think that the actors just make up movies as they go along, McCarthy will take the lion's share of the blame. Henson, who clearly was planning this as the initial entry in a new franchise, forgot the old adage about first impressions. With both critics and audiences in rare agreement, *The Happytime Murders* tanked on its opening weekend. It deserved to. The credit bloopers suggest the cast and crew had a blast making it. That fun is not at all in the movie, and everyone involved knew it.

Hands down, 2018 is the worst summer of movies I can recall.—Alfred Eaker

Fantasia Festival 2018 Diary: Slices of Strange

Ed. Note: Giles Edwards recounts his annual trek to the Fantasia Film Festival. Longer reviews and interviews from this trip are scattered throughout the present volume.

Arrival

Anyone traveling internationally should heed this advice: nothing hurries customs agents along faster than the phrase, "I'll be covering a film festival." Two years in a row now I've seen the *Dear God, all right, moving on…* expression at the border when explaining the reason for my trip.

So without further ado, the reason for my trip: Fantasia Festival movies!

7/12: Nightmare Cinema (Anthology)

"Horror" isn't really my preferred genre—I either find it too pointless, or too scary (!). "Anthology" also isn't my preferred film format — I typically want one movie to carry itself. Combining the two, however, works out well: it allows for a taste of a director's work without committing the viewer to overkill. Mick Garris, supervising a clutch of Horror luminaries, has put together a string of varyingly good vignettes. "The Thing in the Woods" (dir. by Alejandro Brugues) tells the tale of a handful of twenty-somethings making incredibly bad, incrediblier rapid-fire decisions as if they can't get to their gruesome fates fast enough. "Mirari" (dir. by [the Legendary] Joe Dante!) deftly taps into the fears of plastic surgery gone awry. "Mashit" (dir. by Ryuhei Kitamura) is pretty ho-hum, until the very Catholic (that is to say, "Unorthodox") slaughterhouse finale. And "Dead"(?) concerns a boy who, having been … dead … for seventeen minutes can now see the … dead.

What stood out with its bleak tone, creepy understatement, and grisly ambiance, however, was "This Way to Egress" directed by David Slade of *Thirty Days of Night* fame. A mother of two boys is growing increasingly unhinged after her husband leaves her, resulting in her seeing her surroundings and people she meets looking ghastlier and uglier as the hours go on. Her psychologist just about recommends suicide before heading off to a meeting. This short stood out even more so because, unlike *Thirty Days of Night*, it is well-written, very unnerving, and left me creeped the Hell out. (Somewhat appropriately.)

7/13: La Nuit a dévoré le monde (The Night Eats the World)

If any of our readers are fans of the zombie/undead/shuffling corpse-people genre, they should check out Dominique Rocher's directorial debut. Our hero, Sam (Anders Danielsen Lie), passes out in the back room of his ex-girlfriend's apartment after an awkward encounter at a party. Upon awakening, he finds that Paris' entire populace has become little more than walking corpses. What follows, however, is much more a meditative experience than the jump-scare/slasher-thing that the genre usually provides. Sam embraces his extreme isolation in his barricade, and the over-all soundscape is "quiet." In fact, about 80% of the movie goes by before there is any violence to speak of. It's not too weird, but it is a unique take on the undead. (By the way, this feature was preceded by the horror-cum-cutesy short, *The Monster Within*; Ghislain Ouellet's film is worth hunting down if you want another unique take on the near-death/haunting experience.)

Unfriended: Dark Web

Golly, it would seem that I'm being bombarded with horror, horror, horror. But I was pleasantly surprised by Stephen Susco's slice of modern reality — somehow he pulls off the central gimmick (the movie is in real time, displayed exclusively on one lap-top screen) with aplomb and some real tension. In *Dark Web*, a good-natured gang of twenty-somethings (of course) are planning to play a game of "Cards Against Humanity" over Skype. Things go sideways when the starring laptop, operated by slacker Matias (Colin Woodell), is found to hold some *very* unsettling videos. Obviously the gang of youths could have made some better choices as the whatsit hits the fan, but it all holds together nicely. And if you're willing to accept the central conceit that there are a lot of nasty "black hats" out there, well, it comes close to being believable.

(*It just occurred to me that opening weekend was the weekend of Friday the 13th. Mystery of horror solved.*)

7/14: Hanagatami

Epic in both scope and length, Nobuhiko (*Hausu*) Obayashi's latest film (and would-have-been swan-song, had he not recovered from a stage-four lung cancer diagnosis) concerns the interconnected lives of six young Japanese in the years just before the empire's attack on Pearl Harbor. The title translates roughly into "Flower Basket," an audio motif found throughout the film in a recurring song about a young man who went off to war. The heightened color palette, micro-flashbacks, and a tightly constructed cyclical soundscape maintain a sense of dreaminess: pleasant in the first act, subdued in the second, and morphing into darkness in the third. The six leads do a fine job in capturing their archetypes—naive, simmering, stoic, buoyant, awkward, and tuberculotic—but the boys' professor (played by film veteran Takehiro Murata) stands out in particular. His statement, "art should have no borders", is a message Obayashi must hold dearly in his heart. Any fans of Obayashi in particular and of artful Japanese cinema in general should check this out.

Buffalo Boys

Oh how I wanted to love this movie. I truly did. The crowd loved it. I didn't *dis*like it. This revenge tale of an avenging uncle and his two avenging nephews returning to Indonesia to exact revenge for their family's murder hits a bunch of right notes, but veers so much between *The Three Amigos* and *The Proposition* in tone that it is impossible to take it at face value. I must say, though, that the villain—a Dutch colonial commandant by the name of Van Trach (Reinout Bussemaker)—makes this action/adventure piece just about worth it. He's the kind of psycho who by day will execute just one innocent family member (instead of two) and regard it as a praise-worthy kindness, and by night can be found brooding in front of a portrait of himself before raping the indentured help. Nasty stuff. Unfortunately, it is interrupted with so much Disney-Smiley-Gung-Ho that the movie just crumples. Directed by Indonesia's Mike Wiluan, a producer in his first directorial outing.

7/15: Aragne: Sign of Vermillion

I'm torn about whether to bring this to your attention, as I have very little good to say about it. I write this, though, to warn away anyone seeking a solid, unnerving, stylized anime. Saku Sakamoto's movie starts very well, but almost had me walking out by the middle. The uncontextualized, the unexplained, and the utterly meandering swirl repetitively across the screen in a haze of needlessly complex-yet-clunky editing and neat-o visuals (if you don't like evil maggoty things, consider this your second warning). A young woman begins seeing mysterious bugs after she moves to a housing block built on an old industrial site. Her primary

sin, along with the rest of the characters, is never, ever making me care about her fate. A handful of very promising ideas (other-dimensional creepy bugs and military death projects from '44, among them) just shuffle to the periphery of the "was that real?" quandaries and jump-scares. Never have I looked at my watch more during a 70-minute movie.

L'Inferno (1911)

I hope that I hold up this well when I'm 107 years old. It would probably help, though, if I had a legendary electro-prog score composer following me around during my adventures. One of the great daddies of cinema wowed the audience with a performance by Maurizio Guarini (of Goblin fame) that breathed fresh new life into the sometimes creaking source material. Chronicling Dante's trip through Hell under the guardianship of the poet Virgil, *L'Inferno* remains an impressive piece of cinema after all this time — even if it does remind the viewer that there were few things Dante liked more than placing anyone he disagreed with in eternal torment. From my vantage point near the front, I needed only to shift my gaze left to see Guarini plugging away solo on a keyboard. His prowess and enthusiasm carried the piece, and he's as tireless as ever after so many decades of constant creativity. The event was naturally sold out, and even with my press badge and an hour-ahead arrival, I barely got in. Well worth the sore feet from waiting in line.

Crisis Jung

That was one of the strangest things I've seen.

But we don't have to worry about it because it's actually a collection of animated web shorts! Bwahahahaha.

After the reign of the love-extinguishing "Petit Jesus" begins on earth, the ground is scorched, the oceans are dried, and mankind is beset by famine, thirst, and roaming gangs of maniacs with chainsaws where their privates should be. Traveling across this milieu is the legendary hero, Jung, who wishes to reunite with his true love Maria. Through repetition, trials, and devouring his co-adventures, he eventually becomes strong enough to battle Petit Jesus. The Parisian psychos behind bobbypills.com have assembled, in stunning 4K, their collection of hyper-(hyper-)violent episodes of Jung's comic adventure. Join him as he overcomes Compassion, Fortitude, and a slew of other monsters with his ten punch hit.

7/16 Mega Time Squad

New Zealand has a new director to watch out for: *Mega Time Squad*'s Tim Van Dammen. My interest in the picture was cemented when I randomly met Tim while loitering in the Fantasia media room. An affable man, he's created an affable comedy with a time-screwing twist. John (Anton Tennet), a collection boy for the crime boss of comatose Thames, NZ (pop.: not quite 7,000), loves his work — until he gets a bug in his ear about stealing thousands of dollars from an incoming Chinese gang without giving his boss the goods. With the aid of a mystical bracelet, he stumbles through countless bad decisions by zapping time backwards, in the process zapping John after John after John into being. Madcap capering ensues against the half-horse-town backdrop: will John(s) survive, trick the bad guys, grab the cash, and win the girl? It'd be a certainty if only he weren't so dim — but then, time is on his side. (Recommended!)

Ambiance

Demolition is going on not too far from my window. Apologies in advance for any typos or misinformation; I'll blame the occasional ground shudderings and Carbon Monoxide I've been reading warnings about.

7/17: The Nightshifter [Morto Não Fala]

Nightshifter's director, Dennison Ramalho, has been hovering around the periphery of the Fantasia Festival with shorts for over a decade now. During that time has met José Mojica Marins (of "Coffin Joe" fame), looking for that filmmaker's ring (a gift from Boris Karloff's wife) on the dark floor of the cinema, as well as Ken Russell (of Ken Russell fame) at the Fantasia screening of *A Serbian Film*.

What Ramalho brings to the table in this feature-length outing is a refreshing bit of horror (!) revolving around a morgue attendant, Stênio, who can speak with the dead. When he makes the mistake of misusing their information he is doomed to be haunted by an incredibly angry and bitter (and dead) wife. While it is marred by a too-obvious score (we're already dealing with corpses, murders, morgue prat falls, and haunting) that focused too much on the jump-string section instead of maintaining a quiet unease, *The Nightshifter* still manages to pack a bit of a punch. Its necessarily troubling finale is gratifying in its way, too, as Stênio rises to the challenge of accepting his fate. More from Ramalho will likely be a good thing for horror fans.

7/18: Boiled Angels: the Trial of Mike Diana

Trusting the voices inside my head, I took in a screening of Frank Henenlotter's latest film early this afternoon. This the Henenlotter of *Basket Case* fame: what would attract the interest of this genre filmmaker? Nothing less than the once obscure, now infamous trial of Mike Diana: the only artist in American history to have been found guilty of obscenity. Though it's a talking-heads documentary, *Boiled Angels* naturally enough skirts along the genre's periphery, using narrated illustration segments and gee-whiz-colorful meets Dear-God!-extreme examples of comics both from Mike Diana and much of American comics' underground history. Various luminaries provide remarks, from Jay Lynch and Stephen Bissette (who testified for the defense) to George Romero and Neil Gaiman. What makes this documentary stand out in particular is that the filmmakers reached out to Mike's adversaries and gives those players not just screen time, but also a fair shake. Must see for aficionados of underground comics: Mike Diana took R. Crumb as a starting point and drove that particular car right off the cliff.

Cam

For a directorial debut, *Cam* is an impressive piece of work. Along with screenwriter Isa Mazzei, also debuting, Daniel Goldhaber shows both the real fear of having one's identity hijacked and that sex workers are people, too. There is a necessarily claustrophobic tone to the movie: much of it takes place in Lola's (Madeline Brewer) webcam studio where she performs for a group of enthusiastic regulars. After an ill-fated marketing stunt at the Cam Girl's Clubhouse, Lola finds that somehow, some*thing*, has nabbed her account and is posing as her. Cut off from her source of income and eventually exposed to her family, she grows increasingly desperate to stop the impostor as she struggles to keep herself together. While *Cam* holds together for the most part, I had a nagging problem that began at the screening: the phenomenon of Lola's double is never adequately explored. While a number of explanations are given, the filmmakers never wholly commit themselves to the nature of the beast. That is a small complaint, though, against yet another reason this Festival has given me for not using the internet.

7/20: A Rough Draft

Sergey Mokritskiy's science-fiction film lived up to its title quite well. Over the course of two (admittedly rather entertaining) hours, the adventures of Kirill (Nikita Volkov), a talented software designer, unfolded in a flurry of increasingly ill-defined activity. Based on a series

of famous Russian novels by Sergey Lukyanenko (of *Nightwatch* fame), *A Rough Draft* probably would have made an amazing (and comprehensible) miniseries. As it stands, the movie feels a lot like a "Cliff's Notes" movie. I imagine all the plot points were struck, but only in the most cursory manner; it was almost as if they dropped every third page of the script.

After his identity is erased from the lives of his friends and family, Kirill finds himself drafted into becoming a sort of customs agent for interworld travelers, checking paperwork and charging tariffs as appropriate from his tower whose many doors open on to many different Moscows. In a neat little propaganda bit, the "best" Moscow that it opens on never had a Communist revolution (nor discovered oil or gas), with the Russian Empire still being intact. A sentiment Mr. Putin would no doubt approve of.

The Man Who Killed Hitler and Then Bigfoot

The title kind of says it all, in a way. However, Robert Krzykowski's debut feature is really more a meditation on aging and coping with regret. Sam Elliott's performance as Calvin Barr (the man who killed Hitler, and then kills the Bigfoot) was naturally the highlight. As a fairly quiet drama more than an action movie, it succeeded famously, strangely making me wish for more scenes involving the old man. Unfortunately the movie was marred by the excessiveness of flashback sequences pertaining to the young Calvin and his ill-fated romance. Still, that's a small complaint considering the film's other merits, which include the appearance of a marvelously deadpan Ron Livingston as an FBI agent billed only as "Flag Pin." The packed house loved it, particularly being able to pose questions to the great Sam Elliott after the movie. Just about worth my two-and-one-half hour wait in the press line.

7/21: Chuck Steel: Night of the Trampires

Some concepts for short films are expanded to a feature length, and work: last year's stop-motion animation wonder *Junk Head*, for example. Other concepts, like *Chuck Steel: Night of the Trampires*, need, I'll politely say, perhaps a bit more polish and thought. In all fairness, Michael Mort's feature debut (those seem to keep cropping up...) never overstayed its welcome, and necessarily required a lot of skill and effort. But, with the gag as it is ('80s-style loose-cannon rule-breaking maverick cop going crazy-go-nuts violent as he squares off against bloodsuckers), there is only so much steam to power the narrative mechanism. The opening fifteen minutes of action and exposition were top notch. Then it limped. Then it came to life. Then limped. Then—so forth. Fortunately, it was saved by a powerhouse finale which included, out of the blue, a tip-of-the-hat to a stop-motion legend: when our steely hero attacks a mutant laser-shooting lizard, he jumps on the beast with the battle-cry, "HARRRYHAUSSSEN!!!" (Oh yes, I suppose I should have mentioned that in addition to the undead, there's a "world domination by lizard" conspiracy...) Michel Mort... this guy... I'm hopeful for his future; but If you skip *Chuck Steel: Night of the Trampires*, you'll probably be okay.

LOUDER! I Can't Hear What You're Singin', Wimp!

Eh.

Rock sensation "Sin" (Sadao Abe) is a throat-doping death metal performer who is a god to his fans; acoustic-guitar toting Fuka (Riho Yoshioka) is a soft-spoken aspiring artist who lives with her Uncle Zappa and Auntie Demon. Taking a bit too long to tell something of a love-or-maybe-personal-growth story, director Satoshi Miki doesn't find the right tone for the film until around halfway through. Beginning with a Sin concert gone wrong, the

audience is treated to a whole lot of mouth-spewn blood. (My trachea is still wincing from the scenes.) When Sin escapes his handlers and meets up with Fuka, things start to move along, only to be interrupted by cutesy absurdities that sometimes work (Sin as Nicolas Cage from *Wild at Heart* squaring off against Zappa and Demon) but often don't (weird '30s stage musical blocking, idiotically behaving Koreans in a fireworks factory collective, and, less-cute, more random throat blood). I left the cinema feeling rather… Eh.

Puppet Master: the Littlest Reich

Unbeknownst to me until it was introduced, the latest *Puppet Master* movie is the first feature produced by "Fangoria" magazine. And it was far, far more entertaining than it had any right to be. Thomas "144 Acting Credits" Lennon stars as Edgar, a soft-spoken, fast-talking comic book writer/comic shop employee who goes to the 30th anniversary of the "Toulon Murders" to sell off an old puppet that his brother (who died under mysterious circumstances years ago) left behind. Assembled at the convention center are a gaggle of other collectors, all of them bringing their own Toulon puppets. Alas for our cast, that hotel is right near the puppet master's tomb, and once the guests are assembled things start going badly—particularly for those guests whose ethnicities or life-styles might offend the tender sensibilities of Nazi puppets.

Anyone familiar with the franchise will be very pleased to see these 2' psychos back in action. In *Puppet Master: the Littlest Reich*, the (pleasantly) gut-wrenching violence is accompanied by funny dialogue and a protagonist who is neither stupid nor overpowered. As an extra delight, Barbara Crampton makes an appearance as a no-nonsense retired policewoman working as the tour guide at the Toulon Mansion. *And* there's Udo Kier, who against the odds actually seems to be Giving a Damn about his performance. If you're even thinking about checking this out, you should.

7/22: Lôi Báo

As one of Vietnam cinema's few entries in the comic-style super-hero genre, *Lôi Báo* (directed by Victor Vu) skimps a little bit on the action but remains well within the genre's science capabilities. Comic book artist Tam (Cuong Seven) is diagnosed with lung cancer and has perhaps two weeks to live. However, family friend "Uncle Ma" happens to be a medical research scientist who had been working on a bold new procedure: full body transplant. After stumbling across a recently deceased corpse by chance, Uncle Ma slaps Tam's head on the cancer-free cadaver and voila: not only is he healthy once more, he has somehow gotten stronger and can recall the "genetic memory" of his new body. Things go sideways when he's mistaken for the dead man — a henchman of a mafia syndicate that, among other things, dabbles in organ harvesting. I'm inclined to be more sympathetic to this feature considering its novelty, but there is a recurring character that just about torpedoes the movie every scene he's in: the protagonist's son. His presence was so damaging that another reviewer wondered out loud if the boy actor was perhaps the son of one of the financiers. *Lôi Báo* is obviously set up as an origin story, so perhaps better luck on the next outing?

Our House

Perhaps it is too harsh to grouse,

But it's a view that I firmly espouse:

With just family affairs

And not any scares,

I advise against watching *Our House*.

Parallel

You may not believe me, but toying with inter-dimensional portals is a very dangerous hobby. A group of housemates — all on the verge of success but never quite making it — accidentally stumbles across a mirror portal to slightly different worlds; worlds where time goes exponentially more slowly than their own. In the midst of swiping cash, stealing technology, and appropriating their other selves' art, things eventually go wrong; and then things start going wrong again and again. Isaac Ezban's science-fiction drama largely succeeds in a *Primer*-meets-*Shallow Grave* kind of way and the translocation is deftly handled by filming and lightning cues (so for better or worse, we're always grounded in what's "real"). But such clarity greatly undercuts both any sense of weirdness as well as suspense. The conscientious character feels guilty, the unstable character goes nuts, the reluctant character keeps trying to escape, and the ne'er-do-well character does not do well at all. There was some satisfaction in watching the collapse of some not-wholly-relatable people, but as with so many movies, *Parallel* doesn't go far enough in any of the directions it seems it's heading.

7/23: The Dark

It seems almost to be a reward for having sat through the impressively tedious supernatural-movie-with-happy-ending (s/m/w/h/e) movie, *Our House*, that I was able to catch not one, but two (!) very good movies of the s/m/w/h/e genre. The first was Justin P. Lange's debut feature, *The Dark*. When a kidnapper tries to escape the authorities by fleeing toward the Devil's Den, he is in for a shock: the stories about that haunted woods are true. After being viciously murdered, young Mina (Nadia Alexander) is cursed to roam the woods, dispatching any would-be intruders. That is until she meets the kidnap victim (Toby Nichols), who cannot see her grisly undead state—his eyes having been burned closed. While he's dealing with the Stockholmiest of syndromes I've ever seen, Mina tries to help him, and in so doing reacquaints herself with her own humanity.

Among the many things this movie does well is having nearly all the musical cues be diegetic, which allowed for a sense of realism otherwise unattainable, as well as forcing the "jump" scares to stand on their own without an italicization, underscore, and exclamation point driven home by sharp strings. Both the young actors are of that rare breed that actually realistically portray their characters without cloying cutesiness or hammy emotion. Being a house-in-the-woods horror movie, *The Dark* is obviously not without its violence, but the characters' ultimate destination was one that, despite my considerable jadedness, I found heartwarming.

The Witch in the Window

Thank Heaven for efficient movies. In a scant eighty-minutes I saw a father and son bond, a house get fixed up, and a *really* creepy lady looming by a window. Using the horror genre as a backdrop for a story about a family, Andy Mitton painted a realistic and amusing portrait of an estranged father (Alex Draper) reconnecting with his son (Charlie Tacker). The titular character is rarely seen, but delivers a lot of genuine scares when she does appear while also allowing for some humorous reactions from the man and his boy. As they learn more of their house's history from their frightened neighbor, the father becomes increasingly keen to make the house, once again, "a good house." To do this, he is forced to face the witch, with nothing less than his spirit hanging in the balance.

The Ranger

The Ranger (Jenn Wexler), having its Canadian debut at Fantasia, is a prequel to the *Lord of the Rings* trilogy concerning a young Strider as he… I'm just kidding. They didn't let me in to the

packed house. I really don't know what it's about.

Abridgement

Last year there were three fully scheduled screening rooms. This year there are only two. With a flood of dramas from Southeast Asia clogging the Festival, pickings were a little slim. But hope springs eternal as it heads into its second half.

Short: "Hooligans" (dir. Adam-Gabriel Belley-Côté)

After a match that could at best be described as a qualified success, three members of the blue team (the fourth is in hospital with a concussion; the other three are also injured to varying degrees) discuss the prospect of letting the leader's cousin into the group. The controversy? It was that same cousin that caused the blue team their injuries. Presenting violent European football fandom as a sport of its own, "Hooligans" eschews social commentary in favor of rib-tickling reveals about competition, induction, and club-house procedure. Beware appendix 1-A.

Short: "A/S/L" (dir. Benjamin Swicker)

A horror film about American Sign Language? Heck no. I was immediately reminded of my age when I saw this short that hearkens back to simpler times of Windows 95 and AOL 2.5. Doug ill-advisedly makes the titular inquiry of a thirteen-year-old girl he meets online. He compounds his error by taking her up on her offer to visit her place. What could go wrong; her parents are "gone for the weekend." Upon arrival, things turn sinister/awkward. With the appearance of the girl's "sister," they get doubly so—doubling again with the appearance of yet two more under-age girls. In their way, the girls have a feisty-good time; Doug, however, should have stayed at home.

7/24: Inuyashiki

In the tradition of *Kodoku: Meatball Machine* and others, Shinsuke Sato presents another in the genre of "Superannuated Superhero": *Inuyashiki*. By chance, a put-upon father who has just been told he has fatal cancer and a disenchanted young man end up at the same park and they are struck by a blinding light and a massive object. Coming to the next day, the father is first surprised to find himself alive, and then to find he no longer needs his glasses. Slowly he discovers he has a shiny, new interior: a "switch" in his wrist releases a high-tech weapon, and another node in his neck flips his head open to reveal some very impressive central processing power. The young man, on the other hand, learns about his new self faster, but chooses a more destructive path than the older man's healing spree.

Inuyashiki deftly combines sky-high action sequences with down-to-earth ruminations on the nature of good, evil, and the feasibility of forgiveness. Both the father and the young man have understandable gripes with reality, but the former never ceases to try to do the right thing. The latter has known only loss of friendship, and, metaphorically at first, of loved ones; driven to psychotic bitterness, he eventually declares war on all of Japan. Things get serious at times, but never too heavy—and it is a credit to Sato that he juggles the film's pendulous tones so ably. If you see one superhero movie this summer, make it *Inuyashiki*.

V.I.P.

The first of an inadvertent Hoon-jung Park "double feature", *V.I.P.* isn't weird, but is a must see for any fan of gritty violent crime procedurals. (That's an odd genre term, and I may not be using it correctly.) Myung-Min Kim plays Chae Yi-Do, an old-school policeman who is never seen without a cigarette. When his boss gives him carte blanche to solve a case involving

a serial killer, he allows nothing to stand in his way: not South Korea's Intelligence services, not the CIA, and certainly not the slippery, well-connected murderer (a smirkingly twisted Lee Jong-suk, who drops a long-standing "pretty boy" image to play at giggling evil). Colliding bureaucracies, savage murders, and more than a handful of twists keep the viewer on his toes. Stealing every scene he's in, though, is Peter Stormare (you know, that guy from *Fargo*) as chewing gum-chomping, greasy CIA sleaze-pile Paul Gray. Quite worth the time for fans looking for the place where serial killers and political thrillers intersect.

7/25: The Witch, Part 1: the Subversion

Hoon-jung Park again shows off his directing chops, this time with something of a super-antihero origin story. The title itself is a give-away, of course, that this won't be the last time we deal with this particular Witch. Da-Mi Kim as "the Witch" won the increasingly coveted Cheval Noir award for best leading actress, and certainly showed quite a range in *The Witch, Pt. 1*. When a school for genetically engineered superhuman children gets shut down, student massacre-style, some escape, including Ja-yoon, who legs it to a nearby farm run by a charming older couple without children of their own. Raised by the farmers, Ja-yoon is very talented but also very meek—until she isn't. By not making it clear where one's sympathies should lie, Park keeps things moving along until, much like in *V.I.P.*, all the factions smash together for—you guessed it—a grisly finale. While I found it entertaining at the time, upon reflection, it doesn't hold up as well as it should have. In particular, one expository scene has a character talking, and talking, and talking, making the narrative mistake of telling the story instead of showing it, something to be avoided in a visual medium. Unlike the further adventures of old man Inuyashiki, I can take or leave what *The Witch* gets up to in the future.

Anna and the Apocalypse

Despite never having seen the musical episode of TV's "Buffy the Vampire Slayer," I cannot help but think that John McPhail's teen musical comedy (with zombies) must be very similar. At the very least, it hits all the cues of a high school dramedy: Anne (Ella Hunt) feels stifled by the smallness of her hometown; her best friend is filled with ever-to-be unrequited romantic love for her; no one takes the sharp-tongued news reporter woman seriously; and, best of all, the up-and-coming principal is a stuffed-shirt, no-nonsense autocrat that only a teenager could dream up (and he's even ironically [?] named "Savage"). The musical numbers were good, in a "I don't have much to say beyond that" kind of way, except for Savage's solo bit where he sings boisterously about having "finally made it" while leaving the surviving teens to fight some zombies that he let into the school. And yes, the zombies. They dominate the second and third acts, and are used mostly for non-sequitur jokes (one I remember was the "kill/shag/marry" challenge with Zombie-Beyonce, Zombie-Taylor Swift, and Zombie-some other celebrity). Trying to remember any of the songs and other gags right now, I am at a loss, so that *may* be saying something. However, I know I laughed along with the movie at the time. Frankly, you'll know yourself whether a Christmas-Zombie-Apocalypse-Musical movie is something you want to see.

7/26: Cold Skin

Having moved on from his Nazi torture-porn and triple-A blockbusters of a decade ago, director Xavier Gens has focused since largely on horror of one flavor or another. In *Cold Skin*, he presents us with an adventure about as rollicking as the Lovecraftian atmosphere allows. An unnamed man (David Oakes) has come to a remote island in the Antarctic for the purposes of chronicling wind patterns on the outcrop for twelve months. Occupying the only structure

other than the weather officer's hut is a bearded, near-wild man, Gruner, the lighthouse operator. As the weather officer settles in, he quickly comes to learn that there are some inhuman inhabitants in the nearby waters—inhuman inhabitants who are prone to raiding the island from time to time.

So, breaking each-other's solitude, weather officer and Gruner barricade themselves in the lighthouse with the food, flares, guns, ammunition, and, curiously, a female of the hostile species. It is hard to pin the over-all tone of the movie. There is action, quietude, desolation, bright sun, and strange developments in the relationship between the two men and the humanoid aquatic creature. Intending no disrespect to Da-Mi Kim, but having now seen *Cold Skin*, I was much more impressed with the actress who played the fish-woman (Aura Garrido). She made the creature relatable (certainly more so than the human men) and understandable just through body language and her character's mysterious clicking and wailing. The finale's combination of ambiguity and apathy is in keeping with the story's Lovecraftian tendencies, and while it's not an adaptation of any of his works, *Cold Skin* incorporates enough riffs on his adventure-focused tales to be worth a look.

"DJ XL5's Outtasight Zappin' Party"

Structured as an hour and a half of flipping through channels, the "Outtasight Zappin' Party" lived up to its title—I think. I'm not sure what is meant by the "Zappin'" part. Amidst brief clips of old martial-arts movies and at least half a dozen Samuel L. Jackson death scenes, DJ XL5 insinuated eighteen short films. The earlier link will get you to a full line-up, but there were a few that stood out.

Some of you may be familiar with "The Shivering Truth", which is on the bubble for being approved as an Adult Swim series. Over the course of eleven minutes of stop-motion animation, we learn that lunch ladies will get sliced meat however they possibly can, some people just weren't meant to kill themselves, and that butterflies really, *really* hate Bali's natives. Consistently weird and hilarious, it follows associative logic as it jumps from one bit to another, all under-pinned by an ever reliable omniscient narrator.

As one of two French-Canadian inclusions, "Hypochondriaque" (dir. by Carnior Steve Landry) tells the *Alien* story in even more of a stripped-down manner than Ridley Scott did with his eight cast members. A husband and wife are driving their mining vehicle back home after a hard day of work on some planetoid. The wife starts complaining of a stomach ache, which the husband groups with the litany of other symptoms he's known her to complain about. The folly of writing her off as merely being a hypochondriac, though, becomes clear when she shows him the body of a familiar looking face-hugging creature. We quickly find her stomach ache is more than mere whinging.

New Zealand provides another bit of inspired whimsy with the animated disaster comedy, "Fire in Cardboard City" (dir. by Phil Brough). Woe betide the titular metropolis: after an action-packed police chase, the bad guys crash and their cardboard car explodes on the cardboard streets. Enter our heroes, the valiant firefighters of Cardboard City. However, everything is cardboard: the people are drawn on it, the roads and buildings are made out of it, and we learn that that spray of blue-painted cardboard from the fire hose is, like all the surrounding materials, flammable itself. It takes a deus ex machina à la *The Lego Movie* to tame the blaze; but then comes the new title card, "Flood in Cardboard City." A hilarious little outing.

7/27: The Ranger (Special ad hoc Press Screening)

Jenn Wexler's directorial debut can be accused of any number of things, but subtlety is not one of them. *The Ranger* is an eighty-minute howl against the Patriarchy, with a literal howl from the protagonist in the final moments. A gaggle of drug-snorting punk rockers run afoul of the law when one of their crew stabs a policeman who's cornered Chelsea (Chloe Levine), a young woman who grew up in a rural environment (and is later accused of being a city punk "tourist"). They flee to a remote mountain cabin that was left to Chelsea by her uncle, who died some years earlier under mysterious circumstances. From the get-go, they step on the toes of the ranger (Jeremy Holm, in a sinister, regulation-spouting performance) and then proceed to make further bad decisions. Obviously, things start going very badly very quickly, and I was driven to wonder, "When will these people figure out they should play by the rules?" Of course, these are punks and anti-authoritarians: but, c'mon.

Once the ranger's psychotic nature, never lurking far below his officious exterior, surfaces, ping, ping, ping, down they go. The final showdown has Chelsea literally grappling with a Man in Charge; a Man in Charge who in many ways had been her "Faerie God-Ranger." Raw feminine rage wins the day, and we are left with heavy-handed scene of Chelsea being accepted by mountain wolves. Perhaps not a bad message, per se, but the gracelessness of delivery prompted a young female reviewer to turn to me and say, "boooo!" right as the credits came up. The horror genre (if that indeed is what *The Ranger* falls into) isn't easily harnessed for nuanced discussion. Ms. Wexler will hopefully bear that in mind for her next movie.

7/29: Five Fingers of Death *aka* King Boxer (1972; 35mm print)

In a belated effort to educate myself about the heritage of many martial arts films that have been on display, I took in Chang-hwa Jeong's classic about dueling martial arts schools seeking dominance in northern China. *Five Fingers of Death* came at the start of the wave of kung fu/martial arts movies that swept the West in the 1970s, cementing their prominence with Bruce Lee's *Enter the Dragon*. This movie, however, predates Lee's 1973 breakout. Filmed in beautiful "Shaw-Scope" (never quite explained), *FFoD* is the simple but convolutedly-presented story of Chi-Hao as he prepares to win a kung fu contest for the noble Suen school against the dishonorable Ming school. Thugs get thwacked, Japanese assassins get their comeuppance, and a glowing red light emanates from Chi-Hao's hands whenever he prepares to execute kung fu's deadliest move, The Iron Fist. Tarantino swiped its blast-siren sound cue for his *Kill Bill* franchise.

"International Science-Fiction Short Film Showcase 2018"

Eight short films, all competent in execution: most having to do with time manipulation, with a couple of post-apocalyptic ones. I somehow remember greater diversity of subject matter last year, but as we all know, "they just don't make 'em like they used to." One film of the bunch is worth mentioning, though, as it's very good and is honest enough to wear its influence on its sleeve, even declaring it a few minutes in.

"Exit Strategy", directed by Travis Bible, primarily involves a wonderful repartee between two brothers: Matt, a firefighter, and Shane, an MIT graduate (trimmed with all the nerd-awkward fixins you'd expect). Armed with a program with pertinent alarms and a flip notebook, Shane has been working on trying to manipulate events in a time-loop he's constructed (*Groundhog's Day*-

style, as his brother observes early on) to prevent a deadly fire. Shane thinks he's just about cracked the problem after hundreds of attempts (or thereabouts), but Time is a harsh mistress. The short spools out with some great dialogue between the estranged brothers and does the audience the service of following logic. Ending on a bittersweet note, I was reminded of the time-looping troubles of Aaron and Justin in *The Endless*. Here's hoping Travis Bible keeps at it.

Five Fingers for Marseilles

This movie would have made my personal cut for a full write-up, except that it's much, much more in the camp of beautifully made revisionist-Western drama than anything remotely "weird." Michael Matthews utterly astounds us with his directorial debut, the story of five friends (the titular "Fingers") in South Africa. Growing up during Apartheid, they see little change in their lives once the old regime is voted out and "equality" is enshrined. Young Tau is imprisoned for the murder of three corrupt officers and is released two decades later. Toughened by prison, he returns to his dusty hometown of Railway, on the hill above New Marseilles. He finds that one friend has gone on to become mayor, another a corrupt chief of police, a third a pastor at a failed church, and the fourth dying under mysterious circumstances. Tau is given scant time to reconnect with his old gang before a near-mystical gangster, Sepoko, "The Ghost," declares both Railway and New Marseilles to be his.

The prehistoric grandeur of the South African countryside is caught beautifully in all its primal glory; it is a grandly savage counter-point to the ill-functioning towns that have malignantly sprung up on it. All the cast are impressive, including Zethu Dlomo as the adult Lerato, the female friend of the titular "Five Fingers." But it is Hamilton Dhlamini as Sepoko who raises *Five Fingers for Marseilles* from Western Drama to a more mythical level. Each of his speeches is laden with gravitas, delivered in the manner of traditional African story-tellers. In a mountaintop encounter with Tau, the sky even darkens and thunder and lightning rage as Sepoko declares his power and intentions. *Five Fingers* is an elemental movie that has much violence, but none that is unnecessary. Things don't ever get too heavy, either, with another stand-out performance in the part of "Honest John" (Dean Fourie), a white, ne'er-do-well traveling salesman. The finale, like much that comes before, is both brutal and believable. Highly recommended.

Au Revoir

The Festival's second half proved to be quite worthwhile, with a few gems tucked away in the final days. It was good, but my eyes started to hurt.

7/29: One Cut of the Dead

For a couple of days I toyed with doing a fuller write-up of Shin'ichirô Ueda's "found footage" horror exercise. I'm going to ask that you trust me on this, because I cannot say any more without compromising your viewing experience. But you Really, Really Should see this if you can. For those like me who regard the zombie genre as effectively run into the ground, this movie—despite what the premise seems to be—breathes so much life into the tired, tired tropes of zombie-this, -that, and -the-other. Top-notch cast, top-notch direction, top-notch notch. (Highly recommended.)

7/30: The Scythian

I had unfortunately missed seeing this on the big screen as both screenings conflicted with other films. However, even on a modest 41" television in a darkened cubicle, Rustam Mosafir's proto-Russian adventure fantasy proved itself to be one heckuva ride. Filled with sword fights, betrayals, mysterious pagans, and some crazy

berserker-juice, *The Scythian* was everything one could want in a medieval adventure yarn. In particular, the score (which is something I've noticed I've been noticing a lot more) heightened the historical and mystical tones. Both the diegetic music from traveling performers and the ambient tribal chanting grounded the old world feeling; things cut loose a bit more during a fine bit of fighting when the chants were paired with some sick heavy metal guitar. While criticized in its homeland for a lack of historicity, I was more than happy to overlook incongruities from a millennium ago.

Cinderella the Cat

With four directors covering 86 minutes, you get about twenty-one minutes per director. I'm not sure how the assignment was divvied up (though conceivably they could had one for the animation, one for the voice acting, one for the singing, and one for luck), but between them Ivan Cappiello, Marino Guarnieri, Alessandro Rak, and Dario Sansone have put together my favorite adaptation of the classic Basile story. Set on a futuristic luxury ocean liner in permanent port in Naples, *Cinderella the Cat* otherwise hews to the original closely: benevolent father dying, his daughter cruelly mistreated by his new wife and step daughters; but it adds tremendous flair to the proceedings. The step mother is now a reluctant villain; her kids, all six of them, are psychotic to one degree or another. And as for the arch-villain, Salvatore Lo Giusto (known as "The King"), he's a gloriously back-stabbing, tune-belting, business-savvy, cocaine-snorting sociopath. While Cinderella and "Prince Charming" aren't the most interesting of the bunch (as per tradition, I suppose), they make up a solid backdrop for giddily evil machinations.

Others were skeptical, but I was personally struck by four features of the King's character that made me think of a certain music legend. Guess if you can: singer, cocaine, heterodox eyes, and a pendant in the form of a crowned red pepper. If there had been just two or three of the four, maybe I'd think otherwise, but frankly that smacks far too much of someone's mid-1970s lifestyle.

Tigers Are Not Afraid

Mexican director Issa López gives her take on the Peter Pan story with a novel combination of urban realism and the eldritch cousin of magic realism. Primarily starring very talented, very young kids, *Tigers Are Not Afraid* concerns some lost boys who gang together for survival in some ghetto of some slum in Mexico. Their Wendy is a slightly older girl named Estrella (a very compelling Paola Lara), whose mother was recently kidnapped and murdered by the same thugs terrorizing the boys. Estrella's connection to the fantastical is forged when, in the opening scene, a teacher hands her three pieces of chalk (her "three wishes") to help calm her during a school lockdown when a shooter arrives. With her first wish– to have her mother come back— a living line of blood appears and begins its pursuit of Estrella. Also, her mother's ghost talks to her, demanding the man responsible for her and scores of others' deaths.

Both touching and somber, *Tigers Are Not Afraid* isn't really for the standard ghost/horror movie crowd, but for those seeking a darker fairy tale. Like the true stories of that genre, the end is more about justice than happiness.

Tokyo Vampire Hotel

For a colorful, just-barely coherent diversion of repetitive violence, garish luxury hallways, and a strange penchant for a really tedious Romanian folk song, look no further than the *Reader's Digest*™ version of Sion Sono's *Tokyo Vampire Hotel*. Distilled from a six-hour Amazon Prime series, I am informed by those in the know that what I saw was a poor way to enjoy the mayhem. That in mind, I'm more inclined to treat what I saw charitably. In 2022 Japan, it's the Draculas

vs. the Corvins (a rival breed of vampire that surpassed the Draculas some time ago). The last hope for the Romanian home boys? A young woman on the cusp of her 22nd birthday who at birth (at 09:09:09 in 1999) was fed some very special blood. As a potential savior for the Draculas, she's naturally a hot commodity for the Corvins as well—and competing kidnappings ensue.

The oddest thing about *TVH*, at least in the "movie" form, was a spatial conundrum that was never fully addressed: the titular hotel is, we are told, inside one of the ancient Corvin vampires, who herself is inside the hotel. There were some moments that were a hoot, but it felt altogether like cramming too much frosted cake into my skull.

7/31: The Brink

Good Lord, I was very close to walking out of this one; and later, having decided to remain, almost fell asleep. And what is this *"Brink, the,"* I hear you ask? A Hong Kong martial arts action (*cough*) movie involving gold smuggling, dirty cops, renegade cops, and a typhoon showdown. The copious blame can be shared between the director (Jonathan Li) and scriptwriter. There were interminable fight sequences that, though my eyes were dry, bored me to tears—and drove me to question just how much abuse these film-makers think the human body can realistically take. At one point, the protagonist was stabbed in the bladder and kept up the thwack-thwack nonsense before diving under water for minutes without oxygen. And as for you, mister screenwriter, whatever your name is, there is absolutely no reason to tack on a sub-subplot involving a semi-estranged not-quite-daughter who is, oh by the way, pregnant. You're already wasting enough of my time.

I almost wish I had opted for a full review, as I could complain for quite a bit longer. But out of deference to the other features (and the readers), I shall cut myself off here.

Arizona

As Sonny's "accidents" compound, Cassie's day gets worse and worse. Taking place right after the sub-prime mortgage crash, Jonathan Watson's *Arizona* is a comedy of deadly errors. With yet another directorial debut, Fantasia presents a little comedy about a man who keeps on murdering despite his best intentions after kidnapping a single mother who works in the real estate business. With some sociopolitical overtones (realtors are liars who buried countless "innocents" with un-payable mortgages), the action moves forward in a world of derelict houses protected within a gated community. While nothing too special, *Arizona* was an amusing way to burn an hour and a half: chuckle-inducing and sprinkled with a handful of celebrity cameos. One "punchline" I found particularly amusing came at the end of the closing credits when it was revealed that the whole movie was filmed in New Mexico. I didn't suspect such a thing, but I can probably be written off as an East Coast bubble-dweller.

Rokuroku: the Promise of the Witch

Entirely by accident I found myself sitting through yet another anthology horror movie, this time in the guise of an overarching narrative about a young woman whose friends and family are plagued by "yokai", supernatural forms of dead people who linger in this plane because of one regret or another. The variance in tone between the vignettes compromised *Rokuroku*'s overall cohesion, but things were wrapped up better than I expected before the film's climax. Though made in 2017, many of the special effects had much more of a late '90s feel, which oddly enough made them more unsettling, giving them an uncanny valley look in addition to their inherent creepiness.

8/1: Madeline's Madeline and Brother's Nest

I caught an unlikely pairing for my final movies at Fantasia: Josephine Decker's hopeful coming-of-age tale *Madeline's Madeline*, and Clayton Jacobson's dark-as-all-get-out fraternal black comedy *Brother's Nest*. Watching the two one after the other, I was reminded both of what I like in a movie and what I, to put it politely, find more challenging. Both achieve the goals they set out for, but do so in a very different way.

Madeline's Madeline was first on the docket and what little I had read about it left me apprehensive, a state in which I remained for the entire first act. By the end of the second act (loosely speaking–its delineations are subtler than that), I had been on the cusp of leaving the theater for the better part of fifty minutes. This was in no way a reaction against the performances—all three female leads were portrayed exceptionally well—but more so *because* of them. Helena Howard brings Madeline to the screen superbly; her two mother figures (Miranda July playing her actual mother, and Molly Parker as the acting troupe director that Madeline wants to be her mother) struck me as altogether realistic—and altogether horrible.

Whether in personal experience or in movies, I am troubled whenever I see an impressionable youth being raised by the most overbearing and neurotic of parents. And the director of the acting troupe wallows in such faux-artsy chant nonsense that she seems to realize neither her own lack of talent (directors are supposed to direct, and keep things moving forward) nor the inappropriateness of her overtures to Madeline. The shift in tone in the final twenty-five minutes just about saved it for me, as Madeline becomes her own, strong person, as did the remarks from a reviewer friend who was not so blindsided by the unpleasant mothers as to miss the "threading" intricacies of the plot. (He pointed out, among other things, that a hospital-setting porno was echoed later in a hospital-setting improvisation).

While I enjoyed it far more, I've little to say about *Brother's Nest* except that a) it was a wonderfully contrived black comedy about murder for money and b) it is another movie that captures the dynamics of two estranged brothers very well. This second point was no doubt aided by the fact that two real-life brothers play the ones onscreen (though I pray their actual relationship is quite, quite different from what was on display). The older one, Jeff, has maintained an illusion of financial success while suffering deep scars from his parents' divorce and father's suicide decades earlier. Terry, the younger one, has always felt inferior to his brother but is, this murder plan notwithstanding, a stand-up guy. As we learn about their differing experiences growing up in the same household, our sympathies jerk back and forth until their unfortunate machinations begin and actions become less and less forgivable.

"Real" emotional dramas aren't the first thing I'm ever looking for. When family conflicts and personal growth are incidental to the narrative, I find that typically reinforces a good movie for me. When the movie itself is about family conflict and personal growth, it is very difficult to win me over. I know enough about life from living it, and learning about fictional people's tribulations (generally stemming from a lifetime of bad decisions) isn't why I watch movies. 366's Gregory J. Smalley gives *Madeline's Madeline* a much more positive read than I could. On the other hand, jaded old soul that I am, I can enjoy dark treats like *Brother's Nest* much more than the next guy.—Giles Edwards

Harlan Ellison (1934-2018): The Last Dish of Angry Candy

Harlan Ellison died on June 27th, 2018, and the reaction around the Internet has been... strangely more subdued than I expected. Perhaps it's because the man was so ill-suited to our politically correct times. Perhaps it's because he alienated the Internet and computing technology in general to the point that the Internet collectively snubs him in self-defense. Most likely, it's because for all the amazing volume of work he put out, he could have put out ten times more, but preferred to become a professional litigant first and a creator second. Sci-fi forums and geek blogs are taking a bit more notice, but even there he's best remembered as a lovably grumpy bastard.

But me, I'm a train wreck today. All writers, whether they know it or not, have lost a brother. True, Ellison was a walking human pile of road rage, but he devoted half his life to activism that we're better off for. The price he paid was becoming an insufferable bastard to everyone he met. Sometimes the universe needs an angry man. Just be glad it didn't pick you.

In Ellison's spirit of gonzo honesty in writing, let me spill some of my ugliest guts for you: growing up, I was as good as raised by wolves, a functional orphan. I was only born because two hippies met on a blanket at Woodstock and the acid going around didn't turn them off. The hippies grow up to be bums with psychosis in Southern California and, thank Ronald Reagan, California is a rotten place to get help for being crazy. I ran away from home every chance I got, and damned if I wasn't better off on the streets. Reading was the only thing I could always afford to do. So authors became my surrogate family, and Harlan Ellison was in there second or third place as one of the authors who shaped what I have become today.

I shouldn't say that so literally, lest you think I'd been through five divorces and a scandal for groping women on stage. I've been married 25 years (the lady is still sane, miracles never cease), and I know not to make a huge ass of myself in public, at least not without reason. Ellison swore off having kids early; I enjoyed the adventure of raising a family. But the professional side of me, the creative side, owes a lot to him. I don't know how much exactly. My brain is its own little animal living up there in my skull. I don't inquire into its affairs and it doesn't bother with me.

But Harlan, ever the smart-ass, referred to his writing as an addiction, and God can I ever identify. People in real life (the meat space outside the Interwebs, where today there's an extreme heat advisory) ask me why I picked freelance writing of all careers. And I always answer that it didn't; it chose me. I have piss-poor patience with coworkers, a tissue-thin boredom threshold, and a word machine in my head that WILL. NOT. SHUT. UP. I dream a new novel every night. I blather to myself on autopilot while I fumble with coffee in the morning. Left to my own devices, I will wander around the house practicing dad jokes and alliteration headlines and catchy shower thoughts on everybody until they hide in the closets. If I haven't worked in a while, I start yelling at the TV because soap opera writers can't plot for sour beans, and I run around making up homemade labels with more imaginative brand names for the peanut butter, and I rip up the newspaper and chew the crossword puzzle in my foaming mouth.

There's no pill for hypergraphia and hyperlexia. Writing is merely my handle for mental illness. It just so happens to be a paying skill too, but if it wasn't, I'd be on a desert island scrawling rants in crab blood on coconut fronds and sending them out in corked bottles.

We are all hideous hobgoblins of disease and insanity, that's what Harlan taught us.

His only work commemorated by 366 Weird Movies, *A Boy and His Dog*, is but a thread of his work. Over in "Star Trek" forums he's known only for the episode "The City on the Edge of Forever," and little else. Video game forums are remembering him for the game "I Have No Mouth, and I Must Scream," adapted from his short story, and little else. Practical joker culture remembers him for mailing a dead gopher to a publisher he was having one of his endless quarrels with—and little else. But saddest of all, the crooks of this world breathe a little easier today, because he was way more trouble to them than he was to anybody else. Funny thing about Harlan Ellison: He had the work ethic of a monk melded with the attention span of a gerbil, so he dabbled in every medium, culture, franchise, fandom, and genre he could find, but always produced a landmark work in whatever he set his hand to do. Of course he was weird and original and feisty and controversial, he contained the soul of a rabid Balrog with PMS.

As Hunter S. Thompson, another tortured genius who ran all his life from hellbent demons, would have put it, Harlan Ellison was too weird to live and too rare to die. Like a comet striking the Earth, there will be an impact crater where he was for a long time.—Pete Trbovich

"Idiot Control Now": Mystery Science Theater 3000 – The Gauntlet

Following a triumphant return in 2017, MST3K is back for another go-round on streaming service Netflix, and this time, they've bowed to the expectations of an audience that is keen to binge-watch. Season 12 is a tight six episodes, and the show's already thin plot has been tweaked to explain that Jonah, Tom Servo, Crow T. Robot—and you—are going to be subjected to this latest series of world-shattering bad movie experiments in a row, force-fed in one continuous orgy of cinematic incompetence.

This doesn't technically matter as concerns the real heart of the series: bad movies being riffed. But it is significant because the format has encouraged the producers to select movies that will speak to the greatest number of subscribers: they're newer, they're genre, and—unfortunately for us here in the land of weird movies—they're pretty easy to digest. In the campaign to make the show a success, it feels like some of the inherent weirdness has been bleached out.

Mind you, they haven't skimped on the awfulness. Our season kicks off with one of the most notorious bad movies of recent vintage: the blatant *E.T.* rip-off/unsubtle McDonald's promotional cash-grab *Mac and Me* (1988). Unlike a lot of copycats, you can really feel the stress of trying to hit all of the original's story beats while trying to heighten them for maximum payoff. Lonely fatherless child? Let's put him in a wheelchair. Everyone loved E.T. dressed as a ghost? Wait till they see MAC in a bear costume leading a full-on dance number. Oh, and that other film moved truckloads of Reese's Pieces? Think how much Coke we're gonna sell. What makes *Mac and Me* weirdest are the gallons of flopsweat generated by filmmakers who are desperate to surprise you into forgetting about the vastly superior predecessor.

If there is a more mercenary approach to filmmaking than the one exhibited by *Mac and Me*, it lives and thrives at The Asylum, and their ticket to the party is MST3K's most recent subject ever, *Atlantic Rim* (2013). A half-hearted riff on *Pacific Rim* with roughly a thousandth of

that film's special effects budget, the movie isn't so much strange as it is sad. Like most Asylum mockbusters, it's a con job designed to fool people who can't quite remember all two words of the title of the movie they want to see, and as such isn't really worthy of this show's attention. The film goes through the motions while trying to show as little action as possible. Most of the fun to be had comes in the form of a gleefully cast-against-type Graham Greene, chewing scenery in a way he knows he's unlikely to come by again.

Lords of the Deep (1989) is another movie hoping to piggyback on another film's ambition (in this case, *The Abyss*), but hampered by what it can't afford to show. There's some entertaining sniping amongst the crew of an overworked underwater base, and star Priscilla Barnes' interaction with strange ocean-dwelling creatures takes the form of trippy drug-like scenes that come as a surprise. Throw in a comically obvious villain, a body count that rises and falls, and a stilted distaff version of HAL 9000 and you get a movie that's pleasantly odd, but not especially high on the WTF meter.

If Season 12 comes anywhere close to weirdness, it's thanks to *The Day Time Ended* (1979), in which a family out west finds their new home is the nucleus of a dimensional intersection, leading to multiple alien contacts and giant monster battles. More than any other movie this season, *The Day Time Ended* benefits from not really being like anything else you've seen. A little bit of *Close Encounters*, perhaps, but with so many other plots and sci-fi elements thrown in (to say nothing of horses) to make the whole thing a great big B-movie bouillabaisse. Bearing, as it does, the imprimatur of Roger Corman-aspirant Charles Band, it's all rendered in low-budget, goofy ways, but there's a charm to the ramshackle nature of the production, so much so that even the Bots call out some of the more fun moments. Time doesn't really end in *The Day Time Ended*, but the conviction of its forced happy finale does the job nicely.

This episode also features the return of the revived MST3K's greatest hidden weapon: Paul & Storm. The comic songwriters who scored an immediate smash in the previous season with their global kaiju tribute "Every Country Has a Monster" return several times this season, including once inside the theater as well as a parody of their own previous success, mocking the futile nature of any attempt to catch "Every Country's" lightning in a bottle a second time. But then they go and do the damn thing for real with their Music Man pastiche "Concepts", which justifies every off-the-wall moment in *The Day Time Ended* as a piece of scriptwriting brilliance.

Killer Fish (1979) has a lot of what we look for in an MST3K experiment: a big dumb hero, a deadly-if-not-outwardly-intimidating threat, and a whole lot of pointless plot getting in the way of those two things meeting up. If anything, Killer Fish is too aware of itself, with the dim-bulb model, the comic relief fey photographer, and the amusingly low-stakes evil of villain James MacArthur. This is another movie that ends with a late plot twist that rolls eyes more than it blows minds.

The season wraps up with a return to glories past. *Ator, the Fighting Eagle* (1982) reintroduces us to the hero of one of the series' first incarnation's biggest hits: the sword-and-sorcery goof *Cave Dwellers*. This time around, the filmmakers are trying to get in on some of that sweet *Conan the Barbarian* loot, and a charmingly low-budget sword-and-sorcery lark ensues. But it suffers not only in comparison to better movies, but even to its terrible sequel, which manages to up the crazy with out-of-left-field references to atomic power and hang-gliding.

It's a completely suitable set of films, and the crew remains as funny as ever. Everyone feels more comfortable in their roles and the writing staff takes it a little easier with the joke ratio. But there's a weird sameness to the season's films. All color, all relatively recent, all from traditional genres for bad films. (What's a nontraditional genre for bad films? Try the dreary German production of *Hamlet* they tackled in Season 10.) And most of them trying to steal some of the glory shining upon other films, but lacking the skill, budget, or desire to reach similar heights. "The Gauntlet" is never anything but entertaining, but there's none of the joy of a surprise discovery or a nugget of weirdness brought into the sunshine.

In reviewing the roster of the previous season, I made a fateful prediction: "Perhaps a Season 12 will give the producers room to expand the scope of movies selected. Jonah and the 'Bots staff seem well-armed for the challenge." Didn't happen that way. "Mystery Science Theater 3000: The Gauntlet" retrenched, leaning more on films like *Starcrash* and less on curiosities like *Carnival Magic*. As a fan of these funny riffers, I hope their gamble works and Netflix rewards them with additional seasons; I'll be back for more. But as an aficionado of the cinematically surreal, et al, I'm crossing my fingers for a looser leash. There's gold out there. Joyfully incompetent, mind-blowingly unconventional, very weird gold, just waiting to be found. And mocked.—Shane Wilson

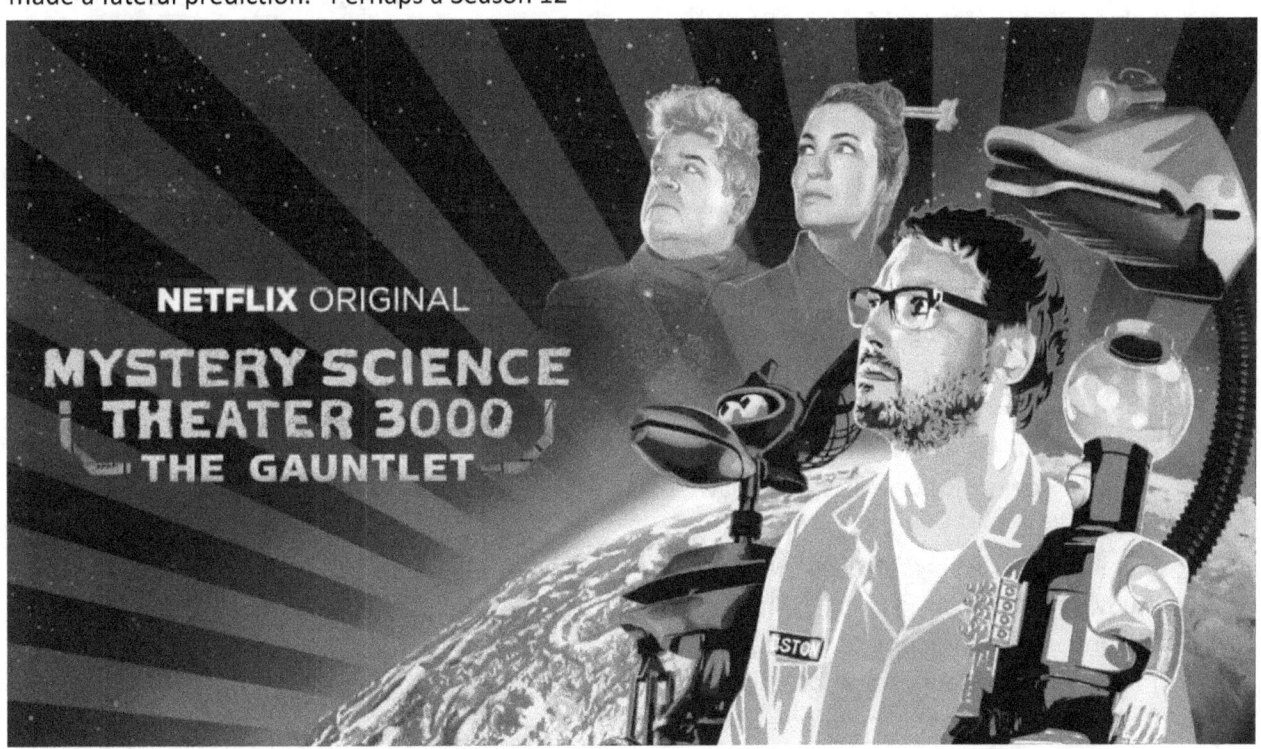

"The Last Coloring Book on the Left" by Jimmy Angelina and Wyatt Doyle

"To avoid fainting keep repeating: it's only a coloring book, it's only a coloring book, it's only a coloring book…"–-Front cover blurb, Last Coloring Book on the Left

WRITTEN & ILLUSTRATED BY: Jimmy Angelina, Wyatt Doyle

FEATURING: Likenesses of Michael Caine, Orson Welles, Robert Mitchum, and many others

PLOT: A coloring book for adults, and more specifically, cinephiles. Every page features a new rendering of an iconic character from a film, with some of their dialogue underneath.

BACKGROUND:

- The second publication from the team behind 2016's "The Last Coloring Book."
- The Author Wyatt Doyle worked at Delco Five Star Video, then Computer and Video Exchange and Pizza and Video to Go. His years at the family shop, Doyle's Premiere Video, overlapped with his tenure at Movies Unlimited—a job that continued into his time at Video Showcase IV. He has published several books. His favorite theaters are the Lansdowne, the Egyptian, Eric Twin Barclay Square, the New Beverly, and the Old Town Music Hall. But he saw *Meatballs* at the Waverly.
- The Illustrator Jimmy Angelina swapped studying filmmaking for drawing pictures. His illustrations have appeared in various publications and on theater posters. He once spent an unforgettable evening watching movies and eating pizza with comics legend Gene Colan. His favorite artist is Fellini. Angelina is currently assembling a collection of his early work and ephemera, provisionally titled "A Portrait of the Idiot as a Young Moron." He loves dogs.

INDELIBLE IMAGE: Every page features an iconic face from a movie.

THREE WEIRD THINGS: Robert De Niro as renegade repairman Harry Tuttle in *Brazil* (1985); Klaus Kinski during his "Jesus Christ Savior" tour (1971); Alejandro Jodorowsky and son in *El Topo* (1970)

WHAT MAKES IT WEIRD: With no context other than the drawing of the character and a line or two of dialogue, you have to know which film the illustration is referencing to make sense of the page. Without this foreknowledge, it presents some striking illustrations of film moments that will be beyond the reader's comprehension. Readers are also very unlikely to ever actually color in said drawings, effectively rendering the book nonfunctional.

COMMENTS: What a strange, yet delightful, occurrence to be called upon to review a coloring book for 366 Weird Movies. Obviously this isn't a List contender (it's not even a film!), but it is a refreshing and unexpected change of pace.

This is an odd book: a publication celebrating cinema without any historical context, production notes, or insight into any of the films included; a coloring book never intended for children, but which adults are unlikely to ever actually color in; and a tome without any major slabs of text or narrative. Unless you're familiar with the films themselves you're unlikely to comprehend the images on each page, and no context is given for the movie the image comes from—most likely for legal reasons.

While definitely an appropriate title for 366 Weird Movies, featuring some obscure gems from the Midnight Movie genre, retro horror films, and odd dramas like 1999's *The Straight Story*, this is purely a curio for the coffee tables of lovers of cinema. A quick read that can be finished in under half an hour, the shelf life of

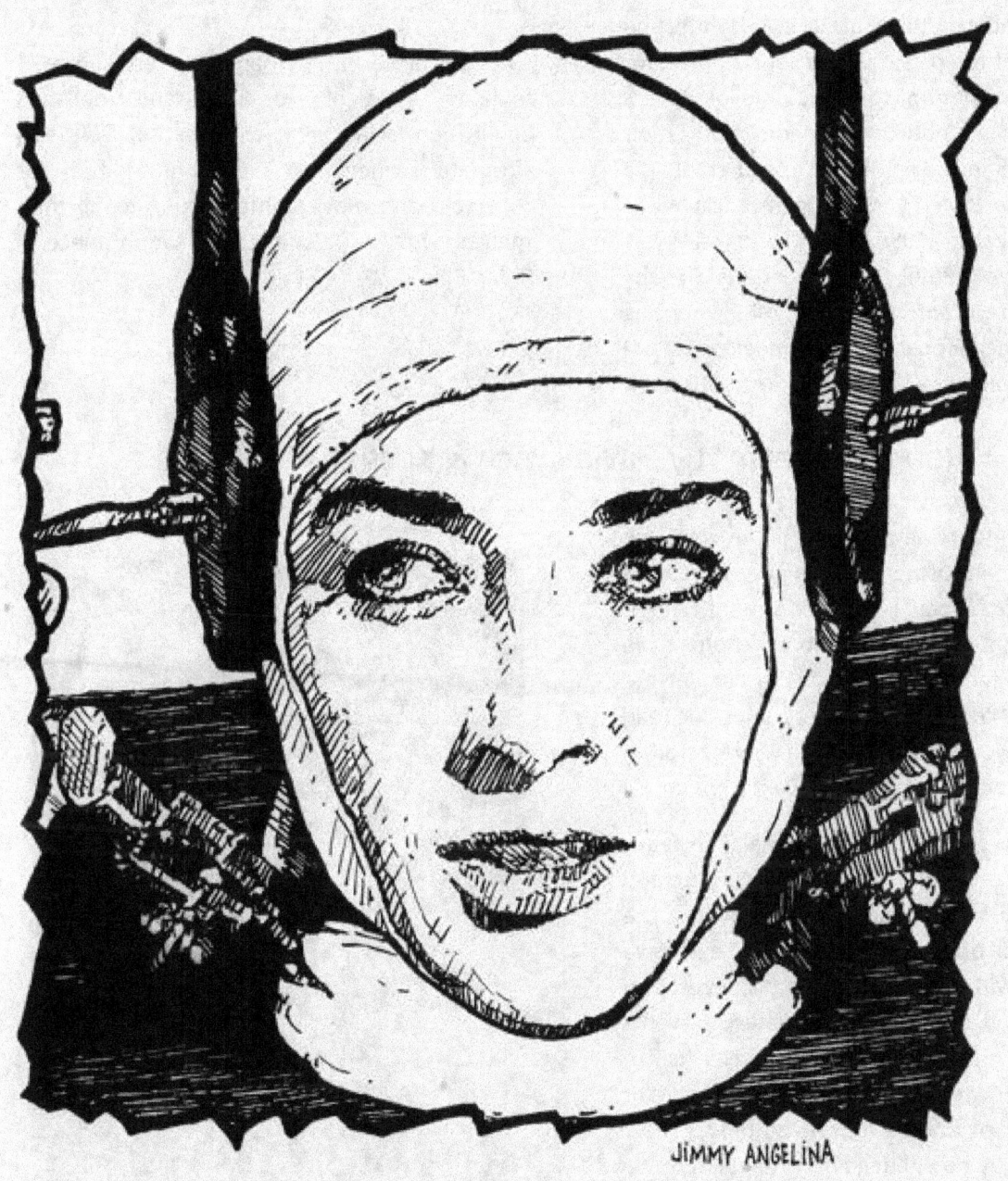

"I am only a head. And you're whatever you are.
Together we're strong!"

will bring it out at parties for the curiosity of others. Unless you intend to actually color in the images, you will be unlikely to revisit it often.

Still, the images themselves are striking ink drawings rendered boldly in black and white, and the quality of the paper and jacket is impressive for an independent publication. Celluloid lovers will delight in spotting moments from their favorite films including Chow Yun-Fat cradling a baby in *Hard Boiled* (1992), Dean Stockwell as Ben in *Blue Velvet* (1986), Peter Fonda as Wyatt in *Easy Rider* (1969), Peter Sellers as Sir Guy Grand in *The Magic Christian* (1969), Sterling Hayden as Jack Ripper in *Dr. Strangelove* (1964) and Lon Chaney as Alonzo in *The Unknown* (1927), among many, many others. This reviewer considers himself a dedicated patron of the cinematic arts and yet was still hard pressed to place all of the images and films contained within.

A novelty piece with perhaps little reuse value, it remains a highly original and polished publication celebrating the best of cult and alternative cinema. A welcome addition for collectors and movie buffs looking to fill their shelves with a unique conversation piece.—Bryan Pike

"Room to Dream" by David Lynch & Kristine McKenna

As an avowed David Lynch skeptic, I readily volunteered to review Lynch's bio-memoir to make sure the artist in question got a fair shake (from a non-"fanboy"), and also so that I might better understand a director about whom I have such mixed feelings. Right off the bat, let me inform you that this book is a very enjoyable read and that anyone who is remotely interested in the life of David Lynch should give it a go.

The format is slightly unconventional. The heavy lifting is done by long-time Lynch associate and friend Kristine McKenna, who provides the academic half of things. She conducted extensive interviews with Lynch's family, colleagues, and the like, as well as got all the dates of events lined up with impeccable precision. Her half of each chapter comes first, providing the facts for every chunk of David's (having gotten to know him so well by now, I'm going to call him by his given name) life, starting with token facts about his parents and early childhood. Having known the guy since the late '70s, she's on solid footing here, and though I haven't run her sections through my fact-checker, I have no reason to doubt them.

David's portion acts as a rejoinder to each of the "academic" chapters, bringing the memoir genre crashing into the more rigorous biographical genre. Coming across as such an all-around swell Midwestern guy might have been unbelievable had his sections been presented without McKenna's. However, judging from the remarks, anecdotes, and testimonials of the dozens (and dozens) of people interviewed for this book (and prior works), David comes across in his sections as honest, interesting, and, again, swell.

"Room to Dream" moves chronologically in structure, and breaking down the chapters so that each covers a specific big project (such as the hard work of *Eraserhead*, the serendipity of *The Elephant Man*, and the trial-by-producer-fiat of *Dune*) allows the book to be read in bits and bobs over a long course of time without compromising narrative flow. As I said before, it is all eminently readable and fun, and the reason I've avoided quoting any specific passages so far is that there are too many to bust out. That said, I will bring to your attention David's most Lynchian phrase I've come across: "There's a donut, and there's a hole; and you should keep your eye on the donut." (This bit of life coaching also appears in interviews he's provided.) And in describing David's voice, Brad Dourif (a court adviser in *Dune*) says it's "kind of like Peter Lorre from Philadelphia."[8]

Indeed, memorable quotations abound; so much so that my book-mark ran perilously close to running out of room as I jotted down page numbers. David Lynch is a great guy who's led a highly enjoyable life marred only on occasion by artistic or professional setbacks (the closest he comes to criticizing anyone is describing his distaste for two French corporate "suits" who don't share their eccentric industrialist boss' vision). His greatest failing is perhaps is he falls in love with a consistency that precludes long marriages (he's on his fourth wife).

And my criticisms of the man and his biography that I had hoped to unleash from the back of my mind? I couldn't muster them. The name-dropping is a little overwhelming at times (less of a problem for readers in "the Biz"), and my only stylistic quibbles have more to do with my archaic language and syntax hang-ups than anything Kristine McKenna gets up to. I personally would never take a compound noun ("Executive-Producer") and morph it into a verb ("Executive-Produce") when the sentence structure could be shuffled ever so slightly to keep it a noun (or, as I'd prefer, the verb phrase "produce executively"). But as any sane person can see, this complaint is almost nonsensical.

To sum up: *Room to Dream* was so good that its section on *Mulholland Drive* (a movie I have disliked with a passion for over a decade) made me inclined to give it another go. Snap up a copy of this fine tome or borrow it from your local library. It will give you all the Lynch you could hope to digest. —Giles Edwards

[8] And *just* one more on a somewhat personal note. My hair is similar to David's and over the years its verticality has oft been remarked on. As such, Kimmy Robertson's "Twin Peaks"-era anecdote struck me: "If I asked him nicely, he let me run my fingers through his hair. The hair that grows on top of that head and what's inside that head—you can feel that in his hair. David's hair does something and it has a function and the function has to do with God."

"The Weirdest Movie Ever Made: The Patterson-Gimlin Bigfoot Film"

Aptly, Phil Hall's latest journalistic endeavor, "The Weirdest Movie Ever Made: The Patterson-Gimlin Bigfoot Film," is this author's weirdest book to date. I doubt that anyone needs to run to their favorite search engine to inquire about what may be the most famous home movie apart from the Zapruder film. Hall never directly states his "belief," or lack thereof, in the authenticity of the 1967 film's claim to have captured footage of an actual Bigfoot; his agnosticism spreads over the book's 100 plus pages. Smartly, authenticity is not Hall's point of entry, because belief, in anything, is an abstraction, despite claims made to the contrary by every pedigree of zealotry. Rather, Hall's approach is a quirky look at a quirky corner of Western mythology. The Patterson-Gimlin film may indeed be the weirdest movie ever made; even weirder in that its weirdness lies in the zealotry of its primary filmmaker and the ballooning mythology of this (roughly) one-minute home movie.

In short: the Patterson-Gimlin Bigfoot film is a religious film in every way, and Hall captures that pulse. His observations in Chapter 2 are shrewdest, beginning with a brief explanation of "cryptozoology" that segues into examples from the Bible. Job is one of several books that mentions creatures like a Leviathan, a Behemoth, and a Ziz. In the longer version of the Book of Daniel (included in Catholic and Orthodox canons, relegated to the Apocrypha in Protestant bibles), the hero of the tale slays a Babylonian dragon by overfeeding it. Of course, St. George also slew a dragon. Hall, who should perhaps consider a theological vocation (we need more pragmatic theologians with a sense of humor), astutely reminds us that St. George is, naturally, more known for his dragon-slaying than for his piety. That makes for far more interesting reading than a saint praying at the altar.

There's a St. George spirit in Roger Patterson. Already ill[9] with Hodgkin's lymphoma, Patterson became obsessed; not with an unseen deity above, but with an unseen mythological creature below, on Earth and in hiding. And why not? Who wants to wait for heaven after death when we can find Eden here? And what better way to find Eden than through the discovery of one of its hidden creatures? Whether Patterson set out to find and film the creature, or create it for a disbelieving world, is irrelevant. It's his religious zeal, magnified by his failing health, which produced a one-of-kind home movie. This is really the Genesis of Hall's book. He punctuates his narrative with "Bigfoot Interludes," such as "Why did the Sasquatch cross the road?" complete with whimsical illustrations by Jose Daniel Oviedo Galeano. These digressions, with accompanying text (that includes occasional typos, which I suspect are intentional and add to the weirdness), are akin to the children's Bibles found in Sunday School rooms across the country; a necessary, lighthearted break from all the surrounding *adult* devotion. We get both child and adult with Patterson, who really is the most interesting and complex character in the book. Bigfoot herself is what she is in the footage; merely a phantasmagoric flicker, not unlike a briefly seen Bela Lugosi in *Plan 9 from Outer Space*. It's Patterson, especially once you read his biography, who looms largest here. In that, he is a bit like that uncanonized saint of weird movies, Ed Wood, Jr. With both,

[9] Patterson died in 1972, only five years after releasing his footage.

appreciation for what they created is far more accessible when you are familiar with their biographical bullet points.

Hall's book zig-zags; you may find yourself convinced the film's an elaborate hoax, only to find yourself wondering if there's actually something to it in the next chapter. However, even Bob Gimlin, who Patterson relegated to the role of sidekick, has wondered aloud recently if Patterson pulled an epic prank, one which used him as more an audience member than a participant. In the end, there's considerably more evidence pointing to a fake than something authentic. (Orson Welles would be proud.) There's even speculation and rumor (supplied by John Landis, although reliability and Landis are oil and water) that John Chambers, who did the makeup work on *Planet of the Apes*, created a Bigfoot suit for Patterson (Chambers denied it).

Prank, however, isn't the right word. A religion needs both a figurehead and a product, be it a church, a book, or a film; and Patterson ambitiously anointed himself as Pope and prophet in providing that product, whether it's "real" or myth. Debating the matter is ultimately pointless, so Hall take us past all that to the film itself, how it stands as "the weirdest movie ever made," and its considerable influence on pop culture. Movies (*The Legend of Boggy Creek* and sequels) were made, and Leonard Nimoy, Peter Graves, the Six Million Dollar Man and the Bionic Woman all addressed the Bigfoot legend in their respective television shows. How cool is that?

In the book's standout Chapter 6: Cinematic Appreciation, Hall addresses the Patterson-Gimlin film's effectiveness as a film, discussing its "fourth wall" moment; when Bigfoot turns and the watched becomes the watcher. This one-minute film provides a jump scare worthy of Hitchcock or *The Exorcist*. Indeed, I remember, as a child, seeing the Patterson-Gimlin footage for the first time, and the subtlety of that moment made the hairs on the nape of my neck stand on end in the same way as when I saw the alien wife of *Unearthly Stranger* removing a roast from the oven without gloves on. There is a similar alien-in our-midst quality to Patterson's Bigfoot; made all the more effective and haunting in its brevity, silence, and "what if?" possibility. It is that simple turn of the creature which sealed the film's legendary status.

Hall provides a summary: "Sure, you can make your own Patterson-Gimlin film with an iPhone and your mom's faux-fur coat, but there's still no beating the original for sheer weirdness. We still want to believe. And if that means heading to YouTube to watch a grainy, 50-year-old clip by a couple of Bigfoot believers and allowing our imaginations to run wild? So much the better."—Alfred Eaker

2018 SUPPLEMENTAL LISTINGS: THEATRICAL/FESTIVAL/DIRECT-TO-VIDEO/STREAMING

7 Stages to Achieve Eternal Bliss by Passing Through the Gateway Chosen by the Holy Storsh (2018): Black comedy about a couple whose bargain apartment comes with a catch: cultists continually break in to commit suicide in their bathtub. Made little impact outside of the festival circuit, despite having the longest title of 2018.

10 Years Thailand (2018): Four Thai directors, including Apichatpong "Uncle Boonme" Weerasethakul, imagine the future in this omnibus film that played a festival or two late in the 2018 season.

All the Gods in the Sky (2018): A man waits for aliens to come and save him and his disabled sister. Screened at Fantastic Fest.

Altered Perception (2018): Volunteers for a trial medication that promises to cure false perceptions find themselves instead addicted to a psychedelic drug that causes psychosis. With a title like that, it better have some great hallucination scenes. Released to a few theaters in 2018.

Being Frank: The Chris Sievey Story (2018): The true story behind the giant-headed performance artist responsible for the character depicted in 2014's oddball comedy *Frank*. As far as we know this documentary only played at the South by Southwest (SXSW) film festival.

Best F(r)iends Vol. 2 (2018): Tommy Wiseau and Greg Sestero continue their post-*The Room* adventures in this comic road trip movie; Sestero stars as a drifter and Wiseau is a mortician. It was released in a series of special one-night-only screenings in 2018, so we didn't catch up with it until 2019 (the Blu-ray review is up on 366weirdmovies.com as you read this).

Between Worlds (2018): *Mandy* wasn't Nicolas Cage's only strange and over-the-top role of 2018; there's also this one, where he must defend himself from the ghost of his wife, who's jealous of his new relationship with a medium. Like most of you, we waited until the 2019 home video release to see this one.

Bikini Moon (2017): When a documentary crew takes a personal interest in their subject—a delusional female African American war vet—both ethical and perceptual boundaries start to blur. Logline: "a documentary about a fairy tale." As far as we can tell, it played NYC (and smaller late-season film festivals) only.

Black Hollow Cage (2017): A girl who lives alone with her father and talks to her dog through a device called "mom" discovers a black cube in the woods. It saw a very limited theatrical release in the U.S. in 2018.

Border (2018): A border agent uses her preternatural sense of smell to sniff out smugglers. We listed this Swedish magical realist piece in our top 10 weird movies of 2018, but ran out of time to fit a proper review in, and so waited until its home video debut in 2019; a full review should be up online by the time you're reading this.

Braid (2018): Drug-dealers on the lam stay at the mansion of an eccentric friend who forces them to play along with her make-believe world. Debuted at festivals in 2018, released theatrically in early 2019, reviewed online at 366WeirdMovies.com.

Cacrcasse (2018): Without context, people are seen puttering around ruins raising livestock; it's possibly a post-apocalyptic scenario... An Icelandic production spotted on the film festival circuit.

Charlie and Hannah's Grand Night Out (2018): Two girls find their boozy pub crawl turn surreal; the underground Slamdance festival programmers used the word "trippy" to describe it, twice

Clara's Ghost (2018): A ghost prompts an actress to confront her dysfunctional family. Starring Chris *"Cabin Boy"* Elliot and his family (it was written and directed by and stars his youngest daughter, Bridey Elliot), this toured various film festivals (including Sundance) in 2018.

The Cleanse (2018): An unemployed man lands at a retreat where he undergoes a "cleanse" therapy, which involves drinking foul brews and vomiting up mini-monsters. The *L.A. Times*' Gary Goldstein called it "one short, strange trip..." Released theatrically and on VOD.

Dead Night (2017): A vacationing family finds a mysterious woman passed out in the snow and takes her back to their cabin; supernatural hijinks ensue. A bit of a weird long shot, but a couple of critics independently mentioned its "strangeness." Played "select theaters" and VOD.

Deadwax (2018): This story about a possessed record that drives people mad was shown on Shudder in 15 minute episodes; it debuted as a feature film at Fantastic Fest 2018. From Graham *"I Can See You"* Reznick, so you know it's weird.

Detective Dee: the Four Heavenly Kings (2018): The venerable detective defends himself against accusations from the Empress while trying to solve a supernatural murder spree. While we missed the second installment of Tsui Hark's near-weird fantasy mystery trilogy, http://bloodbrothersfilmreviews.blogspot.com, at least, thought this one boasted the "strangest and most delightfully batshit insane material that this series may ever see."

Dog (2018): French black comedy about a man who thinks he's turning into a dog. No further info.

The Endless (2017): Justin Benson and Aaron Moorhead's festival hit about brothers returning to a UFO cult gets a limited release, soon followed by a DVD and Blu-ray, from Well Go in 2018. Reviewed in the 2017 Yearbook.

Fatal Pulse [AKA *Untitled Yuppie Fear Thriller*, AKA *Night Pulse*] (2018): Underground director Damon *"Reflections of Evil"* Packard finally released this long-gestating (4 years in the making) feature, a low-budget '90s style thriller about husband and wife moguls and their deadbeat houseguest with his usual trademark non-linear storytelling, trippy post-production effects, and conspiracy theory indulgences. It screened a few times in California, but otherwise flew under even our radar.

The Field Guide to Evil (2018): An anthology horror film featuring directors who've gone weird in the past like Peter *"In Fabric"* Strickland, Agnieszka *"The Lure"* Smoczynska and Calvin *"The Oregonian"* Reeder. Made a few film festival stops in 2018.

Foxtrot (2017): An Israeli father grieves for his dead soldier son in a film structured as an absurdist triptych. The arthouse critics love it, and Sony Pictures Classics picked it up for a limited 2018 release, though it ultimately made little impact on the American cinema scene.

Fugue (2018): Agnieszka Smoczynska's follow-up to her Canonically Weird *The Lure* was about a woman with total memory loss. It did not make the same splash as her killer mermaid musical debut.

Fury of the Fist and the Golden Fleece (2018): An ex-porn star becomes a kickboxing avenger in this '80s action throwback. The trailer makes it look desperately over-camped, but check out the cameos: Danny Trejo, kickboxer Cynthia

Rothrock, kickboxer offspring Bianca Brigitte VanDamme, wrestlers Bill Goldberg and Tiny Lister, *Last Dragon* Taimak, and of course, Ron Jeremy.

Ghostbox Cowboy (2018): A Texas entrepreneur/scam artist goes to China, where he finds he may be out of his depth. We got a 21st century *Midnight Cowboy*-as-cybercomedy vibe from the trailer of this December 2018 indie release.

Good Manners [*As Boas Maneiras*] (2017): A poor nurse takes a job as nanny to a pregnant rich woman, but is there something strange about the unborn child? This Brazilian art-horror reportedly featured werewolves, lesbianism, and musical numbers, which sounds like a solid mix.

The House That Jack Built (2018): Lars von Trier's serial killer pic was one of the most buzzed-about titles at Cannes, and featured a mysterious entity called "the Verge" who dialogues with a murderous Matt Dillon.

Imitation Girl (2018): An alien (Lauren Ashley Carter) takes the form of an adult film star. We've been waiting for the talented Carter to have a breakout performance; this one got good reviews and appears to have echoes of *Under the Skin*, but nevertheless sank at the box office like a Scottish guy into Scarlett Johansson's floor.

Jeanette: The Childhood of Joan of Arc (2017): Bruno Dumont's rock opera about young Joan d'Arc finally arrived in a limited release in the U.S in 2018. Who doesn't want to see medieval nuns voguing? American audiences, apparently.

Keep an Eye Out (2018): Absurdist Quentin "*Rubber*" Dupieux returned in 2018 with a comedy set during an all-night interrogation. We may be able to catch up with this one in 2019: *Keep an Eye Out*.

Happy as Lazzaro [*Lazzaro Felice*] (2018): Guileless Lazzaro is separated from the others in his remote village—where they know nothing of the outside world, as the "Marquise" illegally exploits the people as serfs—and wakes up to finds them all years older and struggling as beggars in the big city. Magical realist political/economic allegory that debuted at Cannes and later showed up on Netflix.

Holy Hell (2018): A priest goes off the deep end and starts slaughtering sinners. This Troma-esque splatter comedy played... somewhere?... in 2018.

Image Book [*Le Livre du Image*] (2018): We haven't been the biggest fans of his late work, but Jean-Luc Godard always demands attention; he describes this film essay as "like a bad dream written on a stormy night." Debuted at Cannes and appeared in select American theaters in 2019.

Insect (2018): Legendary Surrealist stop-motion animator Jan Svankmajer's latest (and, he insists, last) film features the actors metamorphosing into insects. Screened at very select film festivals in 2018, most notably the Annecy Animation Festival.

Ladyworld (2018): Eight teenage girls are trapped in a house by an earthquake in a surreal distaff take on "Lord of the Flies." Played Fantastic Fest in 2018.

Laika (2018): Stop-motion Czech musical positing that a dog the Soviets shot into space in 1957 actually landed on an alien planet.

Let the Corpses Tan (2017): Gold thieves engage in a shootout with cops in Hélène Cattet and Bruno Forzani's latest, this time a tribute to Italian *poliziotteschi* films. It doesn't look as strange as their previous giallo-inspired work, but Mark Medley of the *Toronto Globe and Mail* found it "profoundly weird." We missed it in

theaters in 2018, but you can find a 2019 review at 366weridmovies.com.

Longing (2017): A middle-aged bachelor receives a phone call telling him he has unknowingly been a father since college, and he searches for information about his son. Basically an Israeli arthouse drama, but reviewers described a couple of dream sequences that may make it worth a look for weirdophiles.

Lowlife (2017): An interlocking *Pulp Fiction*-style story about Los Angeles lowlifes (including a luchador). Reviewed in the 2017 Yearbook, saw both a limited theatrical and a home video release in 2018.

Lu Over the Wall: *Little Mermaid* variation in which the fish-girl joins a teen rock band. This kids' movie that carefully describes itself as "joyously hallucinogenic but family-friendly" comes from Masaaki Yuasa—the mind behind the weirder *Night Is Short, Walk on Girl* (not to mention *Mind Game*). It will appear on home video in 2019, and we will likely review it then.

Madame Yankelova's Fine Literature Club (2018): An aging temptress is ordered to bring one final date to her feminist cannibal club, but starts to fall for her prey.

The Man Who Killed Don Quixote (2018): Terry Gilliam's ill-fated Quixote variation, 20 years in the making and still under a legal cloud when it appeared at Cannes in 2018, was one of the most anticipated features of 2018. It's still difficult to see as I write this in early 2019, but hopefully things will finally start looking up for *Quixote*.

May the Devil Take You (2018): The Devil comes to claim the father of an estranged daughter in this Indonesian horror.

MFKZ (2017): In "Dead Meat City," Angelino starts seeing strange creatures—alien invaders?—after a motorcycle accident. U.S. distributor GKids renamed this French feature from its festival title, *Mutafukaz*, for obvious reasons. It saw special two-night-only screenings across the U.S. in 2018.

The Misandrists (2017): A fugitive male hides out at a lesbian separatist boarding school. This 2018 offering was the widest release we've ever seen for a Bruce LaBruce movie (the director started out making arty underground gay porn movies and has gradually moved into slightly more mainstream transgressions). We could not get hold of a copy.

Muere, Monstruo, Muere [*Murder Me, Monster*] (2018): A beheading leads an investigator to develop a strange conspiracy theory. This Chilean/Argentinian co-production appeared at Cannes in the "Un Certain Regard" category.

Perfect (2018): Set in a "vaguely science fictional world," a boy uses implants to seek perfection; executive produced by Steven Soderbergh and electronic musician/filmmaker Flying Lotus. Debuted at SWSX.

Pity (2018): The story of a man addicted to sadness, notable because it was scripted by Yorgos Lanthimos' writing collaborator, Efthimis Filippou (who co-scripted the Greek Weird Wave auteur's strangest pictures, from *Dogtooth* to *The Killing of a Sacred Deer*).

Possum (2018): A puppeteer returns home to face his stepfather and secrets from his past. The script is from a short story the director originally wrote for an anthology exploring Freud's notion of the uncanny. Unfortunately, it played almost exclusively in the U.K. in 2018; we're hoping to catch up with it in 2019.

Premika (2018): A karaoke-loving ghost forces victims to sing for their lives in this Thai horror comedy.

Psychotic (2018): A "psychedelic slasher flick" set in Brooklyn. Premiered exclusively in NYC in January, then languished on VOD.

Reflections in the Dust (2018): The story of a schizophrenic clown and his blind daughter, told through alternating documentary interviews and a fictional post-apocalyptic story. An experimental feature from Australia.

Revengeance (2016): A comic biker noir about a "low-rent" bounty hunter hired to recover an item stolen from "Deathface," a former pro-wrestler turned U.S. Senator. Indie animation legend Bill Plympton completed this feature in 2016 (with the aid of a Kickstarter campaign), but it first debuted in summer 2018 in NYC.

Rock Steady Row (2018): Absurd "frat Western" about a freshman who plays off deadly rival fraternal organizations. Played Slamdance, then disappeared off the radar.

The Secret Poppo (2018): A paranoid eccentric hunts for the granddaughter he never knew in a comedy described by programmers at Chicago's Cinepocalypse festival as "*The Pink Panther* crossed with an acid trip."

Seder-Masochism (2018): Nina "*Sita Sings the Blues*" Paley mixes her musical retelling of "Exodus" with Goddess mythology. In development for almost ten years and frankly, we were a little worried it might never be completed, so to see it show up at a few festivals in 2018 was a thrill, even if most audiences will never find it.

Sicilian Ghost Story (2017): A teenage girl goes after her missing crush in this magical realist story set in mafia country. A lightly weird, critically acclaimed work that garnered some comparisons to the work of Guillermo del Toro.

Sign Gene (2017): Like the *X-Men*, but all the mutants are deaf and get their superpowers through using sign language. A *Deafula* for our times? No word if it comes with subtitles for the hearing. It played at some theater in 2018, we swear.

Slice (2018): The intriguing IMDB synopsis read: "When a pizza delivery driver is murdered on the job, the city searches for someone to blame: ghosts? drug dealers? a disgraced werewolf?" Starring Chance the Rapper. The fact that pro-weird distributor A24 (*Enemy*, *The Lobster*, *Swiss Army Man*, *Under the Skin*) picked it up for distribution was promising, but the flick sadly could not live up to its premise.

Starfish (2018): Things go from bad to worse for young Aubrey when her best friend dies, and then the apocalypse arrives soon after. Played the festival circuit in 2018, and a review should be up on 366weirdmovies.com by the time you are reading this.

Strike, Dear Mistress, and Cure His Heart (2018): Surreal microbudget drama based on Bergman's *Autumn Sonata*, recommended by Fantastic Fest programmers to connoisseurs of the "strange and unusual."

Terminal (2018): Non-linear neo-noir set in a neon nowhere featuring assassins and an Alice-in-Wonderland themed strip club. This Margot Robbie vehicle managed to avoid a wide theatrical release and arrived on home video to complaints that it was "confusing" and "just weird."

The Texture of Falling: Parallel stories of artists in love, with one set playing around with S&M. Bills itself as "unlike any film you've ever seen," but critics who chimed in didn't see that as a plus. It played somewhere in 2018 before falling off the map.

Two Plains & a Fancy (2017): Described as "satirical, experimental 'Spa Western,'" this low-budget indie was partially funded with $36,000 raised on Kickstarter. Three travelers in 1893 have surreal encounters (including one with "ghost whores") while on a journey to find the perfect spa in the Old West. We like co-director Lev Kalman's attitude: "the way we make films is unpredictable, idiosyncratic, weird," says in the

Kickstarter pitch. Debuted at the microcinema Spectacle Theater in Brooklyn in 1018, and has not been spotted since.

Volcano (2018): An interpreter becomes lost in rural Ukraine and has a series of strange encounters. Not much seen outside of Europe.

We Are Not Cats (2018): An indie love story between trichophagiacs (people compelled to eat their own hair). Maybe more darkly quirky than weird, but it's a queasy subject that hasn't been explored before. Disappeared without a trace after a token theatrical run in a few arthouse venues.

Welcome the Stranger (2018): Alice visits her estranged brother, his strange girlfriend shows up, hallucinations ensue. Direct to video-on-demand is the new direct-to-video.

We the Animals (2018): The youngest brother of a trio of neglected kids retreats into an imaginary (animated?) world. Spotted, but not seen, at Sundance.

When the Trees Fall (2018): Ukrainian tale of young lovers and a life of crime, with bursts of magical realism.

The Wolf House [*La Casa Lobo*] (2018): A woman escapes from a religious cult and finds herself in a nightmarish house. The uniquely uncanny and surreal Claymation glimpsed in the trailer makes us hope this will appear on home video in 2019.

You Shall Not Sleep (2018): An aspiring actress joins an experimental sleep deprivation program and begins to hallucinate. Played the Tribeca Film Festival then disappeared.

2018 SUPPLEMENTAL LISTINGS: OLDER MOVIES RELEASED ON HOME VIDEO/STREAMING FOR THE FIRST TIME

The Addiction (1995): Abel Ferrara's philosophical vampire movie has *still* never been released on DVD in the U.S., but thanks to Arrow Video it skipped straight to Blu-ray (complete with Ferrara commentary and documentary featurettes) in 2018.

"Akio Jissoji: The Buddhist Trilogy": Three rare films of the late Japanese New Wave: *This Transient Life (1970)* involves brother/sister incest, *Mandara* (1971) concerns a pro-rape cult, and *Poem (1972)* stars a young boy caught up in a plot to sell his ancestral home. Arrow Academy promises that these little-seen films are all stylized, experimental, erotic, and spiritual. Released on a 2018 Blu-ray (only) set.

As the Gods Will (2014): Aliens stage bizarre elimination contests to kill teenagers in this violent (but not ultraviolent) Takashi Miike sci-fi effort. Arrived on a DVD/Blu-ray/digital combo pack in 2018.

Atmo HorroX (2016): This very low budget "experimental satire inside a psychedelic horror b-movie and wrapped into a cryptic mystery thriller" is—for better and worse—as weird as they come. With all the dialogue in a nonsensical invented language and a chief baddie with a balloon phallus, it easily earns a "weirdest!" rating, although it's also so incoherent that it comes with a "not for everyone" tag. Check it out on Vimeo if you dare.

A Good Dream (2017): The sparse plot description explains it's about a 20-something gal suffering from dreams/hallucinations of a creepy demon bunny. We didn't find much info available on this straight-to-VOD horror/psychological thriller, but the trailer actually looked pretty creepy.

Gothic (1986): Ken Russell's laudanum dream about the night Mary Shelley conceived "Frankenstein" has never had a respectable

home video release, until this 2018 Blu-ray (it also appeared on streaming outlets).

Housewife (2017): A housewife with a disturbed past gets sucked into a cult called "the Umbrella of Love & Mind." The sophomore film from Turkish horror upstart Can Evrenol; many folks used the "w word" to describe it.

Jamón, Jamón (1992): A mother hires an aspiring underwear model to seduce her son's fiancé. Sexy, surreal, and one of the first films for future stars Penélope Cruz and Javier Bardem. Appeared on Blu-ray and DVD for the first time in 2018.

The Killing of a Sacred Deer (2017): Yorgos Lanthimos' first (official) horror movie, a story of irrational karmic vengeance based on classical Greek tragedy. Released on Blu-ray, etc. in 2018, and reviewed in the 2087 Yearbook.

The Last Movie (1971): An actor stays behind on a Western set in Peru after the production has been canceled, then enacts a movie with the natives who think they are performing a magical ritual. This grand 60s psychedelic folly helped change the perception of *Easy Rider*'s Dennis Hopper from wunderkind to persona non grata; it's now restored and ready for reappraisal. Out from Arbelos (formerly Cinelicious) on DVD or Blu-ray for the first time in November 2018; it just missed our cutoff date for print publication, although we did get a capsule online in 2019.

"Mohsen Makhmalbaf: The Poetic Trilogy": *Gabbeh* (1996) is a magical realist fable about a woman who materializes from a Persian rug; *The Silence* (1998) is about a blind boy who tunes instruments; and *The Gardener* is a "surreal documentary" about the Baha'i faith. Arrow Academy continues to put out extremely obscure movies with mildly weird-sounding synopses in expensive box set editions.

My Entire High School Sinking Into the Sea (2017): A mildly psychedelic cartoon that's exactly what it says on the tin. Available in all formats in 2018 and reviewed in last year's Yearbook.

Napping Princess (2017): In the near future a student discovers that the secret to freeing her arrested father may lie in her dreams of a science fantasy kingdom. Light, whimsical dream anime first appearing on DVD, Blu-ray and VOD in 2018.

The Night Walker (1964): William Castle's surreal B-horror was never released on DVD, but Shout! Factory shipped it straight to Blu-ray in 2018.

Orchestra Rehearsal (1978): An orchestra rehearsal degenerates into squabbling and chaos. Rare Federico Fellini, a fake documentary made for Italian television featuring Nino Rota's final score for the director, came out for the first time in 2018 on Blu-ray and video-on-demand courtesy of Arrow Academy.

Psychopaths (2017): Mickey Keating brings us a "psychedelic fever dream" of four maniacs possessed by the spirit of a serial killer, let loose on a one-night rampage. Reviews were generally of the "we're glad they tried something different, but…" variety. Released directly on DVD and streaming without a significant theatrical run.

Red Krokodil (2012): A man takes the homemade Russian drug "krokodil" and finds himself in a post-apocalyptic hallucination. You might remember when "krokodil" was the designer-drug-of-the-month scare sometime back in 2013 (despite never being found in the U.S.); this Italian exploitation film actually came out a year before, and was offered in a "director's cut" on DVD and Blu-ray in 2018.

Satellite Girl and Milk Cow (2014): A satellite transforms into a cyborg and romances a brokenhearted man who has metamorphosed into a cow; the animation style resembles Hayao Miyazaki with a more surreal bent. Released on DVD, Blu-ray and VOD in 2018 from GKIDS.

Sequence Break (2017): The Cronenberg-ish story of a young man absorbed (literally) by a mysterious video game. Streaming exclusively (for the time being, at least) on the Shudder channel in the spring, then showed up later in the year on DVD. Reviewed in the 2017 Yearbook.

The Soultangler (1987): An '80s mad scientist discovers a way to allow living souls to possess corpses, with hallucinatory side effects. Distributor American Genre Film Archives said "[t]his epic of outsider filmmaking is a dream-like wasteland..." First spotted on DVD or VOD in 2018.

Straight to Hell (1987): Alex Cox reportedly wrote this spaghetti western/bank heist script in three days after a musical tour of Nicaragua he was promoting fell apart. Featuring a crazy cast of Joe Strummer, Elvis Costello, Jim Jarmusch, Courtney Love, Grace Jones, the Pogues, and Dennis Hopper. (This is another release that we didn't get around to covering until 2019.)

Vidar the Vampire (2017): A Norwegian farmer is vampirized by a bloodsucker claiming to be Jesus Christ. As far as we know, it appeared only on a wide variety of second-tier streaming services.

The Witches [*Le Streghe*] (1967): An anthology film, with five directors (including Pier Paolo Pasolini, whose segment is reportedly the most surreal) producing stories featuring then-popular Silvana Mangano (who would star in Pasolini's *Teorema* the following year). Clint Eastwood has a small role in this obscure oddity appearing on Blu-ray (and Amazon Prime) courtesy of Arrow Academy.

SUPPLEMENTAL LISTINGS: BLU-RAY UPGRADES/SPECIAL EDITIONS/TV, ETC.

2001: A Space Odyssey (1968): This 50th anniversary release of the sci-fi classic is spectacular: the 4K restoration, on three Blu-rays (one housing the 4K version, another with a standard HD transfer of the film, and a third for extra features), a booklet, postcards, and more. We don't have the hardware capable of doing this release justice, but if you have a 4K player and a huge screen HD TV and audiophile sound system, there's hardly a worthier film to play on it.

Across the Universe (2007): Julie Taymor's hallucinatory Beatles musical got a 4K HD treatment, packaged together with a Blu-ray, in early 2018.

The Adventures of Buckaroo Banzai Across the 8th Dimension (1984): This 2018 release of the wacky cult classic about scientist/rock star/superhero Banzai is identical to Shout Factory's 2016 collector's edition, but in the collectible steelbook format. The movie's on Blu-ray, with a disc of special features on a separate DVD.

The Baby (1973): This drive-in style item about an adult baby kept as a pet is more popular with audiences then it was with us; thus, Arrow Video's super-deluxe Blu-ray special edition came with a commentary track and numerous featurettes.

Basket Case (1982): Arrow Video obtained the rights (appropriately, from Something Weird) to this midnight monster classic and released one of their grindhouse special editions, highlighted by a new transfer and new commentary from director Frank Henenlotter and star Kevin Van Hentenryck, and including a commemorative booklet for the first pressing only. A 2018 Blu-ray.

Beyond Re-animator (2003): The prison-set and typically excessive third installment of the *Re-*

animator franchise got a Blu-ray upgrade in 2018 from Vestron Video.

Brewster McCloud (1970): Warner Archive gave Robert Altman's bizarro comedy about a man who dreams of flying on the Astrodome on a set of homemade wings a bare-bones 2018 re-release, but at least it's back in circulation. On DVD-R and Blu-ray, and could show up somewhere as a deep catalog streaming title.

Cabin Boy (1994): A "fancy lad" takes a job as a cabin boy on a fishing ship. This absurdist comedy from Chris Elliot (of the David Letterman show) went way over the heads of 1994 audiences and flopped like a mackerel, but it's gained a cult following sense. 2018 saw a new DVD and Blu-ray with many extras, including a commentary track from writer/star Elliot and director Adam Resnick.

Dead Man (1995): Jim Jarmusch's moody western about Nobody and William Blake got the Criterion Collection treatment in 2018, with a host of new interviews, features, behind the scenes Neil Young performances, and deleted scenes for uberfans.

"De Palma & De Niro: The Early Films": Three countercultural Sixties satires from a director and star destined for greatness: the b&w farce *The Wedding Party;* 1968's x-rated draft-dodging comedy *Greetings;* and *Hi, Mom!*, with De Niro now a vet involved in radical politics. Considering it's three discs with a ton of extras, this is a reasonably-priced set from Arrow Video.

"Dietrich and von Sternberg in Hollywood": This 2018 Criterion Collection box set included *Morocco, Dishonored, Shanghai Express, Blonde Venus,* and *The Devil Is a Woman,* but you may have bought it for the Expressionistic Catherine the Great biopic *Scarlet Empress.*

Donnie Darko (2001): With two editions in 2017 and one (so far) this year, it seems like we're announcing a new Special/Limited/Definitive release of the demented cult classic *Donnie Darko* every six months. Are we caught in some kind of time loop? This new restoration comes on a 2018 Blu-ray via Arrow Video with some new interviews and some recycled special features from the numerous other *Donnie* releases.

Edward II (1991): Derek Jarman's experimental, queered-up version of Christopher Marlowe's play came out on DVD, VOD and Blu-ray (for the first time) in 2018 from Film Movement.

Exorcist II: The Heretic (1977): Trust the unpredictable John Boorman (*Deliverance, Zardoz*) to make a truly absurd and deranged sequel to the original horror classic. Shout! Factory gave it a super-duper 2 Blu-ray release, with director's and theatrical cuts each getting their own commentary tracks (from Boorman and "The Projection Booth" podcast's Mike White, respectively).

Female Trouble (1974): The middle entry of John Waters' taste-free "Trash Trilogy" arrived in the Criterion Collection on DVD and Blu-ray in 2018, with all new interviews and supplements. It's better than cha-cha heels on Christmas!

German Angst (2015): Transgressive Teutonic trio of grisly horrors involving castration, fascist hooligans, and sexual depravity. Previously on DVD, 2018 saw it debut on Blu-ray, for higher definition grue.

Godmonster of Indian Flats (1973): From American Film Genre Archives (AFGA) comes this special edition (!) of Fredric Hobbs' Canonically Weird modern Western/mutant sheep monster mashup that's actually mainly about real estate shenanigans and dog funerals. The disc comes with exploitation shorts and a bonus feature, 1975's *The Legend of Bigfoot,* on, uh, *Blu-ray?*

Greaser's Palace (1972): Robert Downey, Sr.'s blasphemous, absurdist, satirical retelling of the story of Christ set in the Wild West. A 2018 release from Doppelganger Releasing (a new arm of Music Box films) with no special features advertised marks the Canonically Weird film's debut in the popular Blu-ray format.

Henri-Georges Clouzot's Inferno (1964/2009): In 1964 French master Clouzot (*The Wages of Fear*, *Les Diaboliques*) began work on a big-budget experimental film that shut down three weeks into production. This 2009 documentary examines the movie that might have been, showing us the amazing expressionist footage that was shot along with storyboards, interviews and recreations to flesh out the storyline. It was released previously on DVD/Blu-ray by Flicker Alley, but in 2018 it re-emerged in a solo Blu from Arrow Academy.

Holy Motors (2012): The Shout! Select 2018 "Collector's Edition" Blu-ray of Leos Carax's surreal anthology improves on the old Indomina release; the complete "Merde" segment from the anthology *Tokyo!* is a major bonus feature (we like that iteration of the flower-munching leprechaun better than the one seen in *Motors*).

Horrors of Malformed Men (1969): An escaped mental patient assumes the identity of his own doppelganger and winds up on a mad doctor's island. Teruo Ishii devised this macabre tale by merging several Edogawa Rampo stories; 2018 saw a restored, deluxe edition from Arrow Video (the Criterion Collection of schlock film).

Images (1972): A pregnant children's author goes insane while wondering if her husband is having an affair in this pyschodrama from Robert Altman's brief 1970s "weird" period. Arrow Academy's restored Blu-ray was released in 2018 with their usual extensive extras, including an expert commentary track.

"Ingmar Bergman's Cinema": If you have a couple hundred bucks to spend and *Thirst* for more Ingmar Bergman in your home video collection, it would be a *Shame* to pass up this historic set sure to bring you many *Smiles on a Summer Night*. The Criterion Collection's Bergman set includes an astounding 39 films on Blu-ray (naturally, both *Hour of the Wolf* and *Persona* make the cut, along with rarities like 1955's *Dreams*), plus more than five hours of bonus features.

In the Mouth of Madness (1994): Shout! Factory joins Vestron (*Beyond Re-Animator*, *Dagon*) in 2018's Lovecraftian Blu-ray re-release sweepstakes with John Carpenter's tale of a novelist whose books drive men mad. Restored, and with a new (and an old) Carpenter commentary and new (and old) featurettes.

"Mamoru Hosoda Movie Collection: *The Girl Who Leapt Through Time* (2006)/*Summer Wars* (2009)/*Wolf Children* (2012)/*The Boy and the Beast* (2015)": The only one of Hosoda's movies we've reviewed is the virtual reality feature *Summer Wars*. By reputation, at least, the others are about the same: imaginative fantasies that come oh-so-close to turning into weird movies, but fall just short. This set contains four Blu-rays, all with supplemental interviews.

Metropolis (2001): A Japanese detective and his nephew search for a criminal scientist in the city of Metropolis, and discover instead a naive robot intended for use as a weapon of mass destruction. Inspired (loosely) by the 1927 classic this is one of the best looking animes of all time: Fritz Lang's city remade glorious shades of neon. Out in a 2018 steelbook DVD/Blu-ray combo from Mill Creek.

"Mystery Science Theater 3000: Season Eleven": Even if you're not a fan of the show, if you like (bad) weird movies you may want to know about the existence of the Bigfoot buddy

flick *Cry Wilderness* and the talking chimp of the dreary *Carnival Magic*. Reviewed in the 2017 Yearbook, released on DVD and Blu-ray in 2018 (to supplement its Netflix presence).

Night of the Demons (1988): This ridiculously absurd haunted house supernatural slasher makes perfect Halloween fare. 2018 saw a newly restored, limited edition steelbook Blu-ray with a new commentary track from the director and cast, with the previous two commentary tracks carried over along with a host of other extras—*Citizen Kane* didn't get this kind of Blu-ray treatment.

Night of the Lepus (1972): The infamous badfilm about giant killer rabbits got a 2018 Blu-ray release (!) with a commentary track (!!) from Shout! Factory.

Piranha II: The Spawning (1981): A scuba diver tries to figure out where all these mutant flying piranha are coming from. Debuting director James Cameron was fired from this picture after just one week, arguably making a hopeless project even worse—but it still got a "collector's edition" Blu-ray release from Shout! Factory.

The Sacrifice (1986): Andrei Tarkovsky's final film, about an atheist professor who desperately offers his life to God to save his family from World War III, resembles a Bergman film (it was even shot by Bergman's camera guy, Sven Nykvist). Kino re-released it on Blu-ray in 2018 in a restored version with an entire disc of extra features.

Scanners (1981): This horror about telepaths who can explode your head with a thought is not one of David Cronenberg's weirder efforts; we actually mention this release more because of the inclusion of his experimental student film *Stereo* (which is set at the "Canadian Academy for Erotic Inquiry") as a bonus feature. The Criterion Collection released the DVD in 2014; four years later, here's the Blu-ray.

Tideland (2005): Terry Gilliam's controversial tale about a girl who constructs a fantasy world after her heroin addict father overdoses. This Arrow Video Blu-ray includes the same special features as Capri's older two disc DVD release, but adds a few new interviews with the cast and some additional B-roll footage to the package.

The Tingler (1959): Cinema's first acid freakout, plus a monster that lives in the human spine, plus Vincent Price, on Blu-ray for the first time! (Percepto not included).

The Tree of Life (2011): The Criterion Collection got their mitts on Terrence Malick's surrealistic family drama in 2019, with an additional 50 minutes of footage (!) and new interviews. So much stuff, it required two Blu-rays or three DVDs to fit it all on.

Twelve Monkeys (1995): Arrow Video's "collector's edition" release of Terry Gilliam's time-travel mindbender was remastered in 2018; all special features seem to be the same as previous releases, except that the first pressing of this one includes a commemorative booklet. Blu-ray only.

Welcome to the Dollhouse (1995): This black, black cult comedy about an obnoxious, bullied 7th grade girl saw a Blu-ray debut in 2018.

Wild at Heart (1990): Shout! Factory upgraded David Lynch's "weird on top" road trip to Blu-ray in 2018, with a new interview with original novelist Barry Gifford added to features recycled from older DVD releases.

The Wizard of Gore (1970): Montag the Magician carves up female volunteers in what is arguably the weirdest of Herschell Gordon Lewis' notorious gore films. Arrow Video released a Special Edition Blu-ray with their usual raft of special features

THE LIST

The canonical List of the 366 Best Weird Movies ever made (for the first time in print!)

3-Iron [*Bin-jip*] (2004) – A homeless young Korean man trains himself to be invisible so he can romance another man's wife

3 Women (1977) – Identities merge and personalities shift when ingénue Pinky becomes obsessed with delusional Millie

8 1/2 (1963) – Memories and dreams collide with reality in Fellini's self-reflexive, stream-of-consciousness classic about a director trying to make a movie

200 Motels (1971) – Frank Zappa's psychedelic rock revue includes Ringo Starr as Larry the Dwarf, Keith Moon as a nun groupie, and an oratorio devoted to the penis

2001: A Space Odyssey (1968) – Space monoliths turn apes into men and men into star children

The 5,000 Fingers of Dr. T (1953) – A mad doctor enslaves 500 boys to play his giant piano in this surreal musical fantasy from the mind of Dr. Seuss

The Abominable Dr. Phibes (1971) – Art-deco B-movie with fascinating production design and campy acting from star Vincent Price

Adaptation. (2002) – Charlie Kaufman can't get started on an adaptation of "The Orchid Thief," so he writes himself (and his twin brother) into the screenplay

The Adventures of Buckaroo Banzai Across the Eighth Dimension (1984) – Buckaroo's a neurosurgeon/particle physicist/secret agent/rock star with a backing band of soldier-of-fortune scientists opposed by transdimensional aliens and… it just goes on from there

After Hours (1985) – A word processor stranded in SoHo overnight is bedeviled by a series of odd women and odder coincidences

After Last Season (2009) – An amateurish embarrassment about two med students, a killer on the loose, and a ghost, so full of misguided directorial choices and failed attempts at cinematic poetry that it takes on a dreamlike character

Akira (1988) – A telekinetic maniac wrecks Neo-Tokyo in this trendsetting cult anime

Akira Kurosawa's Dreams [*Yume*; AKA *Dreams*] (1990) – A master filmmaker relates eight of his "dreams," including one where he wanders through Vincent Van Gogh's paintings

Alice [*Neco Z Alenky*] (1988) – Ultra-creepy Czech version of the Lewis Carroll classic, shot in eerie stop-animation in a decaying house

Alice in Wonderland (1966) – Surreal and dreamlike adaptation of the nonsense classic for BBC television depicts the main characters as Victorian ladies and gentlemen rather than talking animals

Allegro non Troppo (1976) – "The Italian *Fantasia*" has some surreal animated sequences, with black and white sequences of an orchestra of old ladies that may be even stranger

Altered States (1980) – Ken Russell's visionary tale of genetic regression under the influence of magic mushrooms may be the greatest "trip" movie ever made

Amarcord (1973) – A year in the life of an Italian town under Fascist rule, as Federico Fellini (mis)remembers his youth in comic vignettes that range from strange to utterly surreal

The American Astronaut (2001) – An absurdist indie sci-fi/western/musical/comedy co-starring the Boy Who Actually Saw a Woman's Breast

Antichrist (2009) – Controversial, extremely graphic allegory about a man and woman who lose their child and retreat to a cabin in the woods where they go crazy and mutilate genitalia

The Apple (1980) – Nutty, campy musical flop that is simultaneously an allegory for the Garden of Eden and the rise of disco

Archangel (1990) – Surreal, nearly silent meditation on forgetfulness set in an icy Russian city just after World War I

Arise! The SubGenius Movie (1992) – "Bob" just might save abnormals from the flying saucers on X-day; learn how in this bizarrely edited fake cult recruitment video

Arizona Dream (1993) – A dream fish swims through the desert as Johnny Depp is romantically trapped between a cougar who dreams of flying and her suicidal daughter

Audition (1999) – A widower holds a fake audition to select a new wife, and makes the absolutely worst pick possible

Bad Boy Bubby (1993) – Relentlessly offbeat character study of a man who was locked in a basement until age 35, then unleashed on modern Australia

Barbarella (1968) – Slinky Barbarella flies through the sinful galaxy finding herself in sexy psychedelic situations

Barton Fink (1991) – A leftist Hollywood screenwriter endures a case of writer's block that turns into a living nightmare on the eve of WWII

Batman Returns (1992) – The Caped Crusader faces off against a capitalist, an S&M themed feline feminist, and a deformed survivor of an infanticide attempt with an army of missile-equipped penguins in the weirdest summer blockbuster ever

The Beast [*La Bête*] (1975) – A drawing room nuptial drama, only with scenes of explicit (simulated) bestiality

The Beast of Yucca Flats (1961) – Dadaist narration courtesy of the eccentric Coleman Francis makes this tale of a nuclear blast turning Tor Johnson into a ravaging desert "beast" weird indeed

Beasts of the Southern Wild (2012) – Six-year old Hushpuppy lives in "the Bathtub" with her dying daddy, and imagines aurochs coming to get her

Beauty and the Beast [*La Belle et la Bete*] (1946) – One of the greatest fairy tale films ever made, with Surrealist-inspired set design including living candelabras

The Bed Sitting Room (1969) – Ralph Richardson mutates into a bed sitting room in this very British, absurd post-apocalyptic comedy

Begotten (1991) – Legendary experimental film, featuring God disemboweling himself and other metaphysical atrocities

Being John Malkovich (1999) – You can enter the head of the titular actor through this weird metaphysical comedy, the screenwriting breakthrough of bizarre movie titan Charlie Kaufman

Belladonna of Sadness [*Kanashimi no Beradonna*] (1973) – A medieval beauty is raped on her wedding night and makes a revenge pact with Satan in this violent, erotic, psychedelic anime

Belle de Jour (1967) – A young French housewife has bondage fantasies that gradually merge with her everyday reality in this once-salacious arthouse hit

Beyond the Black Rainbow (2010) – Modern recreation of a circa 1983 midnight movie, about a telepath imprisoned in the mysterious New Age Arboria Institute

Birdboy: The Forgotten Children (2015) – Cute teenage animals are wracked with despair, delinquency and drug-abuse on a post-apocalyptic island

The Black Cat (1934) – The first and best of the Boris Karloff/Bela Lugosi team-ups is an Expressionist horror masterpiece about Satanism and vengeance

Black Moon (1975) – Louis Malle's unexpected venture in surrealism features gender genocide, breastfeeding, and a unicorn

Black Swan (2010) – A ballerina goes mad as she encounters her lustful double while preparing to dance the lead in "Swan Lake"

Blancanieves (2012) – A modern silent movie retelling of the legend of Snow White set in the bullfighting culture of 1920s Spain

Blood Diner (1987) – Severely out-of-whack horror-comedy with (possibly unconscious) fascist undertones

Blood Freak (1972) – Pot + experimental turkey meat turns Herschell into a turkey-headed killing machine in the world's only Christian anti-drug gore movie

The Blood of a Poet [*Le sang d'un poète*] (1930) – Early Surrealist work where a poet gets a mouth stuck on his hand, visits a strange hotel, and commits suicide after losing a card game on a snowy Parisian street

Blood Tea and Red String (2006) – The Dwellers Under the Oak seek to recover their stolen doll from depraved white mice in this surreal stop-motion animated fairy tale for adults

Blue Velvet (1986) – Jeffrey finds a severed ear and it leads him to a melancholy nightclub singer, a drug-huffing pervert, and a suave karaoke version of Roy Orbison

The Boxer's Omen [*Mo*] (1983) – Surreal black magic battles featuring an evil wizard with a detachable head and a nude she-demon birthed from crocodile carcass

A Boy and His Dog (1975) – Post-apocalyptic tale of a wasteland rapist and his far more intelligent telepathic pooch companion

Branded to Kill [*Koroshi No Rakuin*] (1967) – Seijun Suzuki's surreal, scrambled yakuza thriller about a rice-sniffing hitman famously got him fired by the studio who financed it

Brand Upon the Brain! (2006) – "Guy Maddin" "remembers" his childhood growing up with a domineering mother and a mad scientist father in a lighthouse/orphanage

Brazil (1985) – Terry Gilliam's must-see dystopian black comedy mixes expressionism, surrealism, fantasy, and film noir to create a keen satire of bureaucracy

Bronson (2008) – Overwhelmingly stylized biopic of Charlie Bronson (born Michael Peterson), the self-mythologizing celebrity who prides himself on being Britain's most violent prisoner

Bubba Ho-Tep (2002) – Elvis and black JFK team up to fight a mummy terrorizing their rest home

The Butcher Boy (1997) – Neglected and largely left to his own devices in Cold War Ireland, the incredible Francie Brady goes insane before our very eyes

The Cabinet of Dr. Caligari (1920) – The titular Dr. engages a somnambulist to commit murders in a strangely slanted Expressionist town

Careful (1992) – Residents of an Alpine village fear avalanches and their own incestuous desires in this comic surrealist melodrama shot in "two-strip" Technicolor

Carnival of Souls (1962) – Low-budget creepfest is a minor miracle on film

Catch-22 (1970) – Mike Nichols' underappreciated adaptation of the classic novel is star-studded absurdism

Cat Soup [*Nekojiru-so*] (2001) – The surreal adventures of an anthropomorphic cartoon cat and his half-dead sister

Cemetery Man [*Dellamorte Dellamore*] (1994) – Surrealist arthouse zombie gore film about the caretaker of a graveyard where the dead refuse to stay down

Un Chien Andalou (1929) – A razor through an eyeball announces the Surrealist revolution

Christmas on Mars (2008) – The Flaming Lips bring us the most vaginal imagery ever seen in a psychedelic science fiction Christmas movie

The City of Lost Children [*La cité des enfants perdus*] (1995) – Visionary steampunk fairytale from Jeunet & Caro

City of Women [*La città delle donne*] (1980) – An aging Lothario finds himself lost in a province populated and ruled by females, until he finds refuge at the citadel of the world's last macho man

Clean, Shaven (1993) – A deinstitutionalized man seeks his lost daughter in what may be the most clinically accurate depiction of schizophrenia ever filmed

A Clockwork Orange (1971) – Kubrick weirds it up in this disturbing fable about free will

The Color of Pomegranates [*Sayat Nova*] (1969) – Impressionistic, poetic retelling of the life of Armenian bard Sayat Nova in a series of surreal tableaux

Come and See (1985) – Bleak and intense Soviet WWII classic about a boy soldier, with dreamlike passages

The Company of Wolves (1984) – "Little Red Riding Hood" told as the werewolf nightmare of a pubescent girl

Conspirators of Pleasure [*Spiklenci Slasti*] (1996) – A man with a chicken complex and a woman who snorts dough are two of the six characters whose bizarre fetishes intersect in this intricate Surrealist joke

The Cook the Thief His Wife & Her Lover (1989) – Peter Greenaway's lavish Jacobean revenge fable is set in a French restaurant where a boorish Thief terrorizes the staff and customers

Cowards Bend the Knee, or, the Blue Hands (2003) – Typically surreal modern silent from the inimitable Guy Maddin mixing melodrama, Greek tragedy, psychosexual guilt, and hockey highlights

The Cremator [*Spalovac Mrtvol*] (1969) – An oddball Czech cremator harmonizes his homegrown Buddhism with Nazi ideology

Crime Wave (1985) – A silent screenwriter who can only complete beginnings and endings struggles to create the greatest Canadian "colour crime movie"

Cube (1997) – Five strangers wake up in a hi-tech booby-trapped cube, with no idea who built it or why

Daisies [*Sedmikrásky*] (1966) – Sexy Czech hippie chicks wreaking havoc in this banned satire of something or other

The Dance of Reality [*La Danza de Realidad*] (2013) – Alejandro Jodorowsky's surrealistic autobiography is one of his most accessible films, although it still features a woman who can only sing opera and who cures plague with her urine

The Dark Backward (1991) – The world's worst comic nearly becomes an overnight success when he grows a third arm out of his back in this grotesque show business satire

Dark City (1998) – Mysterious bald Strangers manipulate events and geometries in a city of endless night for their own purposes

Dead Alive [AKA *Brain Dead*] (1992) – A rabid monkey incites the most absurdly gory zombie movie ever made

Dead Leaves (2004) – Hyperactive anime about a guy with a television head and a girl with mismatched eyes breaking out of a mutant clone prison on the moon

Dead Man (1995) – Hypnotic, dreamlike Western about a man bearing the name of a dead poet and an Indian named Nobody

Dead Ringers (1988) – Twin gynecologists (!) go crazy in this odd psychodrama from horror maestro David Cronenberg

Death Bed: The Bed That Eats (1977) – Rediscovered oddity about a man-eating bed is a surreal horror/art film/black comedy, or something?

Death by Hanging [*Koshikei*] (1968) – A Korean killer survives his execution, and puzzled police bureaucrats try to recreate the capital crimes to cure the condemned's amnesia

Death Laid an Egg [*La morte ha fatto l'uovo*] (1968) – A Surrealist giallo set at an experimental poultry farm that's breeding headless chickens

Delicatessen (1991) – Jeunet & Caro's first film is a bizarre but oddly sweet black comedy involving cannibalism in post-apocalyptic Paris

Dementia [*Daughter of Horror*] (1955) – Silent, experimental, and noirish horror about a woman soon to be involved in a "mysterious stabbing"

Der Samurai (2014) – A man with a katana in an evening dress terrorizes a rural German town

Desperate Living (1977) – This grunge fairy tale includes cross-dressing, cannibalism, necrophilia, bat rabies, and gap-toothed queen Edith Massey serviced by leather-bound Nazis

Destino (2003) – Reconstruction of an abandoned 1946 collaboration between Salvador Dalí and Walt Disney; it's a five minute moving Dalí canvas

The Devils (1971) – Ken Russell's most violently deranged film is the true-ish story of a convent of nuns who accuse a priest of being an incubus in league with the Devil

Dillinger is Dead [*Dillinger e Morto*] (1969) – Nearly forgotten late 1960s avant-garde alienation piece about a gas-mask designer who spends an evening puttering about his apartment

The Discreet Charm of the Bourgeoisie [*Le charme discret de la bourgeoisie*] (1972) – Six upper-class twits (and a wandering bishop) attempt to have dinner together, but they are always interrupted

Django Kill... If You Live, Shoot! [*Se sei Vivo Spara*] (1967) – An ambiguously dead antihero who shoots golden bullets fights Mr. Sorrow and his gang of gay fascist cowboys

Doggiewogiez! Poochiewoochiez! (2012) – A remake of *The Holy Mountain* composed entirely of found footage of dogs

Dog Star Man (1964) – A man climbs up a mountain, a star explodes, a baby suckles, and probably more things happen, although you can hardly tell through the four layers of superimposed images

Dogtooth [*Kynodontas*] (2009) – Three children are raised to adulthood in a bizarre estate where words mean just what the tyrannical father wants them to in this shocking Greek art film

Dogville (2003) – This misanthropic fable is like de Sade's "Justine" played out on the set of Wilder's "Our Town"

Donnie Darko (2001) – Angsty, apocalyptic, fantastical drama about a screwed-up, possibly time-traveling teen is an irresistibly lovable mess

Don't Look Now (1973) – Classic psychological horror with a weird twist

The Double (2013) – In a comically nightmarish nowhere, meek clerk Simon James is bedeviled by James Simon, his exact double and his exact opposite

Dr. Caligari (1989) – This pop-surrealist cult movie made by a hardcore porn director suffers from bad acting, but it is weird as hell

Eden and After [*L'éden et après*] (1970) – Bored college students steal a painting and end up in Tunisia, although it could just be the drugs in this surreal sadomasochistic story that could be described as *Alice in Wonderland* meets *Justine* meets *The Trip*

Eisenstein in Guanajuato (2015) – Delirious biopic postulating that Soviet director Sergei Eisenstein lost his virginity to his guide while in Mexico to film a movie that never got made

Elevator Movie (2004) – Surreal and minimalist independent feature about two people trapped in an elevator for months; well-scripted and weird as hell but very amateur

El Topo (1970) – Mystical and surreal Spaghetti Western from Alejandro Jodorowsky

Enemy (2013) – A history professor is obsessed with tracking down a man who appears to be his exact double; spiders appear

Enter the Void (2009) – Provocative and pretentious, Gaspar Noé's "psychedelic melodrama" is nonetheless the best trip film of the young millennium

Eraserhead (1977) – The ultimate nightmare experience, about horror at procreation and loathing for one's own offspring

Escape from Tomorrow (2013) – Surrealist satire secretly shot in Disney World, with mad scientists, evil witches, French jailbait, and a cat flu plague

Eternal Sunshine of the Spotless Mind (2004) – Jim Carrey unexpectedly shines as he fights against a memory-erasing procedure he impulsively undertook; a weird crowd-pleaser

Even Dwarfs Started Small [*Auch Zwerge haben klein angefangen*] (1970) – Dwarf inmates revolt against their dwarf oppressors at an unnamed institution; they burn flowerpots, crucify monkeys, and laugh at defecating camels

Evil Dead II (1987) – The frenetic, fantastic and crowd-pleasing movie about a man trapped in a cabin menaced by evil spirits, mixing equal parts horror and absurd slapstick comedy

The Exterminating Angel [*El àngel exterminador*] (1962) – Attendees at a fancy soirée find they cannot leave the premises–for no reason whatsoever

Eyes Without a Face [*Les Yeux sans Visage*] (1965) – Georges Franjou's influential, poetic horror film

The Face of Another [*Tanin no kao*] (1966) – A man whose face has been burned in an accident gets a synthetic mask based on a stranger's face and sets out to seduce his own wife

The Falls (1980) – Absurdist mockumentary about the 92 survivors of the Violent Unexplained Event whose names begin with "Fall"

Fantasia (1940) – Dinos, demons, and hippos illustrate the classical music canon in Walt Disney's weirdest classic

Fantastic Planet [*La Planète Sauvage*] (1973) – Tale of humans kept as pets by giant blue aliens, told in a Terry-Gilliam-meets-Salvador-Dalí-in-space animation style

Fantasy Mission Force [*Mi ni te gong dui*; AKA *Dragon Attack*] (1983) – An anachronistic team of misfits (including Jackie Chan and guys in kilts) fight Amazons and stay at a haunted house while on a quest to rescue Allied generals captured by Japanese Nazis in Canada

Fear and Loathing in Las Vegas (1998) – Terry Gilliam's adaptation of Hunter S. Thompson's fake-autobiographical cult novel about two burnouts taking insane quantities of drugs in the City of Sin

Fellini Satyricon (1969) – Bizarre androgynous costuming and mythological leaps of logic gird a great director's decadent extravaganza

Female Trouble (1974) – Juvenile delinquent Dawn Davenport (Divine) proves that "crime is beauty" on her way to the electric chair

A Field in England (2013) – Deserters from the English Civil War eat psychedelic mushrooms and hunt for buried treasure at an alchemist's command

Fight Club (1999) – Manhood finds itself tested at the millennium when an actuary and an eccentric soap-maker found an underground "fight club" and find it taking on cult proportions

Final Flesh (2009) – Four separate porn-troupes-for-hire enact an absurdist prank script about the apocalypse

The Forbidden Room (2015) – Guy Maddin's collection of reimagined lost films, with tales curled inside each other like Russian nesting dolls

Forbidden Zone (1982) – Frenchie is lost in the 6th Dimension and her family and friends must save her from the king and queen in this surreal cult musical that often looks like a Fleischer Brothers cartoon

Freaks (1932) – A trapeze artist marries a dwarf for his money, leading to gruesome revenge in this infamous film populated by real carnival freaks

Funeral Parade of Roses [*Bara no sôretsu*] (1969) – Basically, a psychedelic Japanese drag adaptation of "Oedipus Rex"

Funky Forest: The First Contact (2005) – Selection of surreal, interwoven sketches from three Japanese directors is uneven, as you would expect, but contains some of the weirdest sequences you're likely to come across

Glen or Glenda (1953) – Ed Wood's pro-transvestite documentary, with Bela Lugosi as an omniscient one-man Greek chorus and a dream sequence featuring bondage

The Godmonster of Indian Flats (1973) – A mutant sheep embryo develops into a monster that threatens an old-West themed town involved in a sticky real estate deal

Goke, Body Snatcher from Hell [*Kyuketsuki Gokemidoro*] (1968) – Survivors of an airline crash squabble among each other while psychedelic space vampires pick them off

Goodbye Uncle Tom (1971) – A fake shockumentary about slavery in the American south, with nudity and depravity on an epic scale

Gothic (1986) – Hallucinatory excess from Ken Russell, about the night Mary Shelley conceived "Frankenstein"

Gozu [*Gokudô kyôfu dai-gekijô: Gozu*] (2003) – Erotically charged, grotesquely surreal Takashi Miike horror/yakuza mashup

La Grande Bouffe (1973) – Four successful men lock themselves inside a chateau and eat themselves to death

Greaser's Palace (1972) – A zoot-suited Jesus visits a Western town to enact a series of absurd parables

The Greasy Strangler (2016) – Lard-loving Big Ronnie (who doubles as the Greasy Strangler) and his son live together and conduct scam walking tours, until a "disco cutie" comes between them

Gummo (1997) – Indisputably weird but ceaselessly unpleasant portrait of hopeless white trash

Häxan [*Witchcraft Through the Ages*] (1922) – Silent documentary about witchcraft containing the most diabolically visionary horror images of all time

Head (1968) – Prefab pop band the Monkees commit career suicide with this psychedelic spit in the eye of their young fans

Heavenly Creatures (1994) – Peter Jackson brings the fantasy world of two teenaged murderesses to life in this crime drama based on a real-life case

Hedwig and the Angry Inch (2001) – Hedwig, a punk band leader and victim of a botched sex change operation, chases the rock star who stole her songs across the U.S.

Hellzapoppin' (1941) – Anarchic musical comedy from vaudevillians Chick Johnson and Ole Olsen is probably the weirdest Hollywood musical of all time

Help! Help! The Globolinks [*Hilfe! Hilfe! Die Globolinks*] (1969) – The world's only psychedelic children's opera about an alien invasion

Holy Motors (2012) – "Mr. Oscar" drives around Paris taking on "assignments" that require him to become a hit man, accordionist, and a fashion-model abducting leprechaun

The Holy Mountain (1973) – An extravagant, psychedelic tour of world mysticism has a guru lead a Christ-figure and companions on a quest to storm the Holy Mountain

The Horrors of Spider Island [*Ein Toter hing im Netz*] (1960) – A bad misogynist fever dream involving poorly dubbed buxom women, and some spiders, on an island

The Hourglass Sanatorium (1973) – A man meets strange characters at a dreamy sanatorium where the rules of time and logic do not apply

Hour of the Wolf [*Vargtimmen*] (1968) – An artist is invited to visit the castle of—demons? ghosts? hallucinations?—in Ingmar Bergman's Gothic horror

House [*Hausu*] (1977) – The weirdest haunted house movie ever made; no one forgets the scene where the piano eats the girl

Howl's Moving Castle [*Hauru no ugoku shiro*] (2004) – An 18-year old girl is turned into an old woman and goes to work for a wizard in a steampunk castle

How to Get Ahead in Advertising (1989) – A hotshot ad exec grows a pimple that turns into a head in this bizarre, biting satire

Hugo the Hippo (1975) – Hugo's family is brutally slaughtered by Paul Lynde, who later subjects the hippo and his human pal to horrifying hallucinations in this delightful children's fare

The Hypothesis of the Stolen Painting (1978) – A Collector poses actors into *tableaux vivants* in an attempt to divine the esoteric message in a series of 19th century paintings

I Can See You (2008) – This "psychedelic campfire tale" is slow to start, but climaxes in a 20 minute freakout

Idiots and Angels (2008) – A loathsome man grows wings in this occasionally surreal animated black comedy that expertly mixes cynicism with romanticism

If.... (1968) – Malcolm McDowell debuts as a rebellious youth in a British boarding school who fights a (largely imaginary) battle with the authorities

I'm A Cyborg, But That's OK [*Saibogujiman Kwenchana*] (2006) – Romantic comedy set in a mental asylum is likely to remain the weirdest example of its genre

The Immaculate Conception of Little Dizzle (2009) – Experimental cookies cause hallucinations and pregnancy in male janitors in this indie comedy sleeper

Indecent Desires (1968) – This roughie about the symbiotic sexual relationship between a transient, a magic ring, a doll, and a blonde secretary is our choice to represent the oeuvre of Doris Wishman

Inherent Vice (2014) – Pot-smoking detective "Doc" Sportello investigates kidnappings, fake murders, a sinister consortium of dentists, and more in this baffling adaptation of Thomas Pynchon's novel

Ink (2009) – Visually impressive low-budget fantasy about a mysterious figure who snatches a sleeping girl into a world of dreams

INLAND EMPIRE (2006) – This story of Laura Dern trapped in a nightmare while filming a cursed script is perhaps David Lynch's weirdest movie

Innocence (2004) – A girl arrives, in a coffin, for her first day at a strange all-female boarding school

Institute Benjamenta, or This Dream People Call Human Life (1995) – An ambitionless man enrolls in a school for servants and enters into ambiguous relationships with the brother and sister who run the institute

It's Such a Beautiful Day (2011) – Psychedelic animation about the life and death of a terminally ill, terminally confused stick figure in a hat

I Will Walk Like a Crazy Horse [*J'irai Comme un Cheval Fou*] (1973) – Accused of murdering his mother, a man flees to the desert where he meets—and falls for—a mystical dwarf

Jacob's Ladder (1990) – Big-budget cult mindtrip movie with unforgettable demonic hallucinations

Japanese Summer: Double Suicide [*Muri shinjû: Nihon no natsu*] (1967) – A nympho who can't get laid meets a suicidal man who can't get killed in the surreal satire of Japan in the 1960s

John Dies at the End (2012) – A psychedelic drug called "Soy Sauce" gives two slackers the psychic powers necessary to sense an incoming extra-dimensional invasion

Johnny Got His Gun (1971) – Antiwar classic about a limbless, blind and deaf casualty of the First World War, trapped inside his own head where he lives out a mixture of dreams and fantasies

Keyhole (2011) – A gangster journeys through a haunted house unlocking forgotten family memories

Kin-Dza-Dza (1986) – Russian junkyard sci-fi satire about a planet with bizarre customs and an absurdly arbitrary class structure. Also, koo!

Kontroll (2003) – A "kontroller" living in the Budapest subway chases after a mysterious killer pushing people onto the train tracks in this mythic thriller

Kung Fu Hustle [*Kung Fu*] (2004) – Totally off-it's-rocker kung fu comedy/fantasy that became a smash international hit

Kwaidan (1964) – Old Japanese ghost stories turned into Expressionist art

L'Age d'Or (1930) – A documentary about scorpions turns into the story of a man and woman's frustrated love, then into Jesus' Sadean orgy

The Lair of the White Worm (1988) – Ken Russell's ultra-fun, tongue-in-cheek horror movie filled with phallic symbols and impaled nuns

Last Year at Marienbad [*L'Année Dernière à Marienbad*] (1961) – Trapped in a ghostly hotel, a man insists he met a woman last year; the woman denies it; things get strange

The Legend of Suram Fortress [*Ambavi Suramis Tsikhitsa*] (1984) – The fortress of Suram is doomed to crumble eternally until a youth entombs himself in its walls

Lemonade Joe [*Limonádový Joe aneb Konská Opera*] (1964) – Anarchic Czech Communist musical Western spoof about a lemonade-drinking cowboy who challenges the whiskey monopoly in a frontier town

Léolo (1992) – A French Canadian boy who believes he was conceived from an Italian tomato contaminated with semen uses imagination to escape from his dysfunctional family

L'Immortelle (1963) – A professor in Istanbul finds and loses a mysterious woman in novelist Alain Robbe-Grillet's directorial debut

L'Inhumaine [*The Inhuman Woman*] (1924) – Arty avant-garde sci-fi melodrama about a stuck-up diva and the men she drives to madness

Liquid Sky (1982) – Tiny aliens harvest endorphins from New Wave punks at the point of orgasm, killing them in the process

Lisztomania (1975) – Composer Franz Liszt battles composer/vampire Richard Wagner in this crazy classical music comedy

Little Otik [*Otesánek*] (2000) – A barren woman adopts a log as a child, and it comes to life and begins eating the neighbors in this black comedy adaptation of an Eastern European folktale

The Lobster (2015) – Find a mate in 45 days or be turned into an animal of your choice

Lost Highway (1997) – A jazzman allegedly kills his wife, then one day disappears and a totally different man wakes up in his death row cell

Love Exposure (2008) – A virginal Catholic who makes his living as a pornographer with ninja skills at upskirt photography tries to save his unrequited love from a religious cult in this bizarrely plotted four hour comedy epic

The Love Witch (2016) – A mix of witchcraft, campy romantic melodrama, and bubbling feminist subtext, presented as a tribute to 1960s Technicolor spectacles

Lucifer Rising (1981) – Egyptian gods and goddess conjure Lucifer and flying saucers in this short (30 minutes), occult, avant-garde masterpiece

Lunacy [*Sileni*] (2005) – Jan Svankmajer directs the Marquis de Sade in a pair of tales by Edgar Allan Poe

The Lure [*Córki Dancingu*] (2015) - Poland's disco-musical about killer mermaids

Maelstrom (2000) – This tale of a pretty young socialite's guilt is narrated by a talking fish

Malpertuis (1972) – Harry Kümel's big weird dark house tale was confusing and a flop despite the presence of Orson Welles, but drips with surreal atmosphere nonetheless

Mandy (2018) – When a hippy cult leader kills lumberjack Nicolas Cage's girl, he goes on a psychedelic revenge rampage

Maniac (1934) – Resurrection of the dead, an orangutan-man rapist and edible cat eyeballs all feature heavily in this deranged exploitation movie that seems to have been directed by an actual maniac

Manos: The Hands of Fate (1966) – Could have been the worst movie ever made, if not for the redemptive presence of the great oddball character Torgo, the spastic satyr

The Man Who Fell to Earth (1976) – David Bowie is the alien who falls to Earth and corrupted in this nonlinear, experimental sci-fi movie

Marquis (1989) – The story of the Marquis de Sade's imprisonment in the Bastille, performed by characters in animal masks and featuring de Sade's penis in a speaking role

Meet the Feebles (1989) – Fragile egos, double-dealings, accidental killings, pornographic sidelines, rohypnol-aided assault, and drug and sex addictions plague puppets at a variety show

Meshes of the Afternoon (1943) – This fifteen minute afternoon nightmare with cloaked figures with mirrored faces gave birth to the American avant-garde

Metropolis (1927) – Fritz Lang's futurist fantasia, a political allegory with Biblical imagery, undercover robots and Bauhaus designs

The Milky Way [*La Voie Lactee*] (1969) – A dry and cerebral, but very weird, story by surrealist master Luis Buñuel about two tramps meeting various Biblical characters and embodiments of Catholic heresies while traveling on a pilgrimage

Millennium Actress [*Sennen joyû*; AKA *Chiyoko: Millennium Actress*] (2001) – A retired actress recounts her life, with her interviewers entering a story which mixes up reality with scenes from her movies

Mind Game (2004) – Nishi goes on a psychedelic journey after being killed by a yakuza, returns to Earth, and lives in the belly of a whale with an old hermit in this anime with rapidly shifting art styles

Monty Python's The Meaning of Life (1983) – Monty Python discusses life in a series of (frequently weird) sketches

Mood Indigo (2013) – A wealthy inventor's wife grows ill from a water lily growing in her lung in this whimsical and surreal adaptation of Boris Vian's novel

mother! (2017) – Jennifer Lawrence finds hordes of boorish guests descending on, and wrecking, the tranquil home she is refurbishing with her celebrity poet husband

Mr. Nobody (2009) – The last mortal man in the world remembers dozens of parallel reality variations of his life

Mulholland Drive (2001) – Radical identity shifts and surrealistic nightclub acts ignite this dreamlike noir fable about love, guilt and Hollywood

My Winnipeg (2007) – In Guy Maddin's Winnipeg, sleepwalkers roam the streets at night, horses freeze in the river, and mother is everywhere

Naked Lunch (1991) – David Cronenberg's adaptation of the unadaptable William S. Burroughs novel features film's scariest typewriters

Natural Born Killers (1994) – A pair of serial killers become celebrities as they slay their way across a hallucinogenic America

Neon Genesis Evangelion: The End of Evangelion (1997) – This apocalyptic anime feature, serving as an alternate ending to Hideaki Anno's popular TV series, is basically Jungian psychoanalysis acted out by giant robots

Never Give a Sucker an Even Break (1941) – The "Great Man" (W.C. Fields) tries to sell a studio an absurd script that begins when he falls out of an airplane chasing his plummeting whiskey flask

Night of the Hunter (1955) – A homicidal Preacher with "LOVE" and "HATE" tattooed on his hands hunts children carrying treasure in this Southern Gothic Expressionist fable

Night Train to Terror (1985) – God and Satan watch badly edited horror films on a train while a New Wave band practices one compartment down

Ninja Champion (1985) – Rose seeks revenge against her diamond-smuggling rapist, while in another movie clumsily pasted on to that one, an Interpol ninja assassinates evil ninjas as they practice circus tricks

The Ninth Configuration (1980) – A psychiatrist argues for the existence of God in an experimental military mental hospital, but is he as crazy as his patients?

Nosferatu [*Nosferatu, eine Symphonie des Grauens*; *Nosferatu, a Symphony of Horror*] (1922) – F.W. Murnau's unauthorized Expressionist adaptation of "Dracula" is a mélange of sex and disease

No Smoking (2007) – Quit smoking, the Bollywood way, in one of India's few intentionally weird films

Nostalghia (1983) – Andrei Tarkovsky's slow, beautiful, dreamlike spiritual parable about a homesick Russian poet in Italy

Nothing but Trouble (1991) – Dan Aykroyd's grotesque Hollywood misfire about a weird old "reeve" ruling from a junkyard in a backwoods New Jersey "shire"

November (2017) – A tragic romance set in a world where our forefathers' craziest superstitions are literally true

Nuit Noire [*Black Night*] (2005) – In a world where the sun only shines fifteen seconds a day, a strange African woman crawls into a solitary entomologist's bed to die

O Lucky Man! (1973) – Sprawling satire with Malcolm McDowell, Kafkaesque interrogations, a half-man half-hog, and breastfeeding

Orpheus [*Orphée*] (1950) – When Jean Cocteau refashions the Greek myth for postwar France, Orpheus and Death fall in love, and Death's chauffeur gets the hots for Eurydice

A Page of Madness (1926) [*Kurutta ippêji*] – A janitor takes a job in an asylum where his wife is held in this silent Japanese film heavily influenced by the European avant-garde

Pan's Labyrinth (2006) – Guillermo del Toro's beautiful fairytale; a girl completes quests at a faun's behest, while her real world Fascist stepfather is a monster beyond all fantasy

Paprika (2006) – Stunning Satoshi Kon animation; scenario involves terrorists invading dreams, then turning them loose on the streets of Tokyo

Perfect Blue [*Pafekuto buru*] (1997) – A Japanese pop idol tries her hand as an actress, and the pressure of unhappy fans and selling out leads her to a psychotic break with reality; anime as psychological thriller

Performance (1970) – Gangster James Fox is fed magic mushrooms and turned into a hippie by Mick Jagger and groupies in this psychedelic stunner

Persona (1966) – A mute actress and her nurse switch personalities at a vacation home – maybe?

Phantasm (1979) – Crazy, nightmarish, obstinately illogical drive-in horror flick about a kid and a sinister funeral home, featuring the terrifying "Tall Man"

The Phantom of Liberty (1974) – A series of Surrealist sketches by the great Luis Buñuel

Phantom of the Paradise (1974) – A rock n' rollin' mix of *Phantom of the Opera* and "Faust," with just the right amount of crazy

Pi (1998) – Amazing black and white photography and a pulsing electronica soundtrack drive this intellectual thriller about a mad math genius seeking a mystical number

Pierrot le Fou (1965) – A television personality goes on the lam with his babysitter in this playfully fractured, classic Nouvelle Vague road movie

The Pillow Book (1996) – Gorgeous experimental video, full of layered images, illustrates this story of a woman obsessed with creating living books by drawing on nude bodies

Pink Flamingos (1972) – Divine goes to excessive lengths to prove she is the filthiest person in the world

Pink Floyd the Wall (1982) – Bombastic, unfocused, overwrought and often brilliant rock opera, with knockout animation from British political cartoonist Gerald Scarfe

Playtime (1967) – A plotless "day in the life" of modernist Paris that ends with chaotic revelry in a crumbling restaurant

The Pornographers ["*Erogotoshitachi*" *yori Jinruigaku nyūmon*] (1966) – Ogata makes pornographic movies while sleeping with his landlady and lusting after her teenage daughter, under the watchful eye of a carp the widow believes is her reincarnated husband

Possession (1981) – Anna leaves her husband, but not for another man... or even another human

Prospero's Books (1991) – Shakespeare's "The Tempest" as an avant-garde video version of Renaissance painting come to life, with plentiful nudity and all parts voiced by Sir John Gielgud

Reality [*Réalité*] (2014) – An aspiring filmmaker gets lost in nightmares inside of nightmares when he is tasked with finding an award-winning scream as a prerequisite to funding his movie

The Red Squirrel [*La Ardilla Roja*] (1993) – A suicidal man pretends to be the boyfriend of a beautiful amnesia victim, but how long can he keep up the charade?

The Reflecting Skin (1990) – Uneven but sometimes powerful flick teeming with symbolism about a kid who thinks his widow neighbor is a vampire, among other strangenesses

Reflections of Evil (2002) – A bizarrely edited piece of avant-outsider art about an angry, obese street peddler who is watched over by the ghost of his dead junkie sister in a purgatorial L.A.

Repo Man (1984) – A punk kid takes a job as a repo man and searches for a car with a mysterious glowing cargo in the trunk

A Report on the Party and Guests [*O slavnosti a hostech*] (1966) – Picnickers are kidnapped and taken to a party in this Kafkaesque allegory on totalitarianism made (and banned) in Communist Czechoslovakia

Repulsion (1965) – Disturbing Roman Polanski peek inside Catherine Deneuve's disintegrating mind

Robot Monster (1953) – A gorilla alien in a diving helmet and his bubble machine invade Bronson Canyon

The Rocky Horror Picture Show (1975) – Even without its bizarre cult following, this naughty musical b-movie spoof would have earned a place on the list

Roma (1972) [AKA *Fellini's Roma*] – An infamous ecclesiastical fashion show with roller-skating cardinals highlights this Felliniesque sequence of vignettes set in the Eternal City

Rosencrantz & Guildenstern Are Dead (1990) – The two minor characters from "Hamlet" wander around the castle of Elsinore, unaware that they are actually characters in a play

Rubber (2010) – The best tire serial killer movie ever made gets bonus points for including an audience that comments on the absurdly comic proceedings

Rubin & Ed (1991) – Antisocial weirdo Rubin agrees to attend a real estate seminar with sad sack salesman Ed, if Ed will help him bury his dead pet cat first

The Ruling Class (1972) – The 14th Earl of Gurney is unfit to serve in the House of Lords because he believes he is God, but he becomes even worse after he is "cured"

Run Lola Run (1998) – Lola has twenty minutes to raise 100,000 Deutschmarks and get it to her desperate boyfriend; fortunately, she gets a do-over

The Saddest Music in the World (2003) – A legless Winnipeg beer baroness holds a contest to discover the titular music in this typically retro comic outing by Guy Maddin

Sans Soleil (1983) – Remarkable, meandering mondo-style arthouse documentary that mixes a trip to a cat shrine and a monkey porn museum with cinematic poetry

Santa and the Ice Cream Bunny (1972) – Insanely bad holiday cheer about Santa's sleigh stuck on a Florida beach, and Thumbelina, and the sad-sack Pirates World amusement park...

Santa Claus (1959) – With the assistance of his henchman Merlin, Santa fights the Devil while delivering presents on Christmas Eve in this culturally confused Mexican take on Kris Kringle

Santa Sangre (1989) – Psychedelic slasher film about a man raised in a circus who acts as the hands for his armless mother

The Saragossa Manuscript [*Rekopis Znaleziony w Saragossie*] (1965) – A Napoleonic soldier listens to stories inside of stories, all of which may be related to two women claiming to be his Muslim cousins who want to seduce him

Save the Green Planet! [*Jigureul jikyeora!*] (2003) – A man kidnaps and tortures a pharmaceutical executive, believing him to be an alien spy from the Andromeda galaxy

A Scanner Darkly (2006) – An undercover cop addicted to a powerful future narcotic is assigned to investigate himself in this rotoscoped adaptation of the paranoid Philip K. Dick novel

Schizopolis (1996) – Fletcher Munson struggles to write a speech for a Scientology-like leader while his doppelgänger is having an affair with his wife

The Science of Sleep (2006) – The melancholy love life of a man who can't distinguish dreams from reality

Scott Pilgrim vs. the World (2010) – A Toronto slacker must defeat his new girlfriend's seven evil exes in this video game styled cult pic

The Secret Adventures of Tom Thumb (1993) – The fairy tale retold in stop-motion animation and pixilation, set in a dystopian city full of bugs and monstrosities

A Serious Man (2009) – The Coen brothers' retelling of the Book of Job as an absurdist comedy is mystifying and brilliant in equal parts

Seven Servants (1996) – A dying Anthony Quinn hires shirtless young men to stick their fingers up his nostrils

Shadows of Forgotten Ancestors (1964) – An old Ukrainian folk tale told as an elliptical experimental film by incomparable stylist Sergei Parajanov

Shanks (1974) – A mute puppeteer (played by Marcel Marceau) learns to operate dead bodies like marionettes, and ends up fighting bikers

Shock Corridor (1963) – Eccentric auteur Sam Fuller imagines Cold War America as a mental asylum in this campy melodrama with remarkable expressionist visuals

Silent Hill (2006) – Sloppy scripting and apocalyptic imagery combine to create a truly weird experience

Sin City (2005) – Visually stunning, ultraviolent postmodern noir

The Singing Ringing Tree [*Das Singende, Klingende Bäumchen*] (1957) – This magical fairytale featuring an evil dwarf, a prince in a bear suit, and a nightmarish mechanical goldfish terrified a generation of British children

Sita Sings the Blues (2008) – An animated retelling of the Indian epic "Ramayana," with music video interludes featuring a Betty Boop-like demigoddess singing the torch songs of Annette Hanshaw

Skidoo (1968) – Carol Channing strips, Jackie Gleason drops acid, and Groucho Marx is "God" in this all-star psychedelic misfire

Skins [*Pieles*] (2017) – The lives of a butt-faced woman, a reluctant pedophile, an eyeless prostitute, and other internally and externally deformed people intersect in unexpected ways

Society (1989) – This horror satire about a teen who doesn't fit in with his high society family is famous for its wild, surrealist makeup effects

Solaris [*Solyaris*] (1972) – Minimalist, mystical science fiction about a conscious planet that recreates a cosmonaut's dead wife

Songs from the Second Floor (2000) – Millennial and existential panic in a nameless Swedish city, told in a spare, absurd style

Sorry to Bother You (2018) – Far-left-field absurdist agitprop satire about a black telemarketer who shoots up the corporate ladder when he learns to use his "white voice"

Spider Baby, or the Maddest Story Ever Told (1967) – The Merrye family reverts to savagery as they age in this horror/comedy with an utterly unique tone

Spirited Away [*Sen to Chihiro no Kamikakushi*] (2001) – Hayao Miyazaki's masterpiece about a girl trapped in a bathhouse of spirits is Japan's answer to "Alice in Wonderland"

Stalker (1979) – Andrei Tarkovsky's slow, mystifying, beautiful science fiction parable about three men's journey to a room which can grant their innermost wishes

Steppenwolf (1974) – The psychedelic effects in this faithful adaptation of Herman Hesse's novel have dated badly

Strange Frame: Love & Sax (2012) – Romance and intrigue on the moons of Jupiter in this psychedelic animated lesbian science fiction musical

Street of Crocodiles (1986) – Eerie reminiscences unfold when a gaunt man is brought to life after a globule of spittle activates a machine

Survive Style 5+ (2004) – Five fantastical interlocking stories about a revenant wife, a hypnotized salaryman, three teenage burglars, an ad exec, and an assassin with a translator

Suspiria (1977) – Bizarre, unreal color schemes and a pounding score surrealize this horror fairy tale about a coven of witches operating a ballet academy

Sweet Movie (1974) – A beauty contest winner's prize is to marry a billionaire, while in a second plotline a socialist sea captain sails down an Amsterdam canal with a hold full of sugar in this scatological political satire

Sweet Sweetback's Baadasssss Song (1971) – The first blaxploitation movie was actually an experimental art film with explicit sex and a cop-beating hero who spends the movie evading the Man

The Swimmer (1968) – Cheerful go-getter Ned decides to swim home through his neighbor's pools, but has he forgotten something important?

Swiss Army Man (2016) – A suicidal, shipwrecked man uses a flatulent, talking corpse to find his way home

Synecdoche, New York (2008) – Charlie Kaufman working without a net in this absurdist, recursive, and dreamlike story of a sad-sack theater director who builds a replica of New York City inside a warehouse

Tales from the Quadead Zone (1987) – We chose this ultra-low-budget anthology of horror stories to represent the work of outsider VHS shlockmeister Chester N. Turner

The Taste of Tea (2004) – The quaintly surreal adventures of a rural Japanese family include a girl plagued by a giant doppelganger only she can see

Taxidermia (2006) – A penis ejaculating fire is the take-home image from this surreal and twisted Hungarian generational epic; barf bags recommended

Tekkonkinkreet (2006) – Orphans White and Black scrape out an existence on the animated streets of Treasure Town

The Telephone Book (1971) – A nymphomaniac falls in love with the world's greatest obscene phone caller in this arty underground sexploitationer that climaxes with a surreally obscene animation

The Tenant (1976) – A new roomer in an odd apartment complex takes on the personality of the previous tenant, who committed suicide

Teorema (1968) – A handsome stranger sleeps with each member of a bourgeois family, and their lives self-destruct when he disappears

The Testament of Orpheus (1960) – The conclusion of Jean Cocteau's "Orphic" trilogy casts the poet as a time-traveler interrogated by his own fictional characters

Tetsuo: The Iron Man [*Tetsuo*] (1989) – A man inexplicably transforms into metal, set to an industrial soundtrack in grainy 16mm black and white

That Obscure Object of Desire (1977) – A wealthy French businessman romances a young Spanish girl over the years, but she will never submit to him

Thundercrack! (1975) – An absurdist underground spoof of Old Dark House movies, with hardcore sex scenes and an amorous gorilla

Tideland (2005) – Terry Gilliam's dark and controversial riff on "Alice in Wonderland"

Time Bandits (1981) – Time-traveling, thieving dwarfs feature heavily in this weird kiddie film mixing fantasy, comedy, and theology

The Tin Drum [*Die Blechtrommel*] (1979) – A three-year old German boy refuses to grow up, then witnesses the rise of Nazism

The Tingler (1959) – A creature that lives in your spine and causes you to die if you don't scream gets loose in this very theater

Titus (1999) – Anachronistic avant-garde adaptation of Shakespeare's most exploitative play, with gang rape, body parts cut off, and cannibalism

Tokyo Gore Police [*Tôkyô Zankoku Keisatsu*] (2008) – A female cop hunts spontaneously mutating serial killers in this very weird, often imitated splatterpunk classic

Toto the Hero [*Toto le Heros*] (1991) – A man nurses a lifelong grudge against the neighbor he believes stole his life (and maybe the love of his sister)

Trash Humpers (2009) – Geriatric miscreants vandalize a trash-strewn Nashville and force Siamese twins to eat soap-soaked pancakes in this non-narrative celebration of VHS aesthetics

The Tree of Life (2011) – Terrence Malick wonders how best to tell the tale of a Texas boy's strained relationship with his demanding father, and concludes the answer is to include dinosaurs

The Trial (1962) – Josef K. finds he's accused of a crime, but no one will tell him what it is in Orson Welles' adaptation of Franz Kafka's absurdist/existentialist classic

The Triplets of Belleville [*Les Triplettes de Belleville*, AKA *Belleville Rendez-vous*] (2003) – Three retired jazz singers help a nearsighted grandma and her overweight dog save a bicyclist from art deco gangsters in this dialogue-free animation set in a surrealistic 1940s milieu

Tromeo & Juliet (1996) – The creators of *The Toxic Avenger* remake the Bard's tale as an obscene punk epic, with predictably bizarre results

True Stories (1986) – A deadpan narrator in a cowboy hat observes the lives of the strange residents of fictional Virgil, Texas

Tuvalu (1999) – Can Anton get his family's Turkish bathhouse to pass inspection while winning the heart of the girl who blames him for her father's death?

Twelve Monkeys (1995) – A time-traveler from a dystopian future trying to investigate a cult called "12 monkeys" is mistaken for a madman

Twin Peaks: Fire Walk with Me (1992) – David Lynch took an on-the-edge TV series over the cliff with this prequel exploring Laura Palmer's last days

Uncle Boonmee Who Can Recall His Past Lives [*Loong Boonmee raleuk chat*] (2010) – Meditative Thai movie where the border between this world and the next is as thin as a strip of film

Underground (1995) – A Yugoslavian gangster tricks his partner into hiding out in a cellar for decades, making him believe WWII is still raging outside

Under the Skin (2013) – An alien dissolves single men in black goo, then repents

Upstream Color (2013) – An examination of what happens when a woman is infected with a will-sapping worm that is then implanted in a pig to create a psychic link

Urusei Yatsura 2: Beautiful Dreamer (1984) – The characters of an anime sitcom about an amorous flying alien find themselves trapped in one of the cast's dream

Valerie and Her Week of Wonders [*Valerie a Týden Divu*] (1970) – The onset of menses turns 13-year old Valerie's innocent world of childhood into a dream of rapist priests, lesbians, incest, and vampires

Vampire's Kiss (1988) – Nicolas Cage's weirdest role features him overacting brilliantly as a literary agent who believes he's turning into a vampire

Vampyr (1932) – Dreamlike early talkie about a student of the occult who wanders into a French village suffering a vampiric infestation

Vertigo (1958) – An acrophobic detective falls for a mysterious woman in Alfred Hitchcock's obsessive exploration of sexual desire

Videodrome (1983) – Discovery of a pirate snuff film broadcast leads to a hallucinatory melding of man and media

Visitor Q [Bijitâ Q] (2001) – Takashi Miike's story about a mysterious visitor who disrupts dysfunctional family dynamics breaks the lactation taboo

Viva la Muerte [Long Live Death] (1971) – Fernando Arrabal's surreal, semi-autobiographical story about a boy who discovers his mother turned his father in to the Spanish Fascists

Waking Life (2001) – The story of a young man who finds he's dreaming and can't wake up, with serious philosophical monologues and dialogues interspersed, painstakingly animated by over thirty artists in differing styles

Waltz with Bashir (2008) – Dreamlike animated documentary about the director's loss of memories related to his time as a conscripted Israeli soldier during the 1982 war in Lebanon

Wax, or the Discovery of Television Among the Bees (1991) – An experimental mock documentary about a computer programmer who begins communing with Mesopotamian bees, who set him to a strange task

Weekend (1967) – A money-grubbing couple travel through a surreal French countryside full of burning wrecks, fictional characters and feral hippies as they try to secure an inheritance from the wife's dying father

Werckmeister Harmonies (2000) – A Whale and a Prince bring an apocalypse to a poor but peaceful Hungarian town

Why Don't You Play in Hell? [Jigoku de naze warui] (2013) – A team of amateur filmmakers luck out when a real-life yakuza asks them to film a bloody raid

The Wicker Man (1973) – Horrifying and intelligent tale of a devout detective's search for a missing girl on a Scottish island where the residents have adopted an ancient pagan religion

Wild at Heart (1990) – Sailor and Lulu flee mother's assassins as they tool down the yellow brick road that leads to madness

Willy Wonka and the Chocolate Factory (1971) – A laborer race of orange and green dwarfs and the bad acid boat trip from hell tip this kiddie musical into the weird column

The Woman in the Dunes [Suna no onna] (1964) – Existential allegory where an amateur entomologist is trapped in a pit with a widow, forced to shovel sand to survive

Wool 100% (2006) – Our only weird movie revolving around knitting is the tale of a strange girl who appears in the lives of two reclusive old pack-rat sisters

WR: Mysteries of the Organism (1971) – A celebration of the sexual revolution that begins as a straightforward documentary on controversial psychologist William Reich and ends with a decapitated head declaring she's not ashamed of her Communist past

Yellow Submarine (1968) – Animated film inspired by Beatles songs is a psychedelic trip through surreal seas in a quest to defeat the music-hating Blue Meanies

You, the Living [Du Levande] (2007) – 50 bittersweet, absurdist sketches on the crushing mundanity of everyday life

Zardoz (1974) – John Boorman's pretentious, campy sci-fi epic full of floating stone heads, psychedelic effects and Sean Connery in a red diaper

Zazie dans le Metro (1960) – 10-year old Zazie explores a Paris filled with transvestites, dirty old men, desperate widows and polar bears in this absurdist tribute to slapstick comedy

A Zed and Two Noughts (1985) – Two zoologist brothers enter a strange ménage à trois with the legless woman who survived an accident that killed their wives

Zéro de conduite (1933) – Boys in a French boarding school rebel in this anarchist/surrealist anti-establishment classic

ALPHABETICAL INDEX OF REVIEWS

All You Can Eat Buddha 17
Annihilation ... 18
Apocalypsis .. 19
Batman Ninja ... 20
Birdboy ... 66
Black Cobra Woman 84
Book of Birdie, The 21
Caniba .. 22
Chained for Life 25
Dirk Gently's Holistic Detective Agency, Seas. 2
 ... 24
Double Lover .. 28
Fags in the Fast Lane 29
Happytime Murders, The 94
Hereditary .. 31
Hitler Lives! .. 32
How to Talk to Girls at Parties 34
Ichi the Killer ... 84
Inheritance .. 35
It Takes from Within 36
Kaleidoscope ... 78
Like Me ... 37
Liquid Sky ... 69
Luciferina .. 38
Luz ... 40
Madeleine's Madeleine 41, 109
Mandy .. 4
Meg, The ... 92
Mind Game .. 72
Mishima: A Life in Four Chapters 85
Molly .. 43
Mom and Dad 42
Monty Python's The Meaning of Life 86

Moon Child .. 77
Mystery Science Theater 3000 – The Gauntlet
 .. 111
Night Is Short, Walk on Girl 45
November .. 10
On Body and Soul 46
Paradox .. 47
Relationtrip, The 79
Relaxer ... 48
Rondo ... 52
Scarlet Diva .. 87
Shape of Water, The 80
Slender Man ... 91
Snowflake .. 53
Sorry to Bother You 13
Suspiria (2018) 56
Take It out in Trade 81
Texas Chainsaw Massacre: The Next Generation
 .. 87
Tokyo Vampire Hotel 57, 107
Trip to the Moon, A 83
True Stories .. 88
Under the Silver Lake 58
Underground .. 88
Urusei Yatsura 2: Beautiful Dreamer 90
Vampire Clay 82
Violence Voyager 60
Wild Boys, The [Les garçons sauvages] 61
World of Tomorrow Episode Two: The Burden
 of Other People's Thoughts 62
Zama .. 63
Zen Dog ... 64

www.ingramcontent.com/pod-product-compliance
Lightning Source LLC
Chambersburg PA
CBHW080916170526
45158CB00008B/2125